THE IMPRESSIONISTS' TABLE

PAMELA TODD

Happy Mother's Day

Love Amy 2003

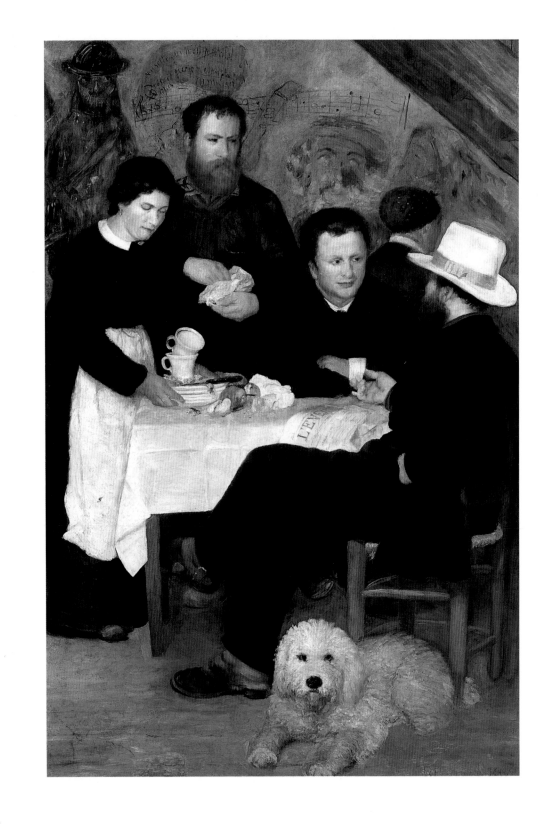

THE
IMPRESSIONISTS'
~ TABLE ~

A CELEBRATION OF REGIONAL FRENCH FOOD THROUGH
THE PALETTES OF THE GREAT IMPRESSIONISTS

PAMELA TODD

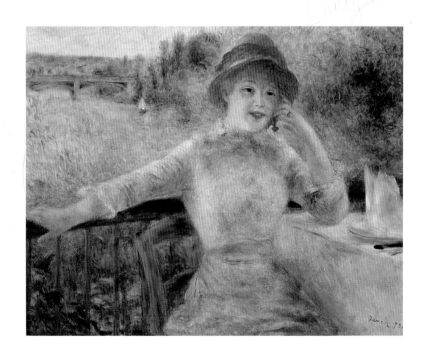

with recipes by LOUISE PICKFORD

PAVILION

TO
KENNETH

ACKNOWLEDGEMENTS
I would like to thank Mrs Lloyd Morgan at the Courtauld Institute's De Witt
Library; the staff and librarians at the London Library, the British Library,
Senate House and Birkbeck University; the curators of the Van Gogh Museum in
Auvers-sur-Oise and Claude Monet's house in Giverny; my family for their faith;
and my oldest friend and art *ami* Kenneth Mahood for his sense of fun, wisdom,
help and encouragement.

First published in Great Britain in 1997 by
PAVILION BOOKS LIMITED
London House, Great Eastern Wharf,
Parkgate Road, London SW11 4NQ

This paperback edition first published in 1999

Photographs copyright © Laurie Evans 1997
Home economist: Louise Pickford
Stylist: Penny Markham

(v) indicates recipes suitable for vegetarians

Art direction and design by David Fordham
Picture research by Lynda Marshall

A CIP catalogue record for this book is available from the British Library

ISBN 1 86205 357 X

Printed and bound in Italy by Conti Tipocolor

2 4 6 8 10 9 7 5 3 1

This book may be ordered by post direct from the publisher.
Please contact the Marketing Department. But try your bookshop first.

Page 2
PIERRE-AUGUSTE RENOIR: MOTHER ANTHONY'S INN

Page 3
PIERRE-AUGUSTE RENOIR: ALPHONSINE FOURNAISE AT THE GRENOUILLÈRE

CONTENTS

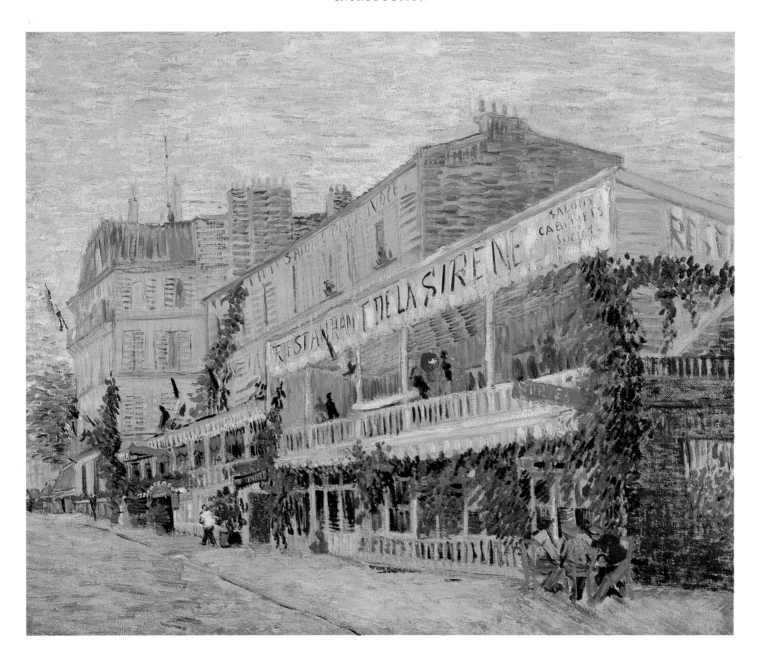

VINCENT VAN GOGH: RESTAURANT DE LA SIRÈNE

INTRODUCTION

'The world knew how to laugh in those days!
Machinery had not absorbed all of life: you had
leisure for enjoyment and no one was the worse for it.'

AUGUSTE RENOIR

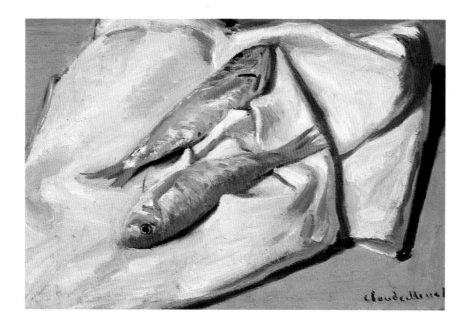

CLAUDE MONET: RED MULLET

THE PAINTINGS OF THE IMPRESSIONISTS communicate an irresistible love of life, a youthful, invigorating energy which grew out of common ideals, privations, celebrations and friendships. Pleasure is their theme, and because of the carefree conviviality of their canvases, the glowing colours, fluid brushstrokes and sunlit scenes it is hard for us now to see anything disturbingly radical or provocatively anti-establishment about their work. Today it evokes in us a feeling of well-being and a tinge of nostalgia for a time when love and light and good companionship – often cemented at the table – were elevated above the petty commercial concerns of everyday living. And yet in their own day their work was misunderstood, mocked and dismissed as the daubings of lunatics. At their first group exhibition in 1874 the public and the critics alike were at a loss to understand the 'inchoate confusions' of the paintings. The immediacy, freshness and improvisation of the work shocked and bewildered them and they fell back on abuse and ridicule.

The influential critic, Albert Wolff, wrote disparagingly: 'They take canvas, paints and brushes, fling something at random and hope for the best.' Louis Leroy had huge fun at their expense in a satirical dialogue he wrote for *Le Charivari* on 25 April 1874, in which he coined the derisory term 'Impressionist'. Monet, delighted, immediately adopted it and became the new leader, at the heart and soul of the group. But Berthe Morisot's teacher Joseph Guichard felt obliged to warn her mother about the dubious company she was keeping: 'As soon as I entered, dear lady, my heart stood still to see your daughter's work in such corrupting company,' he wrote despairingly.

The exhibition did little to improve their precarious financial positions but served to unite them even more closely. Mostly of an age – Camille Pissarro, Edgar Degas, Paul Cézanne, Alfred Sisley, Claude Monet, Berthe Morisot, Auguste Renoir, Edouard Manet and Frédéric Bazille were all born between 1830 and 1841 – they drew together in their favourite cafés and restaurants in Paris, entertained one another in their homes and travelled into the French countryside together, sharing expenses, experiences, insights, triumphs and despairs. Many of them lived on a stream of credit which had a dismaying tendency to dry up. Often they were without money to eat, let alone paint, and were frequently indebted to the better-off members of the group – the dandyish Manet, the original nucleus of the group, the urbane Degas and the tall, bearded Bazille – for moral and financial support. In 1868 Monet wrote in despair to Bazille telling him that he had been thrown out of his lodgings 'without a shirt on my back' and appealed to him to 'write to me without fail, letting me know whether you can

do anything for me'. Bazille, a promising young painter whose own career was cut tragically short when he died in the Franco-Prussian war, loyally bought one of Monet's larger canvases on instalments, which ameliorated the situation somewhat, though Monet was soon crying poverty again. Once, in Arles, van Gogh lived for four days on 43 cups of coffee and stale crusts of bread, while covering canvas after canvas with a glorious explosion of vivid colour. Even those from wealthy backgrounds – like Cézanne – found it hard to make ends meet on a meagre allowance from a father who disapproved both of his son's style of life and of art.

In the summer of 1868, when Renoir and Monet were painting side by side at La Grenouillère, the famous floating café on the banks of the Seine at Croissy, seeking to capture the shimmering effect of light on the grey-green glinting river, Renoir kept Monet, his mistress, Camille Doncieux, and their son from starvation by bringing them scraps filched from his parents' table. 'We might not eat every day,' Renoir wrote to Bazille, 'but I'm content because Monet is great company for painting.'

Back in Paris, the two shared a studio and dined on lentils cooked slowly on the stove in the corner, lit only at the insistence of the model. 'I've never been happier in my life,' Renoir told his son Jean. 'I must admit Monet was able to wangle a dinner from time and time, and then we would gorge ourselves on turkey with truffles, washed down with Chambertin!' In the evenings they met up with the others in the Café Guerbois or the Nouvelle-Athènes and shared their ideas about art and life in animated exchanges which often went on late into the night.

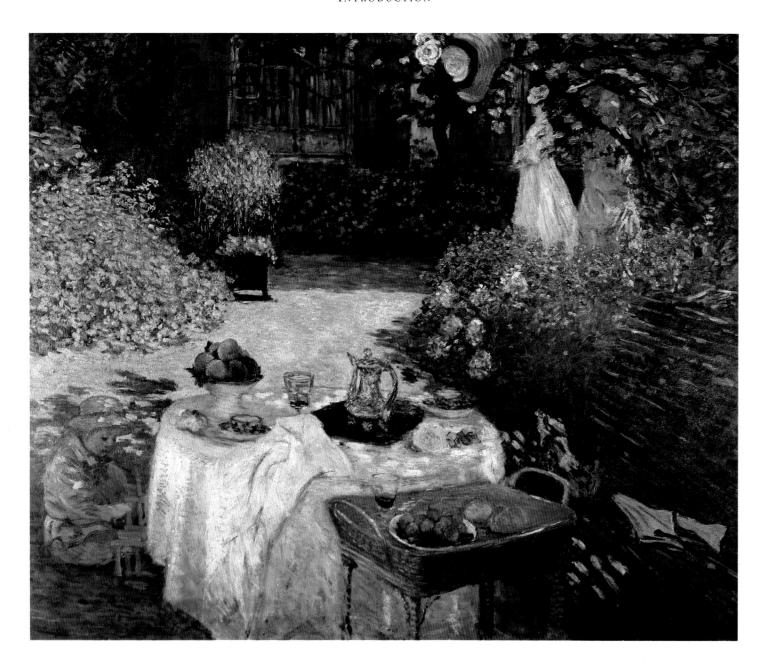

CLAUDE MONET: THE LUNCHEON, MONET'S GARDEN AT ARGENTEUIL

Mostly easy going and fun-loving, they worked to create a new style of art which gave light precedence over form and captured what Baudelaire called 'the presentness of the present'.

The enduring appeal of the Impressionists' paintings is that they capture a landscape and style of life which was fast disappearing and is now largely vanished for ever. We love their work for its limpid play of light and its dazzling happiness. We should not be surprised then that an extraordinary number of pictures focus on the conviviality of food – tables are set out of doors, or vast picnics are spread beneath the dappled shade of hospitable trees. They moved away from the consciously classical subject-matter and monumental history paintings approved by the Salon, into the quieter realms of private domesticity, painting their friends and families sitting around the dinner table or lingering over their coffee at the end of an obviously enjoyable meal. There is a seductive serenity to be found in the grace and beauty of the charmingly laid, untenanted table in Monet's *Le déjeuner* (*The Luncheon*) and a boisterous appeal in the crowded charm of the scene at the riverside Restaurant Fournaise immortalized in Renoir's *Le déjeuner des canotiers* (*The Luncheon of the Boating Party*.) What is most extraordinary about their work is that all trace of the hardship and struggle which characterized their early artistic beginnings has been edited out of their paintings, which exude an air of relaxation and contentment with the simple pleasures of life. Their zest for life and food and friendship communicates itself irresistibly. It has often been pointed out that Renoir did not paint unhappy pictures or even winter scenes. He once said that there were enough burdensome things in life already

without adding to them, and when his teacher at the École des Beaux-Arts accused him of painting for his own pleasure, he replied famously, 'If I didn't enjoy it, I certainly would not do it.'

It took a long time for the art establishment to stop reeling from the violent assault that Impressionism represented, but gradually, thanks to the support of a few enlightened dealers such as Paul Durand-Ruel and Ambroise Vollard, their work began to sell and, as their fortunes rose, so did their standard of living. They were able to exchange the cheap cafés around Les Halles, where they had sat down to steaming bowls of soup with red-faced porters and weather-beaten market gardeners, for the elegant surroundings of Pruniers, Marguéry's, the Café de Paris and the Hôtel Drouot, where successful writers, artists and politicians dined out on the elegant specialities of some of the world's most talented chefs. Monet was the Impressionist with the most robust appetite; Toulouse-Lautrec the most creative and avid cook. Renoir loved company and, like Pissarro and Berthe Morisot, often entertained his friends at home. Manet and Degas frequented the fashionable cafés and restaurants along the *grands boulevards*. They came from different parts of France and different social classes. Manet, Degas and Berthe Morisot were bourgeois, Renoir working-class. Pissarro came from a wealthy background but offended his family by marrying the maid. Some members of the group were family men like Monet and Renoir; others committed bachelors like Degas. Sisley, Renoir and Monet all had children outside marriage, and Cézanne sought to keep the existence of his illegitimate son a secret from his father all his life. What united this

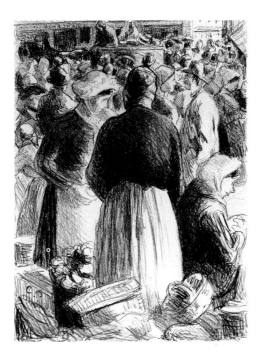

A lithograph of his local market at Pontoise
by Camille Pissarro.

unlikely group was a common cause and their refusal to take the traditional narrowly proscribed institutional path to success and acceptance. They were rebels. They preferred the café to the Academy, the countryside to the studio, and had an insatiable appetite for life, food and friendship.

Theirs was a time of rapid social change, and the history of Impressionism is bound up in the cafés, dance-halls and pleasure pots that proliferated in Paris; in the new English vogue for sea-bathing which turned Trouville and Deauville into elegant seaside resorts; and the coming of the railways which brought the pleasant villages along the banks of the Seine within a fifteen-minute train ride from the city. Increasing industrialization meant more leisure, and new sports such as bathing and boating became popular. Their paintings reveal evidence of the social revolution that was taking place, which allowed women into cafés, or to restaurants to dine alone; and which provided leisure to a burgeoning middle class who chose to spend their Sundays in the country, picnicking or dining out with friends.

In this book we follow the Impressionists through the regions of France with which they were most associated and celebrate their friendship, their art and the food of each distinctive region: the rich and generous gastronomy of Normandy, so beloved of that '*bon gourmand*' Monet; the sophisticated cuisine to be found in Paris at a time when it was undisputed culinary capital of the Western world; a taste of the excellent crayfish, smoked hams, terrines and pâtés served in the bustling riverside inns and small villages clustered along the Seine, and the mushrooms, *cèpes, morilles* and *truffes* freshly gathered in the forests around Fontainebleau; a flavour of the good wholesome farmhouse fare of Brittany and the many shellfish soups, stews, and delicious *fruits de mer* from the lovely prodigal coast; and a feast of the great classic Provençal dishes enjoyed by Cézanne and Renoir.

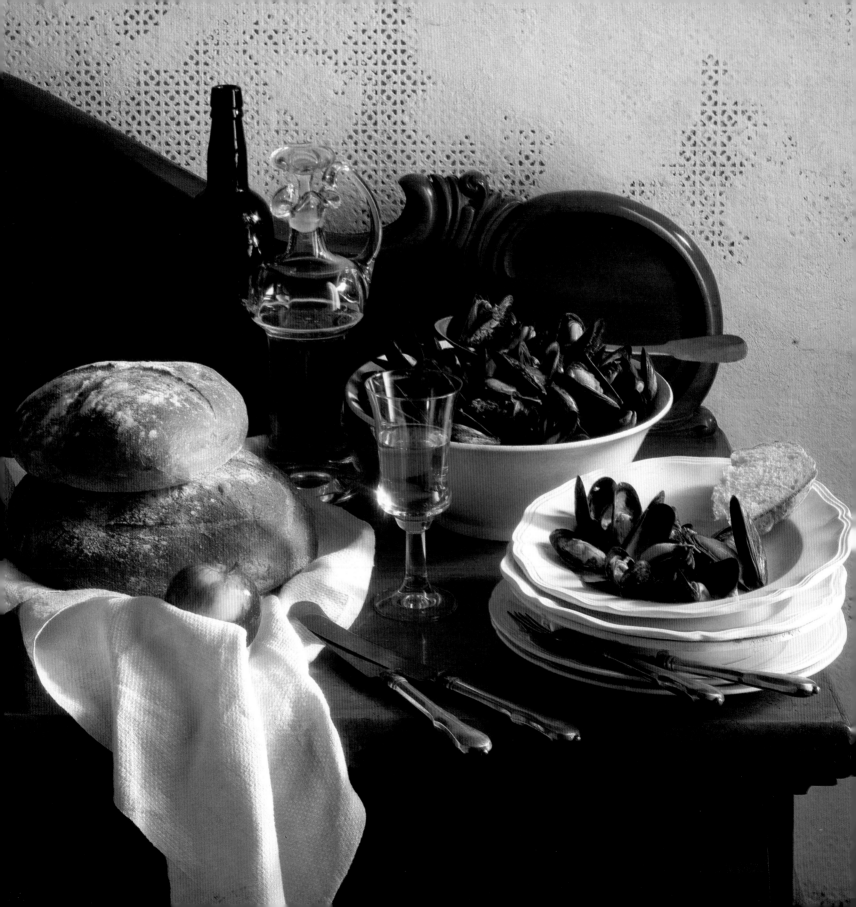

I
NORMANDY
IN LOVE WITH LIFE, FOOD & ART

'I would like to stay for ever in a corner of the world as
tranquil as this.'

Letter from CLAUDE MONET to FRÉDÉRIC BAZILLE, 1868

PIERRE-AUGUSTE RENOIR: STRAWBERRIES ON A WHITE TABLECLOTH

Opposite: MUSSELS COOKED IN CIDER (*see page 30*)

THE ROAD TO THE FERME SAINT-SIMÉON is little changed from Monet's day; it rises in an elegant curve away from the bustle of Honfleur's picturesque horseshoe harbour, a narrow cobbled street lined with a jumble of half-timbered houses, painted in rain-washed pastels. On the right, thin breaks between buildings reveal steep steps descending to a lower, busier, more modern road. It is not difficult to imagine the twenty-three-year-old Claude Monet and his good friend Frédéric Bazille shouldering their paints and easels and setting off up this road in the rosy dawn light as they did each morning through the summer of 1864. They had taken two rooms above a baker's and woke to the heady aroma of freshly baking bread. Young, impecunious, at odds with the traditional artistic establishment, they could never have dreamed that their work would one day hang on the walls of a museum named after the man who first encouraged Monet, on the strength of a few caricatures he was drawing to earn pocket money, to apply himself

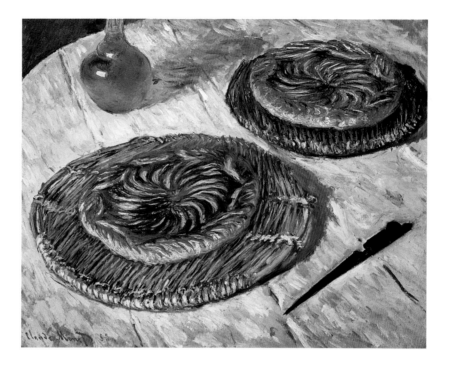

CLAUDE MONET:
THE GALETTES

seriously to the business of art. The Musée Eugène Boudin is situated on the left as the road rises. It houses a stunning collection of paintings by the group of friends we now know as the Impressionists.

That summer in 1864 friendship, not fame, was foremost. Bazille, who was from Montpellier in the south, fell under the spell of Monet's Normandy. 'The country is heaven,' he wrote to his parents. 'One could not see richer meadows and more beautiful trees; everywhere there are cows and horses at pasture. The sea, or rather the Seine broadening out, gives a delightful horizon to the masses of green.' Everything enchanted him: the starched cotton head-dresses of the women, the scenery and the Norman cuisine which he sampled daily at the Ferme Saint-Siméon and enjoyed in Le Havre when he lunched with Monet's family. 'They are charming people,' he told his parents, adding, '. . . I had to refuse the hospitable invitation they made me to spend the month of August there.'

The Ferme Saint-Siméon was a modest country inn in those days. It still stands on the hillside above Honfleur, but in a state of such total refurbishment that Monet would never rec-

ognize it. In 1864 it was a simple place with a thatched roof set in an orchard of apple trees, run by a Norman couple, the Toutains. It was famous for its rustic welcome and Mère Toutain's copious table, at which visitors often remained from noon until evening. In the summer, trestle tables were arranged outside under the trees and it was a favourite haunt of painters. Boudin, described by Baudelaire as a painter of 'the magic of air and water', introduced Gustave Courbet to the delights of Mère Toutain's shrimps and mussels and her mouth-watering speciality *matelote à la marinière*. Courbet was less impressed by the farmer's home-made cider, which, he complained, was good for nothing but washing his hands in, though that did not stop him knocking back a good few glasses from 'Père Toutain's little cask' and then sleeping the effects off under a tree.

There is a captivating sense of camaraderie and *joie de vivre* in the lively sketch Boudin made of a group of painters around a wooden table, which shows a young moustachioed Monet, obviously delighted to be among the august company, raising his glass to the artist.

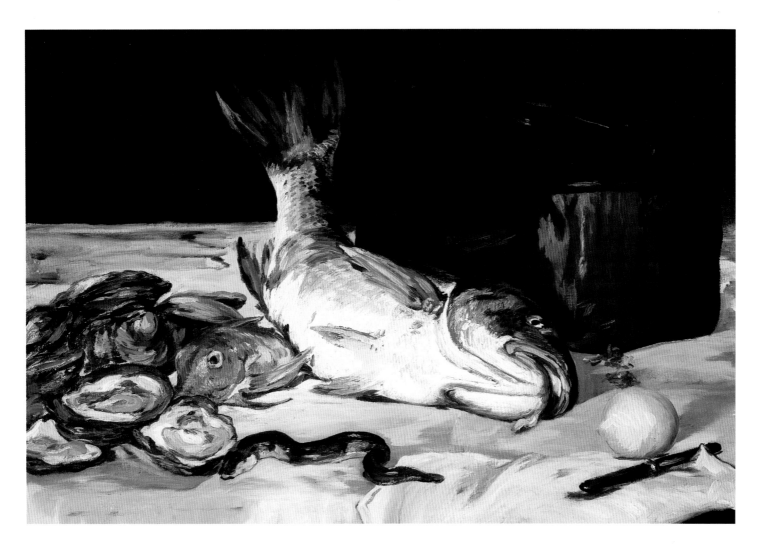

Edouard Manet: Still Life with Fish

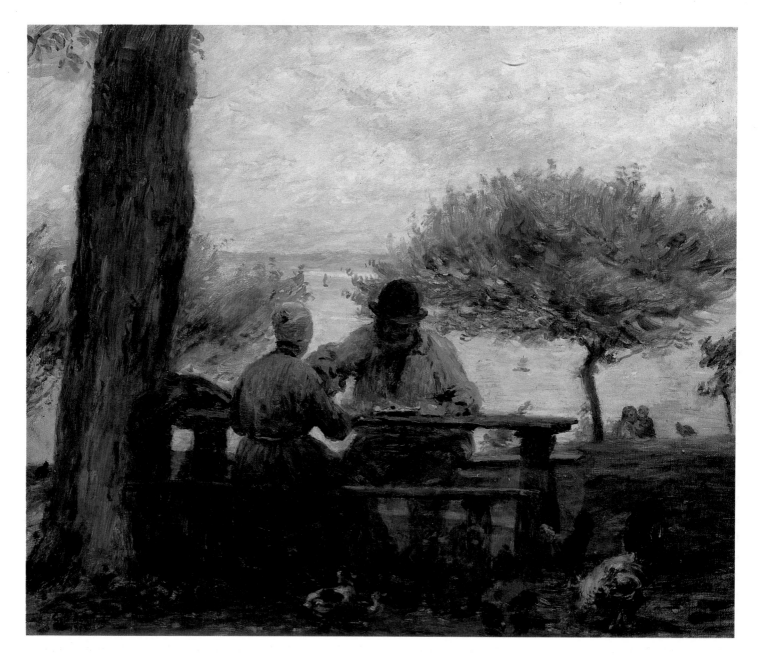

ADOLPHE-FELIX CALS: LUNCHEON AT HONFLEUR

For Claude Monet, Normandy was home. His parents had moved from Paris to Le Havre when he was very young and ran a thriving grocery business, in partnership with his uncle Lecadre. He grew up in a convivial, bourgeois household whose pleasurably busy programme was described by a visitor in 1853 as 'walks and sea bathing in the daytime; in the evenings, improvised concerts and dances . . . everything enlivened this house whose hosts were disposed to take life happily.' His parents' relaxed attitude appears to have extended to the young Claude, who spent his childhood roaming the beaches and playing truant from school. 'I was born undisciplined,' he wrote.

Never, even as a child, could I be made to obey a set rule. What little I know I learned at home. School was always like a prison to me, I could never bring myself to stay there, even four hours a day, when the sun was shining and the sea was so tempting, and it was such fun scrambling over cliffs and paddling in the shallows. Such, to the great despair of my parents, was the unruly but healthy life I lived until I was fourteen or fifteen. In the meantime I somehow picked up the rudiments of reading, writing and arithmetic, with a smattering of spelling. And there my schooling ended. It never worried me very much, because I always had plenty of amusements on the side. I doodled in the margins of my books, I decorated our blue copy paper with ultra-fantastic drawings, and I drew the faces and profiles of my schoolmasters as outrageously as I could, distorting them out of all recognition.

Monet's precocious interest in art was encouraged by Boudin, who urged Monet to 'seek the simple beauties of nature' and led through example, taking the youth with him on painting expeditions in the countryside. Watching Boudin deftly capture the translucent light, or the darkening surface of the water as a sudden storm rolled in, was a revelation to the young painter. 'Suddenly,' he wrote, 'it was as if a veil had been torn away: I had understood, I had grasped what painting could be.' It was a lesson Monet never forgot and his work thereafter was shaped by the vast skies, wide, bracing beaches, changeable sea and the shifting patterns of light on the lush countryside all around him; while his gargantuan appetite (it was said of Monet that he ate enough for four) was formed by the honesty, authenticity and above all generosity of the local cuisine.

Norman cooking is among the richest in France, based on good, basic, wholesome dishes, using the best ingredients: fabulous butter, a heavy smooth cream, the colour of ivory, the healthiest vegetables and fruit, and some of the best-fed meat and freshest fish in France. Its regional cheeses such as Camembert, Livarot, Pont-L'Évêque, Pavé d'Auge and Neufchâtel are deservedly famous, and apples are used profusely, lending piquancy to *tripe à la mode de Caen*, giving themselves up to the definitive Normandy apple flan and providing the central ingredient in cider and Calvados. The combination of coast, lush pasture land and orchards of Normandy produced a rich cuisine, and meals were serious affairs.

The vigorous exercise and long sunny days spent painting out in the open sharpened the young painters' appetites. Thanks to the newly invented zinc paint tubes, which did away

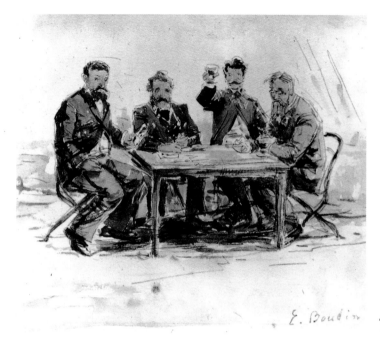

Eugène Boudin made this lively
watercolour sketch of his friends
'At the Saint-Siméon Farm' in 1867.

with the laborious business of mixing pigments and oils which had hitherto tied painters to their studios, Monet and Bazille were able to paint outside until the light began to fade. Towards eight they packed up their easels, square sketching palettes, stowed their paints and brushes away in a wooden box, and retired to the tables around the farm, where they ate and drank and discussed the day's work as the sun sank in a red haze over the wind-ruffled water, flecked with fishing boats. We can derive some idea of the food served by Mère Toutain, with the help of her daughter, 'la belle Marie', and a young girl named Rosie, from the sign André Gill painted for her inn, which shows a rabbit, a salmon and a swan cavorting merrily in a vast saucepan filled with cider and spilling eggs and pork chops, while a biddable duck patiently awaits its turn for the pot.

Honfleur was so conducive to work and good fellowship for Monet that he continually put off his departure. In the autumn he wrote rhapsodically to Boudin: 'I'm still at Honfleur. It is definitely very hard for me to leave. Besides, it's so beautiful now that one must make use of it.'

From time to time he took the paddle steamer over to Trouville to visit Courbet, who was staying in this fashionable resort for the winter. Monet enjoyed the Rabelaisian company of Courbet, who had an insatiable appetite and an extraordinary capacity for serious drinking. It was Courbet who introduced Monet to Alexandre Dumas, author of *The Three Musketeers* and *The Count of Monte Cristo*, who loved food and cooking as much as he loved writing, perhaps more. Dumas combined the two in his *Grand dictionnaire de cuisine*, much of which was written while staying at Roscoff on the Brittany coast and later in Le Havre. He adored the shrimps and *bouquets roses* (prawns) of that stretch of coast and invented a *potage à la crevette* for an appreciative Monet and Courbet.

Many of the Impressionists visited Normandy. It became a focal point for them, attracting even the committed city-lover Degas, who stayed in Étretat and Dieppe, drawn by the elegance and gaiety of the beaches there. Madame Morisot rented picturesque farmhouses and mills in the countryside around

NORMANDY, LATE AUTUMN 1885

'My dear Mama,
I'm writing to tell you that my ears are cold and that I'm drinking a
lot of cider. The countryside is quite white with hoar-frost but still
has its charms. . . .'

Letter from TOULOUSE-LAUTREC to his mother,
COMTESSE ADÈLE

Dieppe for her talented daughters, Berthe and Edma, to use as bases on their summer painting expeditions, and Berthe often returned to Fécamp or Cherbourg after her marriage to Manet's brother, Eugène. Renoir was a frequent guest at the château of the banker Paul Bérard, at Wargemont, six miles from Dieppe, where he was finally able to indulge his taste for high living. Honfleur was important to Seurat, who spent the summer of 1886 there, painting, for the first time, tender, contemplative landscapes composed entirely of dots and a view of the port's 'indefinable greys' in misty monochromes. Pissarro was disappointed to find the place, 'completely flooded by villas' when he stayed there in 1903. He wrote to his son Lucien in London, apprising him, sadly, of the changes to the place:

We slept at the famous Hôtel Saint-Siméon, at which all the painters since 1830 have stayed. Formerly it was a farmhouse, with apple trees in the green fields and a view of the sea; Boudin, Corot, Daubigny, Monet, Jongkind stayed there, but nothing remains of those glorious days. These idiotic new proprietors have put the place in 'good order'. It is horribly painted up and polished, there are rectilinear gravel paths, one can get a view of the sea only from the dining halls, from the room windows you can't even get a glimpse of the sea now, in short, it is arranged to suit the taste of the English ladies who abound. It is heartbreaking! So I returned to the Hôtel Continental. . . .

Pissarro spent a good deal of time in the old town of Rouen. He particularly loved the winding streets crowded with *charcu-* *teries,* displaying terrines and *galantines,* pâtés and *ballotines; boucheries,* proudly offering ready-cooked tripe in earthenware bowls; and *boulangeries,* crammed with long crusty loaves and dark round *miches*. He was always drawn to markets and made many studies of housewives poring over displays of meat, fish and vegetables in search of value and freshness. The kerchiefed country women beside their stalls offering long, shining leeks, green-white cauliflowers and carefully bunched displays of salad leaves and herbs inspired him, and there is great tenderness in his portrayal of the young entrepreneurial woman depicted in his painting *La charcutière* (*The Pork Butcher*). As well as fresh meat, she would have offered the favourite local pork dishes, including *andouille de Vire*, a lightly smoked chitterling sausage with a black skin, and great pyramids of *rillettes*, a soft melting potted pork that, along with pâté, is one of the mainstays of a Norman *hors d'oeuvre*.

Just as Monet's earliest years were spent in Normandy, so were his last. In 1883 he bought the long, low Maison du Pressoir (House of the Cider Press), surrounded by two acres of apple orchards, walled in the tradition of Norman farmsteads, in the village of Giverny, which stretches along a slight slope of the lovely Seine valley, 40 miles north-west of Paris. There, shielded from an increasingly intrusive world and lovingly looked after by his second wife, Alice Hoschedé, who was an excellent cook, he spent the second half of his life, surrounded by friends and his extended family – for his own two children grew up happily alongside Alice's six and the household numbered ten.

Opposite:

CLAUDE MONET: BREAKFAST

Both the house and the garden needed a great deal of work. Monet had the grey outer walls painted a soft pink, and the shutters, wooden terrace and balustrades a distinctive green which the local villagers came to call 'Monet green'. He supervised the planting of exuberant flower-beds, which have now been restored to their former glory and, along with the house, can be visited today. Inside the colours sing. Monet mixed the two tones of yellow used for the dining-room himself and the paint was spread over the walls, chairs, small tables and panelled sideboards, making the room glow. On the walls he hung his collection of Japanese prints. Next to the dining-room a large light and airy blue-and-white tiled kitchen was furnished with a formidable array of gleaming copper pans which did sturdy service on the handsome Briffaut stove.

Despite his irregular and bohemian youth, Monet came from good middle-class stock and it was to this bourgeois style of life that he returned at Giverny, becoming a great gourmet. Along with Renoir, Monet was one of the most convivial of the Impressionist painters and certainly the one with the most robust appetite. His strict routine was dictated by the light and his fondness for meals. He would rise at five, eat a hearty Dutch-style breakfast of cooked meats, hardboiled eggs and cheeses and then spend the morning painting in the garden. He had a willing band of helpers in his children, who would sometimes be allowed to trundle the wheelbarrow containing his equipment down to whichever site he was painting that day. At eleven-thirty the family was summoned to lunch by two rings of an outside bell. The table could comfortably seat fourteen, with room for a further six places to accommodate

Monet's frequent guests; or they might lunch outside on the wooden terrace where Monet's lovely garden, sloping away down to the river, could be admired in all its glory. Monet adored black pepper and would dress the salads himself at the table. Endives from his own vegetable garden, laden with garlic and croûtons or dandelion leaves with strips of bacon, were favourites. Lunch was a substantial and gregarious meal which often ended with fruit 'as beautiful as flowers' placed on the table.

After a stroll around the garden, sipping a glass of home-made plum brandy, Monet would return to work until it was time for tea, taken in the garden. Monet preferred not to entertain in the evenings, as he liked to be in bed by nine-thirty, after a dinner which could hardly be described as frugal.

The house was practically self-supporting. The Monets kept turkeys and chickens; the children were willing fishermen and the river was well stocked with fresh fish, including eel; and a team of six gardeners maintained the vegetable garden and the luxuriant flower garden which unfolded in a rippling sea of colour beyond the windows of the yellow dining-room.

Monet was not himself a cook, though he was a keen collector of recipes and persuaded the proprietor of the Restaurant Marguéry in Boulevard de Bonne-Nouvelle, in Paris, to give him his recipe for *sole Marguéry*, so that he could try it at home. He liked to plan menus and be involved with the masterminding of meals. We know, from the six closely written books of Mme Monet's recipes which have survived, that he dined sumptuously on tempting dishes such as '*truffes à la servette*', '*entrecôte marchande de vin*' and '*vert-vert*', a

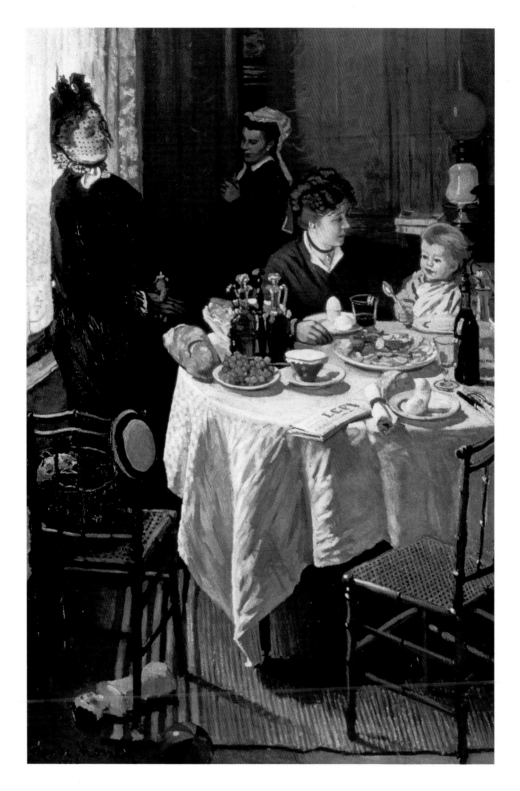

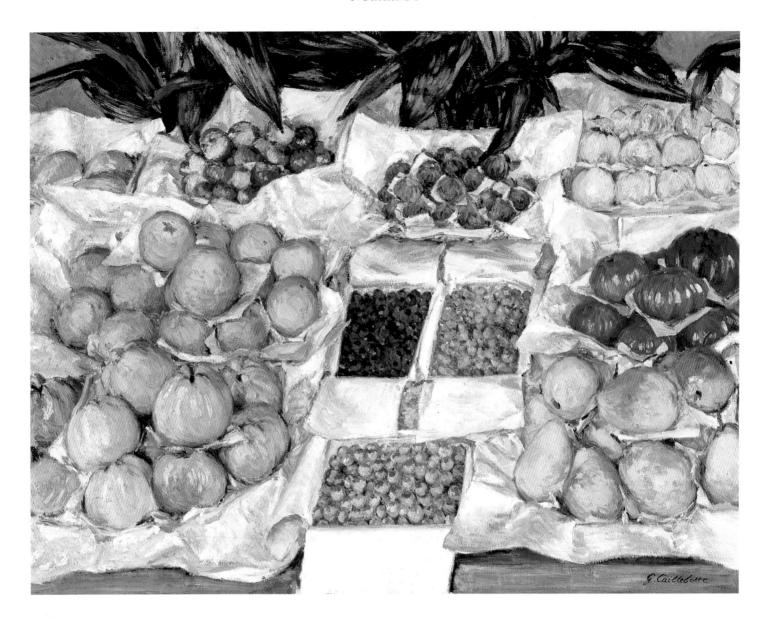

GUSTAVE CAILLEBOTTE: FRUIT DISPLAYED ON A STAND

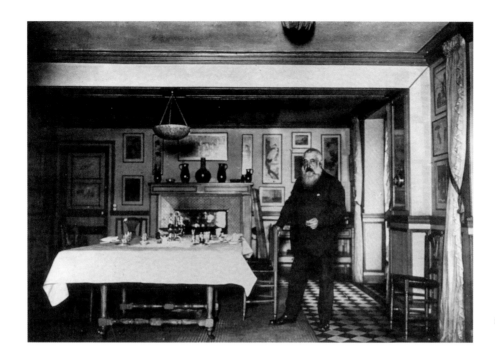

Claude Monet in his
stunning yellow dining
room at Giverny.

delicious sponge cake, studded with pistachios and covered in fondant icing coloured green with a spinach purée. Of the many cooks the Monets employed at Giverny, the most famous was Marguerite, who became so precious to her employers that when she was about to marry, Monet immediately employed her husband Paul as a butler rather than risk losing her.

In 1893 he bought a further piece of land and was granted permission to re-route a tributary of the River Epte through this, creating a pond which he filled with spectacularly beautiful water-lilies. The pond is spanned by a Japanese-style bridge and surrounded by irises shaded by graceful willows.

In the autumn of 1900 Alice's daughter Marthe married the American Impressionist painter Theodore Butler, and the ceremony was followed by a sumptuous six-course lunch at Giverny, which included *hors d'oeuvres*, followed by turbot in a Hollandaise or prawn sauce; roast venison and turkey; *lardons* fried in marrowbone; crayfish; *pâté de foie gras*; salad; praline and ice cream. Monet loved gadgets, and a state-of-the-art hand-cranked ice-cream maker held pride of place among the copper fish kettles, casseroles, sieves and pans in the blue-and-

white kitchen. He never learned to drive himself but was an enthusiastic passenger and, at the first hint of good weather, the family would pack picnic baskets, bottles and flasks into the boot of their Panhard-Levassor and set out for a sedate jaunt through the gently undulating countryside.

Monet was sociable and kept in touch with his fellow Impressionists, extending warm invitations to them to stay at Giverny. On 23 November 1894 he wrote to tell his friend Gustave Geffroy, 'I hope that Cézanne will come here again and join our party,' adding, 'but he is so strange, so afraid of meeting someone new, that I am afraid he will let us down, despite his wanting to meet you. How unlucky that man has been not to find enough support in life! He is a true artist who has come to doubt too much, and he needs to be encouraged.' Geffroy found Cézanne every bit as odd as Monet had hinted. 'He seemed, immediately, to all of us, to be a strange person, timid, violent and intensely emotional.'

Cézanne chose to stay at the Hôtel Baudy in the village, so as not to inconvenience his host, and Mary Cassatt, who was also staying there, described this disconcerting genius in a letter:

Opposite:
PIERRE-AUGUSTE RENOIR: BREAKFAST AT BERNEVAL

He resembles the description of a southerner by Daudet. When I saw him for the first time, he struck me as a kind of brigand, with large, red bulging eyes, which gave him a ferocious air, further augmented by a pointed beard, almost grey, and a manner of speaking so violent he literally made the dishes rattle. I later discovered that I had let myself be deceived by appearances, for far from being ferocious, he has the sweetest possible temperament, like a child.

His manners at first rather startled me – he scrapes his soup plate and then tilts it and drains the last drops into his spoon; he even takes his chop in his fingers, and pulls the meat from the bone. He eats with his knife, and with that instrument, which he firmly grasps at the beginning of the meal and doesn't relinquish until he rises from the table, he accompanies every gesture and movement of his hand. Yet, despite his total contempt for good manners, he displays towards us a politeness that none of the other men here could possibly equal. He never allows Louise to serve him before us, in the order in which we are seated at the table; he even treats that stupid maid with deference, and he takes off his cap, which he wears to protect his bald head, as soon as he enters the room. I am gradually learning that appearances are not to be relied on here.

Conversation at lunch and dinner is mainly about art and cooking. Cézanne is one of the most liberal artists I have ever seen. He begins each sentence with 'For me, it's this way,' but he acknowledges that others can be equally honest and truthful with regard to nature, according to their convictions. He does not think that everyone must see in the same way.

When Cézanne joined Monet's house guests – including President Georges Clemenceau, the critics Geffroy and Octave Mirbeau and the sculptor Auguste Rodin – on 28 November, his eccentric behaviour continued. During a tour of the garden, he suddenly threw himself on his knees before Rodin, 'to thank a celebrated man for having shaken his hand'. And he became even more emotional two days later when Monet invited Renoir, Sisley and a few others to a dinner to welcome him. During the dessert, as Monet was making a sincere and innocent speech, on behalf of the others, assuring Cézanne of their affectionate admiration, he burst into tears and, stuttering, cried, 'You, as well, Monet! You, too, are making a fool of me!' Then, jumping up from the table, he bolted back to Aix, leaving unfinished canvases behind in his hotel room.

The picnics and house parties continued at Giverny. There were wedding breakfasts for Germaine, Lily and Sisi, but finally, in 1926, having outlived most of his friends, Claude Monet died at the age of 86, and the association of Normandy with the last of the Impressionists was severed. The simple service he had requested was held on a wintry day when his magnificent garden lay shrouded in frost.

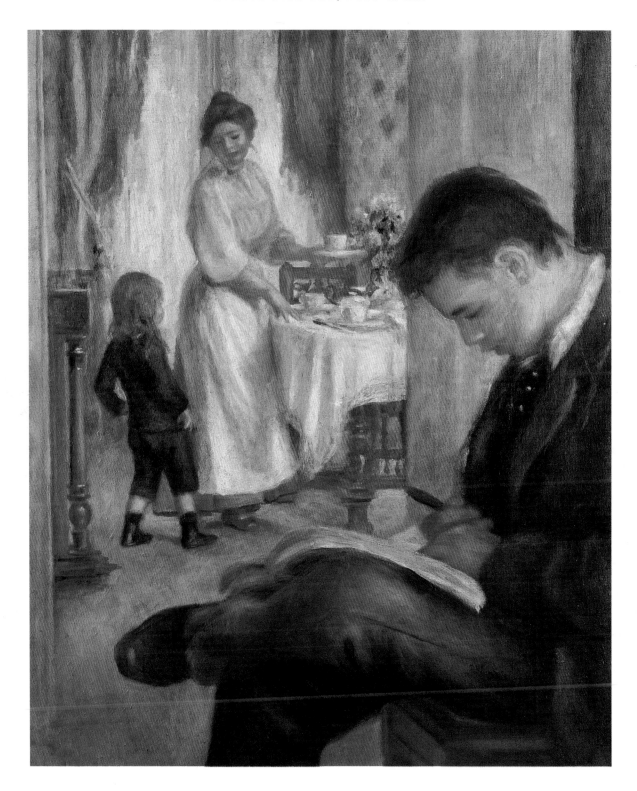

CRÊPES NORMANDES
NORMAN PANCAKES (CRÊPES)

SERVES 4

100g/4 oz/¾ cup plain (all-purpose) flour
pinch of salt
1 egg, beaten
300ml/10 fl oz/1¼ cups milk and water mixed
50g/2 oz/4 tbsp butter, melted
vegetable oil

FOR THE FILLING
85g/3 oz/6 tbsp butter
225g/8 oz/3 cups button mushrooms, wiped and quartered
40g/1½ oz/3 tbsp plain (all-purpose) flour
450ml/16 fl oz/2 cups milk
pinch of grated nutmeg
2 tbsp double (heavy) cream
2 tbsp chopped fresh tarragon
8 thin slices smoked ham
salt and pepper

Make the pancakes (crêpes): sift the flour and salt into a bowl. Make a well in the centre and gradually beat in the egg, milk and butter until the batter is smooth; set aside for 30 minutes. Meanwhile, preheat the oven to 190°C/375°F/Gas Mark 5 and grease an ovenproof dish.

Heat a little oil in a non-stick 20cm/8 in frying pan (skillet) until it is just starting to smoke. Spoon in a little of the batter, swirling it to the edge of the pan. Cook over a medium heat for about 1 minute, then use a palette knife (metal spatula) to free the edge and centre of the pancake and flip it over. Cook for about a further 30 seconds until the pancake is set. Remove from the pan; set aside to cool. Repeat to make 8 pancakes.

Next prepare the filling: melt one-third of the butter in a frying pan. Add the mushrooms and sauté over a high heat for 4–5 minutes until brown and starting to release their juices; set aside.

Melt the remaining butter in a saucepan. Stir in the flour and cook for 30 seconds. Remove pan from the heat and gradually beat in the milk until smooth. Return the pan to the heat and cook gently, stirring constantly and until the sauce is thick. Simmer for 2 minutes, then remove from the heat and stir in the nutmeg, cream and tarragon. Strain in the mushroom liquid.

Working with one pancake at a time, place a slice of ham on top, then spoon over a few of the mushrooms in a row close to one edge. Spread a good spoonful of the sauce over the mushrooms and carefully roll the pancake up Swiss-roll fashion (jelly-roll style).

Transfer to the prepared dish and repeat with the rest of the pancakes. Pour the remaining sauce over the top, spreading it out over the pancakes. Bake for 15–20 minutes until the sauce is bubbling. Serve at once.

OMELETTE AUX PALOURDES
CLAM OMELETTE

Small clams called *palourde* are found along the Normandy and Brittany coast, where they are popular. Clams in brine can be substituted, but rinse them well before using to remove the brine.

SERVES 2

6 eggs
good pinch of salt
25g/1 oz/2 tbsp butter
1 tbsp chopped fresh chives, to garnish
2 lemon wedges

FOR THE FILLING
450g/1 lb fresh palourde clams
2 tbsp olive oil
1 small leek, trimmed, thinly sliced and rinsed
1 garlic clove, crushed

PREPARE THE FILLING: wash the clams under running water and scrub the shells clean. Discard any open ones that do not close when sharply tapped with a knife. Transfer to a large saucepan with just a splash of water, cover the pan and cook for 3–4 minutes, shaking the pan frequently, until the shells open. Discard any that remain closed. Strain and reserve 2 tablespoons of the cooking liquid, and immediately refresh the clams under cold water. Discard the shells.

Heat the oil in a saucepan. Add the leeks and garlic and sauté for 5 minutes until soft but not brown. Stir in the clams and the reserved cooking liquid, then remove the pan from the heat.

Beat the eggs with some salt. Melt the butter in a large non-stick frying pan (skillet). As the butter starts to brown, pour in the eggs, swirling them to the sides of the pan. Stir gently with a fork until the eggs start to set, then add the clam mixture and half the chives. Continue to cook for a few seconds longer, then carefully flip half of the omelette over the other and slip on to a warmed serving plate. Scatter over the remaining chives and add a squeeze of lemon juice. Serve at once.

SOUPE DE CRESSON ET POMME DE TERRE ⓥ
WATERCRESS AND POTATO SOUP

SERVES 4

225g/8 oz watercress
25g/1 oz/2 tbsp butter
1 onion, chopped
350g/12 oz/2½ cups potatoes, peeled and diced
600ml/1 pint/2½ cups vegetable stock
300ml/10 fl oz/1¼ cups milk
pinch of grated nutmeg
salt and pepper

TO SERVE
4 tbsp single (light) cream
4 sprigs watercress

TRIM THE LEAVES and finely chop the stalks of the watercress. Melt the butter in a saucepan. Add the onion and potatoes and fry gently, stirring frequently, for 10 minutes until soft and lightly golden. Add the watercress, stir once and pour in the stock and milk.

Bring to the boil, then lower the heat, cover and simmer for 15 minutes until the potatoes are cooked. Transfer to a blender or food processor and blend until smooth. Pass through a fine sieve (strainer) into a clean pan, add the nutmeg and seasoning to taste and reheat gently.

Spoon the soup into warmed bowls and swirl a little cream into each one. Garnish with watercress sprigs and serve at once.

'Mother Chantemesse made a speciality of pared vegetables; on her stall, covered with a strip of damp black lining, were little lots of potatoes, turnips, carrots, and white onions, arranged in pyramids of four – three at the base and one at the apex, all quite ready to be popped into the pans of dilatory housewives.'

from *Le ventre de Paris* (*The Fat and the Thin*)
by ÉMILE ZOLA

BISQUE DE CREVETTES
CREAM OF PRAWN (SHRIMP) SOUP

Alexandre Dumas, author of the classics *The Three Musketeers* and
The Count of Monte Cristo, was such a passionate cook that he wrote the
Grand Dictionnaire de Cuisine. He adored prawns (shrimp) so much
that he invented a *potage à la crevette*, similar to this one, for his close
friends Courbet and Monet.

SERVES **4**

25g/1 oz/2 tbsp butter
1 onion, chopped
1 garlic clove, chopped
2 celery sticks (ribs), roughly sliced
2 carrots, chopped
2 sprigs parsley 2 sprigs fresh thyme
150ml/5 fl oz/⅔ cup dry cider
450g/1 lb cooked prawns (shrimp) with shells, rinsed and dried
225g/8 oz white fish fillets, such as cod, haddock or whiting, skinned

600ml/1 pint/2½ cups fish stock
1 × 400g/14 oz can chopped tomatoes
50g/2 oz/1 cup fresh breadcrumbs
85ml/3 fl oz/6 tbsp double (heavy) cream
salt and pepper

FOR THE CROÛTONS
2 tbsp vegetable oil
2 thin slices white bread, crusts removed and cut into 1cm/½ in dice

MELT THE BUTTER in a large saucepan. Add the onion, garlic, celery, carrots and herbs and fry over a low heat, stirring frequently, for 20 minutes until all the vegetables are soft and golden. Stir in the cider and cook until almost all of the alcohol has evaporated. Meanwhile, make the croûtons: heat the oil in a frying pan (skillet) until very hot. Add the diced bread and stir constantly until evenly brown. Drain on kitchen paper (paper towels); set aside.

Add the prawns in their shells, the fish fillets, stock and tomatoes to the vegetables. Bring to the boil, then lower the heat, cover and simmer for 30 minutes.

Purée the soup in a blender or food processor, then pass it through a fine sieve (strainer) into a clean pan, pressing down with the back of a wooden spoon to extract all the juices.

Add the breadcrumbs to the cleaned blender with about a ladleful of the soup and blend until smooth. Pour back into the soup, then stir in the cream and season to taste. Reheat until the soup just comes to the boil. Serve with croûtons or crusty French bread.

BEIGNETS D'HUÎTRES
DEEP-FRIED OYSTERS

Oysters are prolific along the Normandy coastline and naturally were
popular with the Impressionists who painted there,
especially Bazille and Monet.
The batter in this recipe is made with cider, the 'wine' of
the region.

SERVES 4

vegetable oil for frying
1 egg, separated
1 tbsp olive oil
100ml/3½ fl oz/7 tbsp French cider
65g/2½ oz/5 tbsp plain (all-purpose) flour, plus a little extra for dusting
salt and pepper
16–20 large plump oysters, shucked, rinsed and patted dry
lemon wedges, to garnish

FOR THE MAYONNAISE
1 egg yolk
pinch of sugar
1 tsp mustard powder
1½ tsp white wine vinegar or lemon juice
pinch of sea salt
pepper
150ml/5 fl oz/⅔ cup extra virgin French or light olive oil

MAKE THE MAYONNAISE: place the egg yolk, sugar, mustard, vinegar or lemon juice, salt and a little pepper in a bowl and whisk together until pale and thick. Very gradually whisk in the oil in a steady stream until the sauce is thick, pale and glossy. Adjust the seasoning and cover the surface with cling film (plastic wrap); set aside.

Heat 10cm/4 in vegetable oil in a deep, heavy-based saucepan to a temperature of 180°C/350°F on a sugar (candy) thermometer, or until a cube of bread browns in 30 seconds. Meanwhile, lightly whisk the egg yolk, then gradually whisk in the oil, cider, flour and seasoning until smooth. In a separate bowl, whisk the egg white until stiff, then fold into the egg yolk mixture until evenly combined.

Dust the oysters with a little flour. Working with 3 at a time, dip them into the batter to coat well, then deep-fry for 1–1½ minutes until crisp and golden. Remove with a slotted spoon and drain on kitchen paper (paper towel); keep warm in a low oven while frying the remainder.

Garnish with the lemon wedges to squeeze and serve at once with the mayonnaise.

MOULES AU CIDRE
MUSSELS COOKED IN CIDER

The Ferme Saint-Siméon, a small country inn near Honfleur, was a regular haunt for several Impressionist painters, including Monet, Bazille and Boudin. A speciality of Mère Toutain, famous for her hospitality as well as her cooking, was mussels cooked in cider.

SERVES 4

1.5kg/3 lb small mussels
2 shallots, chopped
2 garlic cloves, chopped
2 sticks (ribs) celery, chopped
150ml/5 fl oz/⅔ cup dry Normandy cider
100g/4 oz/½ cup crème fraîche or double (heavy) cream
salt and pepper
1 tbsp chopped fresh parsley
1 tbsp chopped fresh chervil
crusty French bread, to serve

RINSE THE MUSSELS under cold running water, scrubbing the shells clean and discarding any straggly 'beards' protruding from the shells. Discard any open ones that do not close when sharply tapped with a knife.

Combine the shallots, garlic, celery and cider in a saucepan. Bring to the boil, then add the mussels, cover and cook over a medium heat for 4–5 minutes, shaking the pan frequently, until all the shells open. Discard any that remain closed.

Strain the mussels through a colander placed over a bowl to catch the juices. Transfer the mussels to a large bowl, cover with foil and place in a very low oven to keep warm. Strain the juices through a fine sieve (strainer) into a clean pan and bring to the boil. Whisk in the crème fraîche or cream and simmer for a few minutes, stirring, until thickened slightly. Season to taste.

Pour the thickened juice over the mussels, scatter over the herbs and serve immediately with plenty of crusty French bread to mop up the juices.

MAQUEREAUX MARINÉS SAUCE MOUTARDE
SOUSED MACKEREL WITH MUSTARD SAUCE

SERVES 4

4 small mackerel, each about 225g/8 oz, cleaned
1 carrot, thinly sliced
½ red onion, thinly sliced
1 garlic clove, sliced
2 cloves
1 tsp fennel seeds
2 bay leaves
4 sprigs fresh dill
1 tsp white peppercorns, lightly crushed
2 lemon slices 2 orange slices
sea salt
150ml/5 fl oz/⅔ cup dry cider
85ml/3 fl oz/6 tbsp white wine or cider vinegar

FOR THE MUSTARD SAUCE
175g/6 oz/¾ cup crème fraîche
1 tbsp Dijon mustard
pinch of sea salt

RINSE AND DRY THE FISH inside and out. Scatter half the carrot, onion, garlic, cloves, fennel seeds, bay leaves, dill, peppercorns, lemon and orange slices and a little salt over the base of a large, deep frying pan (skillet) or flameproof dish. Lay the mackerel over the top and scatter with the remaining vegetables, spices, herbs and citrus slices.

Pour over the cider, vinegar and 150ml/5 fl oz/⅔ cup water and slowly bring to the boil, skimming the surface to remove any scum. Lower the heat and as soon as the liquid reaches a steady simmer, remove the pan from the heat, cover and leave the fish to cool completely in the pan.

Refrigerate for 2–3 days, turning the fish over occasionally.

To serve, return the fish to room temperature and remove from the liquid. Transfer to a serving plate.

Make the sauce: place the crème fraîche in a bowl and stir in mustard and salt to taste. Serve with the mackerel.

Potée aux Fruits de la Mer
Seafood Stew

The Toutains, proprietors of the Ferme Saint-Siméon country inn
near Honfleur beloved by many of the Impressionists,
often served a delicious seafood stew,
which quickly became a favourite of Boudin's.

SERVES 4

1kg/2 lb mussels in their shells, scrubbed (see page 30)
450g/1 lb raw tiger prawns (jumbo shrimp) with shells
85g/3 oz/6 tbsp butter
1 onion, chopped
2 garlic cloves, chopped
2 leeks, trimmed, chopped and rinsed
450g/1 lb/3 cups potatoes, peeled and diced
1–2 tbsp curry paste
600ml/1 pint/2½ cups fish stock
300ml/10 fl oz/1¼ cups double (heavy) cream
2 bay leaves
450g/1 lb monkfish or cod fillets, skinned, rinsed and cut into
2.5cm/1 in cubes
2 tbsp seasoned flour
chopped fresh chervil
salt and pepper

PREPARE THE SEAFOOD: discard any open mussels that do not close when sharply tapped with a knife. Place the mussels in a large saucepan with just the water on their shells. Cover and cook for 3–4 minutes, shaking the pan frequently, until the shells just open. Discard any that remain closed. Strain the liquid through a fine sieve (strainer) and reserve. Immediately refresh the mussels under cold water and remove from the shells; set aside.

Peel the prawns (shrimp), leaving just the tail section attached. With a small sharp knife, cut along the back of the body and pull out the thin black vein. Rinse and dry the prawns.

Prepare the stew: melt half the butter in a frying pan (skillet). Add the onion and garlic and fry for 5 minutes, stirring. Add the leeks and potatoes and fry for a further 5 minutes. Use a slotted spoon to transfer to a flameproof casserole. Stir the curry paste into the frying pan with the reserved mussel liquid and boil until reduced by half. Add to the casserole with the stock, cream and bay leaves. Bring to the boil, then lower the heat, cover and simmer for 15 minutes until the potatoes are tender.

Dust the prawns and monkfish with seasoned flour. Melt the remaining butter in a clean frying pan. Add the prawns and monkfish, in batches, and fry until golden. Add to the casserole with the pan juices and simmer for a further 10 minutes.

Add the shelled mussels and cook for a further minute until heated through. Scatter over the chervil, and season to taste. Serve at once.

SOLE À LA NORMANDE
NORMANDY SOLE

Monet so liked this classic Normandy dish, which he ate at the
Restaurant Fournaise on the River Seine in Paris, that he asked the
proprietor for the recipe so that he could have it at home in Giverny.

SERVES 4

oil for brushing
4 Dover sole fillets, cleaned, skinned, rinsed and dried
25g/1 oz/2 tbsp butter
4 tbsp dry cider
juice of 1 lemon
2 tbsp chopped fresh dill
fresh dill sprigs and flowers, to garnish

FOR THE SAUCE
300ml/10 fl oz/1¼ cups fish stock
50g/2 oz/4 tbsp unsalted butter, diced
4 tbsp single (light) cream
salt and pepper
100g/4 oz cooked peeled prawns (shrimp)

PREHEAT THE OVEN to 220°C/425°F/Gas Mark 7. Cut 4 large sheets of foil and brush each one with a little oil. Place a sole fillet in the centre of each piece of foil. Season lightly, pull up the edges of the foil and add a little butter, cider, lemon juice and dill to each fillet. Seal the edges of the foil to form parcels. Bake for 15–20 minutes until the sole is cooked through and the flesh flakes easily if you open one of the parcels to test.

Meanwhile, prepare the sauce: pour the stock into a saucepan and boil to reduce by two-thirds. Lower the heat to a very steady simmer and whisk in the butter, a little at a time, until the sauce thickens slightly and is glossy. Stir in the cream and season to taste.

Remove the foil parcels from the oven and carefully transfer the fish to warmed serving plates; keep warm. Strain the juices into the sauce and return to the boil. Stir in the prawns (shrimp) and immediately remove from the heat. Spoon the sauce and prawns over the sole fillets. Garnish with dill and serve at once.

Opposite: NORMANDY SOLE

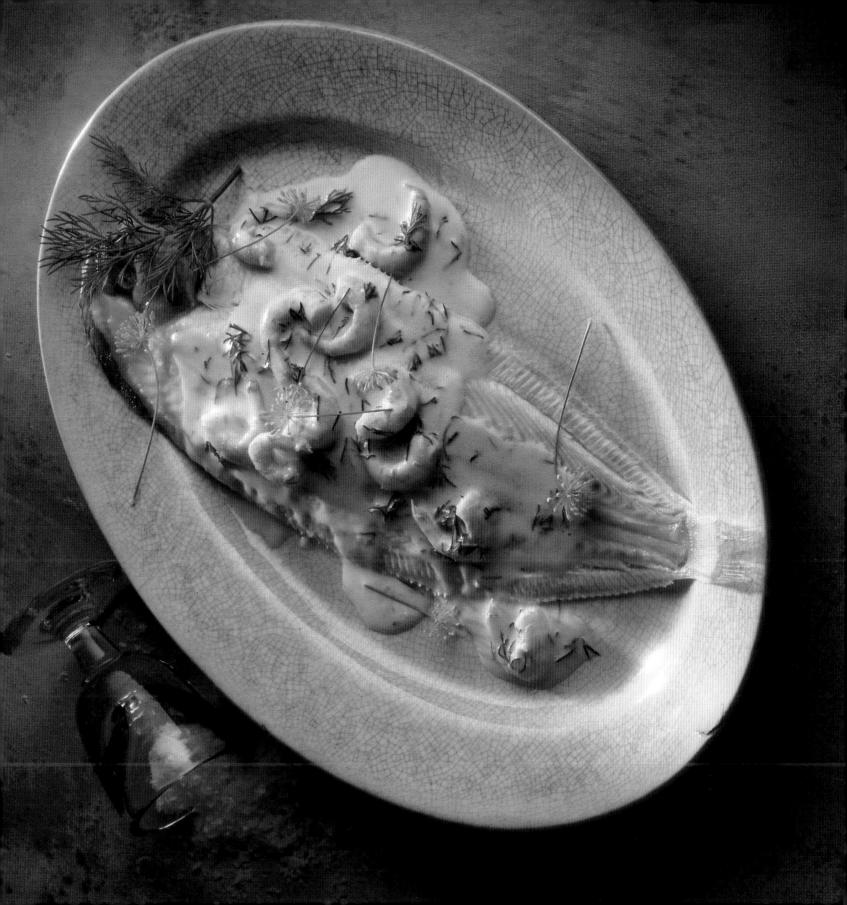

POULET VALLÉE D'AUGE
CHICKEN FROM THE AUGE VALLEY

Monet loved the taste of chicken, and was so particular about the hens
and capons raised at his home in Giverny that he would only use the
very best-quality birds, such as the Bresse hen, which were often served
in this typical Normandy dish.

SERVES 4

50g/2 oz/4 tbsp butter
2 onions, thinly sliced
1 tbsp chopped fresh thyme
1 tsp salt
1 tsp sugar
2 tbsp olive oil
1 large free-range chicken, cut into 8 portions, rinsed and dried

150ml/5 fl oz/⅔ cup dry cider
2 apples, cored and thickly sliced
4 tbsp Calvados
4 tbsp crème fraîche
pepper
2 tbsp chopped fresh parsley

MELT HALF THE BUTTER in a deep, heavy-based frying pan (skillet). Add the onions and fry, stirring frequently, over a high heat for 5 minutes. Add the thyme, salt and sugar and cook over a medium heat for a further 10 minutes, stirring occasionally to prevent burning.

Meanwhile, melt 15g/½ oz/1 tbsp of the remaining butter and the oil in a separate frying pan. Add the chicken pieces and fry over a high heat for 10 minutes until brown on all sides. Transfer to the pan with the onions. Add the cider and boil rapidly until almost all the liquid evaporates. Add 150ml/5 fl oz/⅔ cup water and return to the boil, then lower the heat, cover and simmer for 25–30 minutes until the chicken is cooked through and the juices run clear if tested with the tip of a knife.

Meanwhile, melt the remaining butter in a clean pan. Add the apples and fry for 3–4 minutes until golden on both sides; set aside.

When the chicken is cooked through, add the apples to the pan. Heat the Calvados in a separate pan, ignite it and immediately add to the chicken, swirling the pan carefully until the flames subside.

Stir in the crème fraîche and season to taste. Scatter the casserole with the parsley and serve at once.

In 1868, while renting a small house in Normandy,
Monet declared himself 'as happy as a *coq en pâté*'.

CANARD AUX CERISES
DUCK WITH CHERRIES

The inn sign above the popular Ferme Saint-Siméon was painted by
André Gill and featured the local produce used in the tempting meals
served there, including a duck tantalizingly ready for the oven.

SERVES 4

4 duck breasts, rinsed and dried
2 tbsp olive oil

FOR THE MARINADE
1 onion, sliced
2 celery sticks (ribs), sliced
1 garlic clove, crushed
2 sprigs fresh thyme
2 bay leaves
150ml/5 fl oz/⅔ cup light red wine

FOR THE SAUCE
150ml/5 fl oz/⅔ cup chicken stock
675g/1½ lb fresh red cherries, stoned (pitted), or
350g/12 oz stoned (pitted) cherries
2 tbsp balsamic vinegar
salt and pepper

USE A SHARP KNIFE to score the duck breasts' skin 4 or 5 times and place in a shallow non-metallic dish. Combine the marinade ingredients and pour over the duck. Cover and marinate in the refrigerator overnight.

Preheat the oven to 200°C/400°F/Gas Mark 6 and line a roasting tin (pan) with foil and put into the oven to heat. Remove the duck breasts from the marinade and pat dry on kitchen paper (paper towel), then strain and reserve the juices.

Heat the oil in a heavy-based frying pan (skillet). Add the duck breasts and fry for 1–2 minutes on each side until brown.

Transfer to the warmed roasting tin (pan) and roast for 6–8 minutes.

Meanwhile, make the sauce: add the stock to the pan used to fry the duck, scraping the bottom to deglaze the pan and stir in the juices. Bring to the boil, and boil rapidly to reduce by half. Add the cherries and balsamic vinegar, cover and simmer for 5–10 minutes until the cherries are soft and begin to release their juices; check the seasoning and adjust as necessary.

Remove the duck from the oven and slice each breast through into thick slices. Serve at once with the cherry sauce.

FAISAN AUX FEUILLES DE VIGNE ET AU CALVADOS

PHEASANT WITH VINE LEAVES AND CALVADOS

This recipe was inspired by one in Jenny Baker's marvellous book *Cuisine grand-mère*, where the pheasants are cooked with gin, juniper berries and chicory. In this version, they are laid on a bed of baby onions flavoured with rosemary and Calvados.

SERVES 4

100g/4 oz/½ cup cream cheese
4 allspice berries, crushed
1 tbsp chopped fresh herbs, including chives, parsley or tarragon
2 garlic cloves, crushed
salt and pepper
2 small hen pheasants, cleaned, rinsed and dried
50g/2 oz/4 tbsp butter, softened

4 vine (grape) leaves in brine, drained, rinsed and dried
4 large bacon rashers (slices), rind removed if necessary
225g/8 oz baby onions
4 sprigs rosemary
4 tbsp Calvados
150ml/5 fl oz/⅔ cup chicken stock
fresh herbs, to garnish

CREAM TOGETHER the cheese, allspice berries, herbs, garlic and salt and pepper and divide equally between the 2 birds, filling the stomach cavities. Rub the birds all over with a little of the butter and wrap each one firstly with 2 vine leaves and then with the bacon, then tie up.

Melt the remaining butter in a small flameproof casserole or roasting tin until it is foaming. Add the birds and fry over a medium heat for 5 minutes until brown all over, then remove with a slotted spoon. Immediately add the onions and sauté gently for 10 minutes. Add the rosemary and return the birds to the pan, setting them on the bed of onions.

Heat the Calvados in a separate pan, ignite it and immediately pour over the pheasants. Allow the flames to die down, then pour in the stock and bring to the boil. Lower the heat, cover and simmer for about 50 minutes until the birds are cooked through. Lift out the birds, wrap in foil and leave to rest for 10 minutes.

Season the sauce to taste. Divide the birds into halves and arrange them on a bed of onions, pouring over the sauce. Garnish with fresh herbs and serve.

Opposite: PHEASANT WITH VINE LEAVES AND CALVADOS

Petit Salé aux Lentilles
Salt Pork Cooked with Lentils

SERVES 4

1 × 1kg/2 lb piece salt pork or knuckle gammon, rinsed and dried
225g/8 oz/1½ cups Puy lentils
2 small onions, quartered
4 turnips, peeled and halved
4 large carrots, peeled and quartered
4 large sticks (ribs) celery, trimmed and cut into 4 pieces
4 juniper berries, lightly crushed 3 cloves
25g/1 oz/2 tbsp butter, or 25ml/1 fl oz/2 tbsp double (heavy) cream
salt and pepper
4 tbsp chopped fresh parsley

FOR THE BOUQUET GARNI
1 short celery stick (rib)
1 short leek, rinsed
1 garlic clove, peeled but left whole
1 bay leaf
1 sprig fresh thyme 1 sprig fresh parsley
6 white peppercorns

PLACE THE PORK in a large saucepan with 1.2 litres/2 pints/5 cups cold water and bring to the boil. Lower the heat, cover and simmer for 30 minutes, skimming the surface occasionally to remove any scum.

Meanwhile, make the bouquet garni: place all the ingredients in the middle of a small square of muslin (cheesecloth) and tie with string to form a sachet.

Add the lentils, vegetables, bouquet garni and spices to the pork. Return to the boil, then lower the heat, cover and simmer for a further 30–45 minutes until the lentils, vegetables and pork are tender.

Remove the pork and cover with foil; keep warm. Remove the bouquet garni. Whisk the butter or cream into the lentils and simmer until glossy. Season to taste and transfer to a large warmed dish. Slice the pork into strips and stir into the lentils. Sprinkle over the parsley and serve at once.

Navets Glacés au Jambon et à la Ciboulette
Glazed Turnips with Ham and Chives

SERVES 4

675g/1½ lb baby turnips, scrubbed and trimmed
25g/1 oz/2 tbsp butter
1 tsp sugar
1 tsp salt
225g/8 oz/1½ cups cooked ham, diced
2 tbsp chopped fresh chives
pepper

CUT THE LARGER OF THE TURNIPS in half as necessary. Place in a large pan of cold water and bring to the boil, then lower the heat and simmer for 5 minutes. Drain well; set aside to dry.

Melt the butter in a heavy-based frying pan (skillet) until it is foaming. Add the turnips and sauté over a medium heat, keeping the pan moving constantly, for 5 minutes. Sprinkle over the sugar and salt, stir once and continue to fry for a further 5–8 minutes, stirring occasionally.

Stir in the ham and heat through for a few minutes. Sprinkle over the chives and plenty of black pepper and serve at once.

Opposite:
GLAZED TURNIPS WITH HAM AND CHIVES

Gratin Dauphinois aux Trois Légumes Ⓥ

Mixed Vegetable Gratin

SERVES 4

450ml/16 fl oz/2 cups milk
450ml/16 fl oz/2 cups double (heavy) cream
2 garlic cloves, peeled but left whole
4 sprigs fresh rosemary, bruised
2 bay leaves, bruised
1 onion, sliced
15g/½ oz/1 tbsp butter, softened
350g/12 oz potatoes, peeled and very thinly sliced
225g/8 oz peeled celeriac (celery root), very thinly sliced
225g/8 oz large Jerusalem artichokes, peeled and very thinly sliced
2 leeks, trimmed, finely chopped and rinsed
grated nutmeg
salt and pepper

PREHEAT THE OVEN to 190°C/375°F/Gas Mark 5. Put the milk, cream, garlic, rosemary, bay leaves and onion in a saucepan. Slowly bring to the boil, then remove from the heat; set aside to infuse for 10 minutes. Strain and reserve the cream.

Butter the inside of a large ovenproof dish. Arrange the potatoes, celeriac (celery root) and Jerusalem artichokes in alternate layers in the prepared dish, scattering some leeks, nutmeg and salt and pepper between the layers.

Pour over the cream and cook for 2 hours until the vegetables are tender when pierced with a knife and the top is brown. Allow to cool slightly and serve as an accompaniment to steaks and stews.

Salade Normande

Normandy Salad

Monet's Giverny garden was always abundant with vegetables and fruits, which his cook Marguerite prepared for him; he always insisted that his beloved black pepper was placed beside him at the dining-table so that he could dress his salad himself.

SERVES 4

225g/8 oz new potatoes, scrubbed
225g/8 oz celeriac (celery root), peeled
1 dessert apple, cored
100g/4 oz cooked peeled prawns (shrimp)
2 heads chicory (Belgian endive), trimmed
1 bunch watercress, trimmed
2 spring onions (scallions), trimmed and sliced
1 tbsp chopped fresh chervil

FOR THE DRESSING
100g/4 oz/1 cup crème fraîche
1 tbsp dry cider
2 tsp white wine or cider vinegar
1 tsp grated fresh horseradish
salt and pepper

MAKE THE DRESSING: place the crème fraîche in a bowl and whisk in the remaining ingredients until combined, then season to taste. Cover and set aside.

Put the potatoes into a pan of lightly salted, cold water and bring to the boil, then boil for 10–12 minutes until tender. Drain and immediately refresh under cold water. Dry well, cut in half and place in a large bowl. Grate the celeriac and apple and squeeze out as much liquid as possible. Add to the potatoes, along with the prawns (shrimp). Add the dressing and stir until the vegetables, apples and prawns are well coated.

Separate the chicory (Belgian endive) leaves and arrange around the edge of a large plate. Scatter over the watercress leaves and spoon the potato mixture into the middle. Sprinkle over the spring onions (scallions) and herbs and serve at once.

Plateau de Fromages Normands
Cheese Board from Normandy

The most famous Normandy cheese is Camembert from the *Vallée
d'Auge*, where it shares the spotlight with Livarot and Pont-L'Évêque –
all are rich, creamy soft cheeses. Neufchâtel is another quality
Normandy cheese. Cut a wedge from each of these cheeses and arrange
on a large wooden board. Garnish with bay leaves and serve with a
selection of fruit.

Tarte Tatin ⓥ
Upside-down Apple Tart

Monet's Giverny home had two acres of apple orchards
and he was particularly fond of this classic tart
made famous by the Tatin sisters.

SERVES 8

FOR THE CARAMEL
85g/3 oz/6 tbsp unsalted butter
85g/3 oz/⅓ cup caster (superfine) sugar
1 tsp ground cinnamon

1.5kg/3 lb russet or other eating apples, peeled, halved and cored
crème fraîche or fromage frais, to serve

2 × quantity pâté sucrée (see page 119)

PREHEAT THE OVEN TO 200°C/400°F/Gas Mark 6 and place a baking sheet on the middle shelf.

To make the caramel: melt the butter in a 25cm/10 in heavy-based, ovenproof frying pan (skillet). Add the sugar and cinnamon and heat gently for 1 minute. Bring to the boil and cook for 5 minutes until golden and starting to caramelize.

Add the apples to the pan, cut side up, fitting them in tightly, and continue to cook over a medium heat for a further 6–8 minutes until the underneath of the apples are a golden brown.

Meanwhile, roll out the prepared pâté sucrée on a well-floured surface to a circle just slightly larger than the frying pan. Take the pan off the heat and, working as quickly as possible, place the pâté sucrée over the apples and press down into the sides of the pan. Transfer to the heated baking sheet and bake for 20 minutes until the pâté sucrée is firm and golden. Remove from the oven and leave to cool for 15 minutes.

Invert the pie on to a large plate and serve warm with some crème fraîche or fromage frais.

GÂTEAU NORMAND AUX POMMES Ⓥ
NORMAN APPLE CAKE

SERVES 12

100g/4 oz/1 stick butter, softened
100g/4 oz/½ cup caster (superfine) sugar
2 eggs, lightly beaten
225g/8 oz/2 cups plain (all-purpose) flour
1 tbsp baking powder
3 tbsp dry cider
450g/1 lb eating apples, peeled, cored and chopped
50g/2 oz/⅓ cup walnuts, chopped
50g/2 oz/⅓ cup sultanas (golden raisins) or raisins
1–2 tsp ground mixed spice (apple pie spice)
2 tbsp clear honey, to decorate
crème fraîche, to serve

PREHEAT OVEN to 180°C/350°F/Gas Mark 4 and grease and base-line a deep 23cm/9 in cake tin (pan) with greaseproof (waxed) paper. Cream the butter and sugar together until pale and light. Beat in the eggs, a little at a time, until incorporated. Sift the flour and baking powder together, then fold them into the mixture (batter) with the cider.

Fold in the apples, nuts, sultanas (golden raisins) and mixed spice (apple pie spice) and transfer to the prepared tin. Smooth the surface, making a small dip in the centre. Bake for 1–1¼ hours, or until a skewer inserted in the centre comes out clean.

Remove the cake from the oven and brush over the clear honey. Cool in the tin for 20 minutes, then transfer to a wire rack to cool completely. Serve in wedges with crème fraîche, if wished.

Opposite: NORMAN APPLE CAKE

POIRES FARCIES AUX ÉPICES Ⓥ
SPICED STUFFED PEARS

SERVES 4

4 pears lemon juice

FOR THE FILLING
25g/1 oz/2 tbsp unsalted butter, softened
50g/2 oz/⅓ cup dried apricots, finely chopped
50g/2 oz/½ cup (finely) ground (blanched) almonds
1 tbsp lemon juice ¼ tsp ground cinnamon

FOR THE SAUCE
50g/2 oz/¼ cup sugar
juice of ½ lemon 1 tbsp Calvados
85ml/3 fl oz/6 tbsp unsweetened apple juice
50g/2 oz/4 tbsp unsalted butter, diced

PREHEAT THE OVEN to 180°C/350°F/Gas Mark 5. Make the filling: place all the ingredients in a bowl and beat together until combined; set aside. Peel the pears, leaving the stalk in place, then, using a melon baller, carefully scoop out the cores from the bottom of each one; cut a small slice off each base so the pear will stand upright.

Divide the filling between the pears and stuff into the hollow centres, pressing in well. Sit the pears in an ovenproof dish, add 4 tablespoons of cold water and cover with foil. Bake for 40–45 minutes until the pears are tender.

Meanwhile, prepare the sauce: place the sugar and 2 tablespoons water in a small saucepan and heat gently, stirring, to dissolve the sugar. Then boil rapidly for about 5 minutes, until the syrup begins to caramelize and turn golden. Be careful not to let the syrup burn or it will become bitter.

Remove from the heat and whisk in the lemon juice, Calvados and apple juice, then return to the heat and boil rapidly to reduce slightly. Lower the heat to a steady simmer and gradually whisk in the butter until the sauce is velvety smooth.

As soon as the pears are cooked, transfer them to warmed bowls and pour a little sauce over each one. Serve at once.

II
PARIS
CONVERSATION & SOPHISTICATION

'Life became easy and assumed an aspect of pleasure, a tart,
low-life flavour.'

A. TABARANT

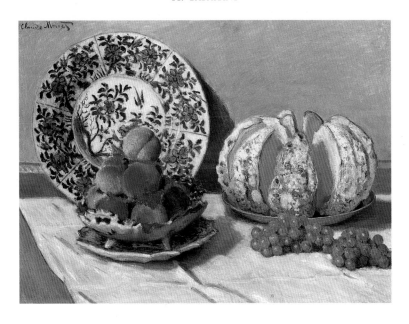

CLAUDE MONET: STILL LIFE WITH MELON

Opposite: ENTRECÔTE STEAK WITH A BERCY SAUCE, SERVED WITH FRENCH FRIES (*see page* 79)

PARIS WAS VITALLY IMPORTANT to the life and art of all the Impressionists. For the wealthiest members of the group – Degas, Manet and Berthe Morisot – it was home, although they all lived in the capital at some time and came together in boisterous gatherings at the Café Guerbois and, later, the Nouvelle-Athènes, from which they derived moral support, renewed confidence and inspiration. The Paris in which they found themselves living in the 1860s was going through a period of rampant prosperity and social upheaval. The very face of the city was changing. Narrow streets and, in places, whole quarters had been demolished to make way for Baron Haussmann's vast pavilions housing fruit, vegetables, livestock and fish in the legendary Les Halles and his broad boulevards which sliced through the city. Along the boulevards, elegant restaurants and smart cafés – the Maison Doré, the cafés Riche, du Helder, Anglais and Américain, Tortoni's, the Grand Café and the Café du Grand Hôtel – attracted a fashionable, cosmopolitan crowd.

The huge international exposition of 1867 drew thousands of English and American visitors, and the writer Henry James spent a great deal of time in the cafés along the boulevards which he described as 'little promontories of chairs and tables projecting into the sea of asphalt'.

At night the city came alive, sparkling with fête and spectacle and a new mood of optimism. Edouard Manet, who cultivated a fashionable, even dandyish style of life, captured this intensely modern moment in his series of paintings of taverns and brasseries, cafés, cabarets and the café-concerts. In these he records the extremes of café life, from the quiet introspection of solitary moments – the sad-faced woman lost in a reverie before her glass of plum brandy in *La prune (The Plum Brandy)*; the top-hatted gentleman writing at a small table in a window at Tortoni's in *Chez Tortoni (Man Writing in a Café)*; the passive beauty of the country girl behind the bar in *Un bar aux Folies-Bergère (A Bar at the Folies-Bergère)* – to the bustle and clamour of the pleasure-seeking crowd in *Au coin du café-concert (Corner of a Café-concert)*, in which a solid, stern-faced waitress, severely buttoned up in black, carries tankards of frothy amber-coloured beer to rapt customers, who look beyond her, entirely engrossed in the antics of the skimpily clad dancers with whom she makes such a stark contrast. Manet used a real waitress from the Brasserie de Reichschoffen as a model for his central figure. A little shy of this stylish, witty and flippant man, she only agreed to come to the studio to pose for him, if her *protecteur* could accompany her, so Manet put him in the painting too, smoking a pipe, in the foreground.

Café-concerts were a new form of entertainment, described by one contemporary writer, Louis Schneider, in *La Revue Illustrée* as places 'people go to casually dressed, on the spur of the moment; they smoke, they drink beer, they crack jokes; the show starts an hour late and finishes at an early one, and the price is modest in the extreme.' Most were situated in Montmartre, which had always been popular with writers and artists, for rents were cheap, and which, Schneider deplored, 'has become the navel of Paris'.

The city's bustling cafés, theatres and other places of entertainment offered an array of subjects that ideally suited Edgar Degas, too. Like Manet, he also lived the life of a wealthy man about town, spending his time at the races at Longchamp, the opera and the ballet. In the mornings, he copied the great masters in the Louvre and towards noon would meet his fashionable friends in Tortoni's or the Café Riche, where successful writers and artists mixed with aristocrats and diplomats, while rich tourists looked on. 'In the Café Riche,' wrote one contemporary, 'the most pleasant novels are sketched out, the intrigues of the boulevards are carried out and the anxieties of politics and the boredom of everyday life are entirely forgotten.'

Paris boasted grand restaurants like Le Doyen, the Palais Royal and the Rocher de Cancale, where Brillat-Savarin went once a week to eat *turbot à la broche*, and one could be sure of finding the best fish and oysters of an exquisite freshness. But it was also bursting with brasseries offering the standard meat, vegetables, salad and dessert; tiny, husband-and-wife-run *bistros* with a small selection of traditional home-style dishes

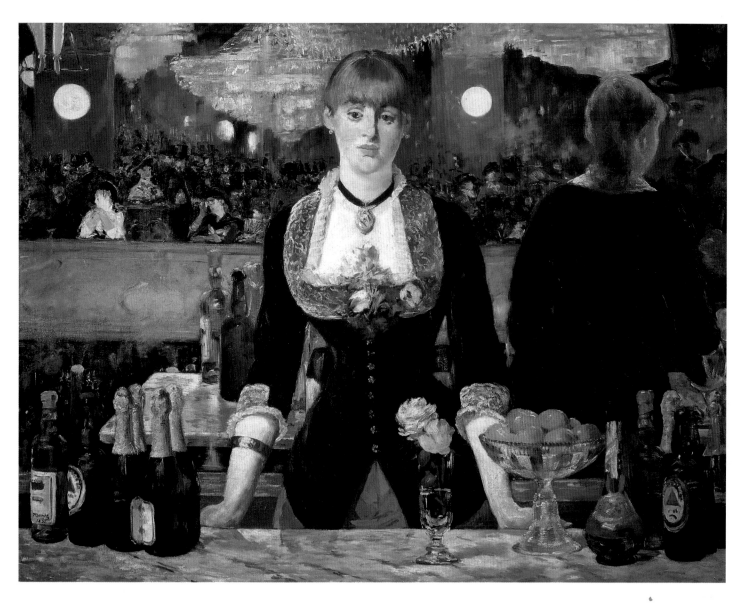

EDOUARD MANET: A BAR AT THE FOLIES-BERGÈRE

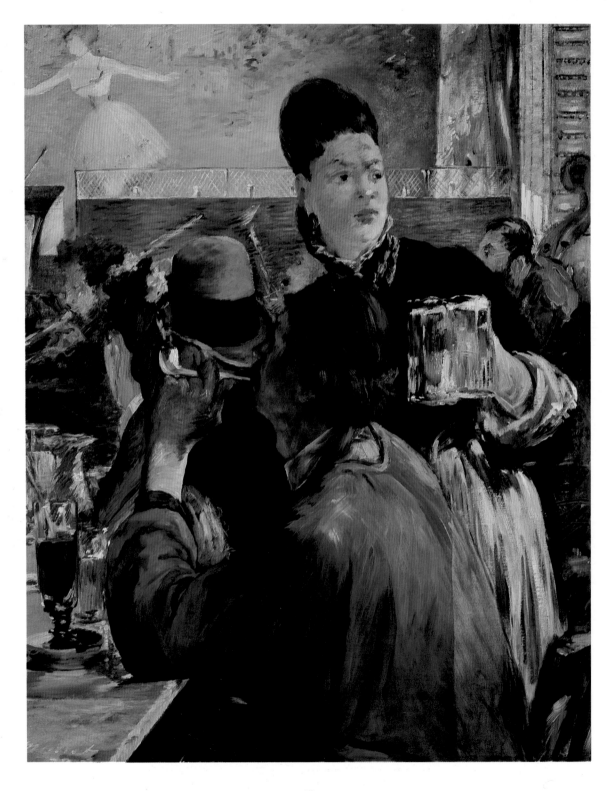

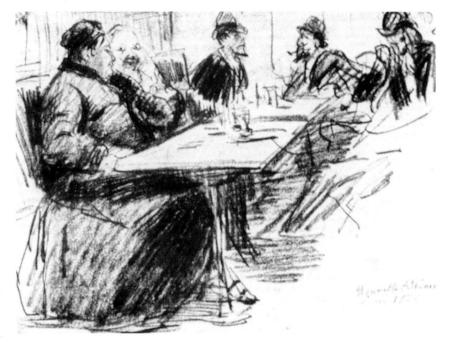

Opposite:
EDOUARD MANET: CORNER
IN A CAFÉ CONCERT

Edgar Degas captures the
bustle of the Nouvelle-
Athènes, a favourite haunt
of the Impressionists.

like *pot-au-feu* or a rich casserole kept going on the stove all day long and wine generally offered by the carafe; or very simple *crémeries* like the one run by Mme Camille in Rue St-Georges, just opposite Renoir's attic studio, which, in addition to selling cream, milk, butter and eggs, provided simple meals for a few regulars who could buy their wine from the dealer next door. Renoir would sit down at lunchtime with local workmen, house-painters and young seamstresses (one of whom, Aline Charigot, 21 years his junior, would eventually become Mme Renoir) in the small room warmed by a little stove in the corner and eat the *plat du jour* – a bowl of broth and a slice of boiled beef and beans, or a veal or mutton stew – followed by a piece of cheese. Brie, which he called 'the King of cheeses' was his favourite, though he believed it was only at its best in Paris. 'Once it goes beyond the city limits, it's no good,' he told his son Jean.

Money was a constant problem for Renoir at this time. At one point he preferred to go hungry rather than impose on Mme Camille's good nature any further. He knew she would willingly have extended him credit, for she was always generous with the 'nice-mannered' young painter, setting aside the best bit of brie for him, but Renoir was anxious not to run up a bill he would never be able to repay. Instead, he stayed in and ate haricot beans cooked for hours over the small stove which heated his studio. Friendship sustained him.

The ties of friendship came together in a knot in the lively triangle of café-crowded streets between Place Clichy, Place Pigalle and the church of Notre Dame de Lorette where, in the early days, the principal members of the group lived and worked.

The Café Guerbois, where Manet reigned supreme, superseded the Brasserie des Martyrs, at 9 Rue des Martyrs, which had been such a favourite of the bohemian poets and writers of the 1850s and where Monet, as a young student at Thomas Couture's *atelier libre*, used to go occasionally though, he confessed, it 'cost me a great deal of time and was extremely bad for me. . . .'

Monet, fresh from Le Havre, had never been a big city person, and all his later homes were in the country, but he nevertheless agreed readily when:

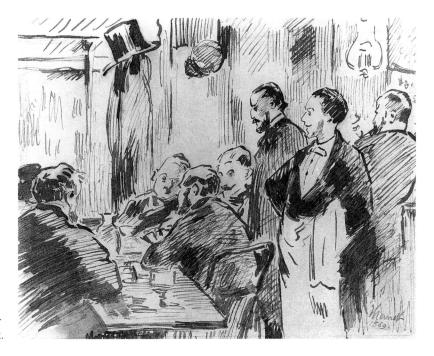

A waiter looks on approvingly as the debate deepens in the Café Guerbois. Lithograph by Edouard Manet.

Opposite:
PIERRE-AUGUSTE RENOIR:
THE END OF THE LUNCHEON

Manet invited me to accompany him to a café in the Batignolles, where he and his friends met and talked every evening after leaving their studios. There I met Fantin-Latour, Cézanne and Degas, the art critic Duranty, Émile Zola, whose literary career was just beginning, and many others. I myself took along Sisley, Bazille and Renoir. Nothing could have been more stimulating than these debates, with their perpetual clashes of opinion. They kept our wits sharpened, inspired us to unbiased and honest experimentation and supplied us with a stock of enthusiasm which kept us going until our ideas had been finally realized. We always came away with a sense of greater determination, our thoughts clearer and more sharply defined.

The Café Guerbois, just around the corner from Manet's house in Rue St. Petersbourg and a short step from his studio in Rue de Douai, where Pissarro also lived, has been called the birthplace of Impressionism: between 1869 and 1872 it became the central focus for the writers and painters of Manet's circle. As the day ended, the lights would go off in the high studio windows in the bohemian Batignolles and Clichy districts and the painters would roll down their sleeves, pack away their brushes and make their way to the welcoming warmth of the café, which was furnished in Empire style with ornate tiles and gilded mirrors in elaborately carved frames all splendidly illuminated by the new flaring gas lamps. The *patron*, Auguste Guerbois, was a man of commanding presence and strong personality who had grown up in La Roche-Guyon on the banks of the Seine and often advised the young artists on perfect painting sites along the river. He always kept the first two tables at the left of the entrance reserved for the group, though often they would spill across and the waiters in their long white aprons would have to push their way between the marble-topped tables, serving drinks in an atmosphere thick with cigar-smoke and lively discussion. Against the background click of billiard balls, revolutionary new ideas about art were exchanged, advanced, argued and passionately defended. Manet would sit in the centre, his elbows planted on the table, his hat pushed to the back of his head, conducting the debate,

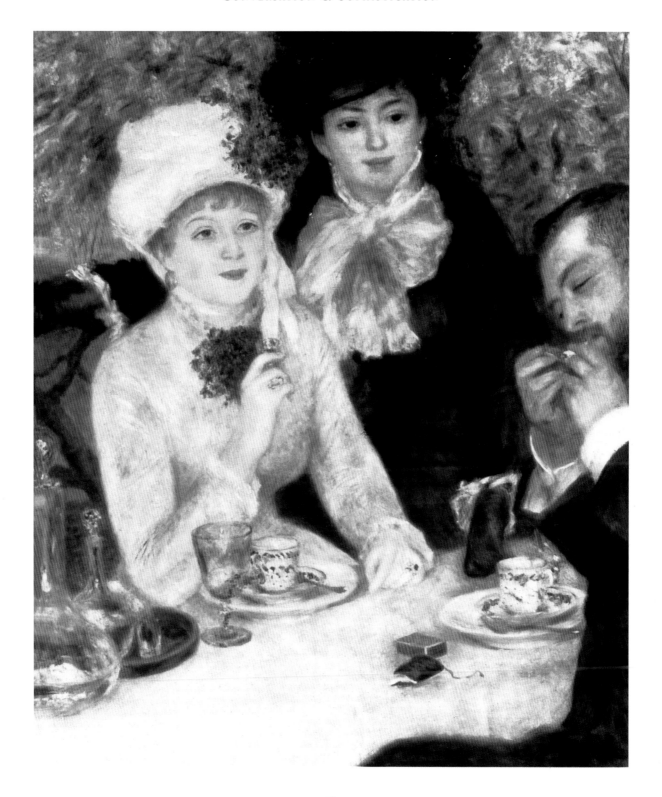

Café life has been an important part of the Parisian scene since the Sicilian Francesco Procopio dei Coltelli first opened Le Procope in 1686. By the end of the 18th century the city boasted 700 cafés – all-male domains serving as centres of political life and discussion – and half a century later the number had grown to 3,000 – some offering special rooms reserved for women, although in 1916, in an effort to curb prostitution, a law was passed that prevented serving women sitting alone on the terraces of those along the boulevards.

surrounded by the bantering, sharp-tongued Degas, a surly Cézanne, hauled along by his friend Émile Zola, Renoir, witty and seemingly carefree, Sisley, amiable and relaxed, Monet, broad-shouldered and handsome, and the modest, sociable Pissarro, who came in by train from the middle-class suburb of Louveciennes, south of Paris, where he had installed his growing family.

In 1872 the group switched their allegiance to the Café de la Nouvelle-Athènes, at Place Pigalle. The Irish writer, George Moore, captured the flavour of the place in his *Confessions of a Young Man* (1886). For him, the French café was his university:

I did not go to either Oxford or Cambridge, but I went to the Nouvelle-Athènes. What is the Nouvelle-Athènes? He who would know anything of my life must know something of the academy of the fine arts. Not the official stupidity you read of in the daily papers, but the real French academy, the *café*. . . . Ah! The morning idlenesses and the long evenings when life was but a summer illusion, the grey moonlights on the Place where we used to stand on the pavement, the shutters clanging behind us, loath to separate, thinking of what we had left unsaid, and how much better we might have enforced our arguments. . . . I can recall the smell of every hour. In the morning that of eggs frizzling in butter, the pungent cigarette, coffee and bad cognac; at five o'clock the fragrant odour of absinthe; and soon after the steaming soup ascends from the kitchen; and as the evening advances, the mingled smells of cigarettes, coffee and weak beer. A partition, rising a few feet or more over the hats, separates the glass front from the main body of the café. The usual marble tables are there and it is there we sat and aestheticized till two o'clock in the morning.

Inside, Moore would find newcomers, Vincent van Gogh and his brother Theo, and always Manet:

At that moment the glass door of the café grated upon the sanded floor and Manet entered. Although by birth and art essentially a Parisian, there was something in his appearance and manner of speaking that often suggested an Englishman. Perhaps it was his dress – his clean-cut clothes and figure. That figure! those square shoulders that swaggered as he went across the room, and the thin waist; and that face, the beard and nose, satyr-like shall I say? No, for I would evoke an idea of beauty of line united to that of intellectual expression – frank words, frank passions in his convictions, loyal and simple phrases, clear as well-water, sometimes a little hard, sometimes as they flowed away, bitter, but at the fountain-head sweet and full of light. He sits next to Degas, that round-shouldered man in a suit of pepper-and-salt. There is nothing very trenchantly French about him either, except the large necktie; his eyes are small and his words are sharp, ironical, cynical. These two men are the leaders of the Impressionist School.

Émile Zola had been urging his boyhood companion Paul Cézanne to come to Paris for years. In an early letter, dated March 1860, he devised a schedule, culminating in the

promise of Sunday jaunts in the country: 'We'll take off and go somewhere outside of Paris; there are charming places, and if you care to, you can jot down on a bit of canvas the trees under which we will have had lunch.' In case this beguiling picture failed to persuade, Zola also set out Cézanne's expenses:

As for the matter of money, it's true that 125 francs a month won't allow for any great luxuries. I'm going to figure out your budget. A room at 20 francs a month; lunch at 18 sous and dinner at 22 sous, which makes 2 francs a day or 60 francs a month; adding the 20 francs for the room, that's 80 francs a month. Then you'll have your studio to pay for; the Suisse, one of the least expensive, is 10 francs I believe; I'm figuring an additional 10 francs for canvases, brushes, paints, which makes 100 francs. So you will have 25 francs left for your laundry, light, the thousand little things that come up, your tobacco, your amusements; you see that you'll have just enough to get by. . . .

Cézanne came but he never liked Paris. Even Zola's friendship was not enough to compensate for the noise, the cold and the general unfriendliness he found. He rarely went to the Nouvelle-Athènes and when he did he tended to be rude, irritable and badly dressed. In 1878 Edmond Duranty wrote to tell Zola: 'Cézanne turned up a short while ago at the little café in Place Pigalle, in one of those get-ups of his: blue shirt, white linen jacket covered with marks made by his brushes and other instruments, old crumpled hat. He was a hit! But

such exhibitions are dangerous.' Cézanne did not seem to care, indeed he delighted in offending the bourgeois tastes of Manet and Degas by exaggerating his own vulgarity. He seemed, whether out of pride or defiance, to want to behave like a complete peasant. Monet tells how, on one occasion, Cézanne entered the café, unbuttoned his jacket, hitched up his ragged trousers with a coarse shake of the hips and then, stopping in front of Manet, greeted him in an exaggerated southern accent and told the immaculately dressed painter that he would not shake his hand because he had not washed for eight days.

Cézanne moved between the capital and his home in the South, always keeping loyally in touch with Zola and acknowledging himself in the character of the struggling painter, Claude Lantier, who first appeared in Zola's novel *Le ventre de Paris (The Fat and the Thin)*. In September 1878 he wrote from L'Estaque to tell Zola that his letter had arrived 'just as I was making a soup of pasta and olive oil, the kind Lantier liked so much'. Then, in 1885, came the break, with the publication of Zola's new novel *L'oeuvre (The Masterpiece)*. This time the portrayal of the lonely Lantier, obsessed by his art to the painful and at times heartbreaking exclusion of his family, was too bleak for comfort. The book ends with the painter's suicide before his unfinished masterpiece. It was too much. Cézanne, who acknowledged receipt of the novel with a curt and chilly note of thanks, felt betrayed and never spoke to Zola again, nor did he ever again attend any of the Thursday dinners Zola gave regularly to his circle of Impressionist friends.

In *L'Oeuvre* we see how these meals grow in grandeur as the novels of the thinly disguised Zola character, Sandoz, find

The Nouvelle-Athènes, one of the cafés frequented by Degas, Manet and Morisot.

fame. The first simple meal of skate, served 'with the vinegar bottle left on the table, for those who wanted to give an extra fillip to the black-butter sauce', gives way by the end to uncomfortably elaborate affairs fraught with tension. Long, lavish dinners of ostentatious show – caviar and oxtail soup, followed by grilled red mullet, fillet of beef with mushrooms, *ravioli à l'Italienne*, hazel hens from Russia and a truffle salad, praline ice cream, a little Hungarian cheese, 'green as an emerald', fruit and pastries – are served in brilliantly lit opulence on hand-painted plates under vast chandeliers. No wonder the assembled guests were tongue-tied by this pompous show of success, and the fine decanters of vintage claret, Chambertin and sparkling Moselle, offered 'as a change from the same old champagne' with the dessert, did little to put them at their ease.

Pissarro, who was always welcomed and admired by the other painters for his indomitable spirit, goodness and cheerfulness in the face of extraordinary hardships and difficulties, did his best to put Cézanne at ease whenever they met at the Nouvelle-Athènes. George Moore recalled how no one was

'kinder than Pissarro', who always took the trouble to explain things to students, to share his ideas and theories with the young. 'He was so much a teacher,' Mary Cassatt later stated, 'that he could have taught stones how to draw correctly.' His modest, gentle and conciliatory manner did much to ease the tensions between members of the group and made him much sought out by the younger generation of Impressionists, particularly Paul Signac and Georges Seurat.

It was in the Nouvelle-Athènes that the idea of organizing the first independent Impressionist exhibition was discussed during the winter of 1873–4. Pissarro, Cézanne, Renoir, Sisley, Guillaumin, Degas and Berthe Morisot had always been in favour of the plan and they fell in with Monet, who, in desperate financial straits, was the driving force. The photographer Nadar, who was just then leaving on holiday, generously put his studio in Boulevard des Capucines at the group's disposal free of charge. The exhibition opened on 15 April and was due to run for a month. It created something of a sensation but drew down a hail of derision and abuse from the press and the public, who came to roar with laughter. Unfortunately, this

EDOUARD MANET: BREAKFAST IN THE STUDIO

succès de scandale did nothing to improve their fortunes but it did provide the group with a name – the art critic of *Le Charivari*, poking fun at Monet's canvas entitled *Impression: soleil levant (Impression, Sunrise)*, coined the term 'Impressionism' as a gibe. Undeterred, Monet adopted the name at once and became the leader of the new school of painting.

Berthe Morisot's former teacher, Joseph Guichard, felt obliged to write to her mother with a full report: 'I have seen Nadar's exhibition and I want to give you my sincere impression. As soon as I entered, dear lady, my heart stood still to see your daughter's work in such corrupting company.' He did concede that it was 'possible to find some excellent things, but for the most part all the exhibitors are a bit touched in the head'.

Attacked and ridiculed on all sides, the Impressionists drew even closer together. In December 1874 Berthe Morisot married Manet's brother, Eugène, and the couple entertained regularly. Following the pattern of her mother-in-law and her own mother, she chose a fixed day, Thursdays, to give dinners, which became as famous for their refinement as for their company. Stéphane Mallarmé, who regularly attended these weekly soirées, described the exquisite atmosphere of her drawing-room 'rarefied by friendship and beauty'. Here, on her own ground, she was able to entertain writers, musicians and critics, as well as the other Impressionist painters and catch up on the debate about modern art which she, as a respectable middle-class woman, was unable to participate in at the Guerbois or the Nouvelle-Athènes. The talk and the food – one particularly piquant menu included Mexican rice and chicken with dates – were guaranteed to be stimulating on these occasions.

Her sister Edma, who had given up painting, envied Berthe's intimacy with these modern masters and wrote to her: 'Your life must be charming at this moment, to talk with M. Degas while watching him draw, to laugh with Manet, to philosophize with Puvis [de Chavannes].'

The Impressionists also came together at monthly dinners, organized by Gustave Caillebotte, a wealthy new recruit, which took place on the first Thursday of each month at the Café Riche. There they dined elaborately on *moules marinière* and the house speciality – fish with diplomat sauce – woodcock *à la Riche*, lamb chops on a bed of asparagus or partridge. Gustave Geffroy, critic and novelist, often attended and, in his book on Claude Monet, he recalled how the evenings were:

dedicated to talk and conversation, in which the happenings of the day were discussed with that freedom of spirit which was peculiar to artists who were free from any contact with official organizations. It must be admitted that the Impressionists' table was a very lively and noisy one, and that these men, relaxing from the burden of work, were rather like children just let out of school. The discussions sometimes got quite heated, especially between Renoir and Caillebotte. . . . I well remember a real duel for and against Victor Hugo which unleased a flood of passion, ardour and wisdom, and from which everybody emerged reconciled, to go and sit on a café terrace and contemplate the ever fairy-like appearance of Paris by night.

'Next Wednesday, Mallarmé will give me the pleasure of coming to dine at Montmartre. If such a climb is not too much for you in the evening, I am sure he would love to meet you here. Durand-Ruel is coming . . . I would have liked to invite Degas but must confess that I can't scrape up the courage. I don't speak of my sweet and lovely Julie; her presence is taken for granted. I believe that Mallarmé's younger daughter will come with him.'

Letter from RENOIR to BERTHE MORISOT, March 1894

The Café Riche dinners were such a success that Monet and Geffroy instituted Friday dinners at the Hôtel Drouot as well. There they feasted on Drouot's specially prepared champignons, woodcock, thrush, brill in red wine, lobster *à l'Américaine* and *potage au vin*, and sampled Escoffier's innovative *salade Japonaise*, made with pineapple, oranges, tomatoes, lettuce hearts and fresh cream.

Renoir was never a man who liked to commit himself, and for many years he refused to tie himself down to marriage or a proper home. In 1884, however, Aline Charigot, who gave him 'the time to think' and 'kept an atmosphere of activity around me, exactly suited to my needs and concerns', moved into his studio in Rue St-Georges. Her mother came too and would whip up 'soufflés, blanquette of veal and caramel custard', even though Renoir longed for a more 'peasant' kind of food. His wish was granted when Aline, pregnant with her second child, Jean, invited her fifteen-year-old cousin Gabrielle Renard to Paris from Essoyes to help with the housework in their new home in Château des Brouillards, situated in a part of Montmartre which was still almost rural. Gabrielle, familiar to us now from the many portraits Renoir made of her, had never been out of her native village of Essoyes before. She was, by all accounts, an extraordinary person. At ten she could tell the year of any wine, catch trout with her own hands – without being caught by the game-keeper – tend the cows, help to bleed the pig, gather greens for the rabbits, and collect the manure dropped by the horses as they came in from the fields.

The two women lavished their care on Renoir. They prepared his favourite meals – pigeon, stuffed courgettes, or herring, bought from the local fish-woman, Joséphine, who rose before dawn each morning to collect two large baskets of fish from Les Halles, which Aline would broil over a charcoal fire and serve with a memorable mustard sauce.

His son, Jean Renoir, in his charming book *Renoir, Mon Père* recalls how the family would visit his grandmother in Louveciennes by train, always taking 'a cheese from Granger's with us, a pâté from Bourbonneux's or some smoked eel from Chatriot's'. In the evening they would stagger home, up the steep slope of Montmartre, laden with vegetables and fruit from the suburban garden, which thrifty Aline would transform into fabulous, tempting meals.

Renoir and Aline often entertained at home. Berthe Morisot and her daughter Julie came frequently, as did Ambroise Vollard, one of the great dealers of the period, who was instrumental in promoting the careers of many artists of the Impressionist generation. Aline once asked Vollard, who was French-Creole, how to cook rice without it forming into a sticky mess, and was told, 'In Réunion the natives have no time-pieces. They just put rice and water into a calabash, heat it over a fire made with sugar-cane cuttings, go to sleep, and when they wake up it's done, and absolutely perfect!' Sensibly, Aline served *pot-au-feu*, which Renoir loved, for it reminded him of his childhood, when his mother used to prepare a huge *pot-au-feu* on Saturday nights and throw the house open. Guests never needed to let her know in advance if they could come, and if no one turned up, the family simply ate cold

'The rectangular room had one of its large sides entirely of glass and exposed to the West. During the summer, the sun would fill the room with light, in spite of the curtains of thick material designed to control it. The walls were covered in light grey paper and a few unframed canvases were hung against them. Against the walls grew, in piles, canvases painted or white, of which the visitor only ever saw the backs. There was no other furniture except for two easels, a few cane chairs of the most ordinary kind, two collapsed old armchairs covered with a very faded flowering material, a tired divan recovered with a material of indeterminate colour and a white wooden table upon which tubes of colours were piled together with brushes, bottles of oil or turpentine and spattered paint rags.'

Description of RENOIR'S studio at 35 Rue St. Georges by MICHAEL DRUCKER

boiled beef, with the pickles Renoir had helped to prepare, for the rest of the week. Renoir's love of food and good company had been formed here in the modest, though gregarious, 'pocket handkerchief' apartment that was his childhood home in Paris, where one room did for everything, serving as a workshop for his father, a tailor, who sat in the traditional cross-legged pose, while the boy sat in a corner helping his mother to shell green peas or peel the onions for pickling.

Renoir, always lively and full of an irresistible gaiety, loved Montmartre for its honest charm and the way, at night, it burst into life. Many of the popular music-halls were situated there, and yet it retained a village atmosphere, with its leafy lanes, steep gardens descending vertiginously northwards away from the city, and carefully cultivated allotments. The beautiful white dome of the Sacré-Coeur was slowly rising, and another Paris landmark, the Eiffel Tower, was also under construction. Fruit and vegetable shops, supplied by nearby farms, lined the steep pavements with colourful displays of impressively fresh produce. Rents were cheap, and cheaper still if you lived high. A top-floor studio could cost as little as 500 francs a year, though water had to be carried up numerous flights of steps from the iron pump in the courtyard, and the huge north-facing windows could make the studios incredibly cold in the winter and stifling in the summer when the sun fell full on the glass.

Montmartre was full of lively *bistros* and restaurants like Père Lathuille, which had started life as a farm with a herd of sixty cows providing fresh milk for Parisians and offering simple meals to travellers, but by 1879, when Manet used it as a setting for *Chez le Père Lathuille*, had become an old established restaurant and favourite place for wedding breakfasts and receptions. The great speciality trumpeted on the restaurant's signboard was *poulet sauté*, which the chef Prosper Montagné cooked with artichoke hearts and served sprinkled with chopped parsley and a little grated garlic, surrounded by onion rings.

At first glance one might think that Manet's picture shows a couple of young lovers lunching contentedly together, but on closer inspection it is plain that a rather more modern drama is in progress. For a start, the young woman has been taking a late lunch alone (all the other tables are empty) and the young man, with his arm so possessively draped along the back of her chair, is not sitting at the table but kneeling beside it and making advances to her.

Flirting, of a soft, good-natured kind, is Renoir's theme, too, in *Le Bal au Moulin de la Galette (Dancing at the Moulin de la Galette)*. His sunlit pink, blue and gold dancers are a far cry from the decadent-looking spectators Toulouse-Lautrec was to depict in his energetic and seductive, though not always positive, paintings of the same dance-hall thirteen years later. Renoir loved the Moulin de la Galette – so called because of the thin flat cakes (*galettes*) traditionally served with drinks – with its rackety, rheumatic old windmills, once used to grind the grain from the rich valley below. By now the place had been converted into a dance-hall, where every Saturday night and Sunday the shop girls, laundresses, seamstresses, apprentice

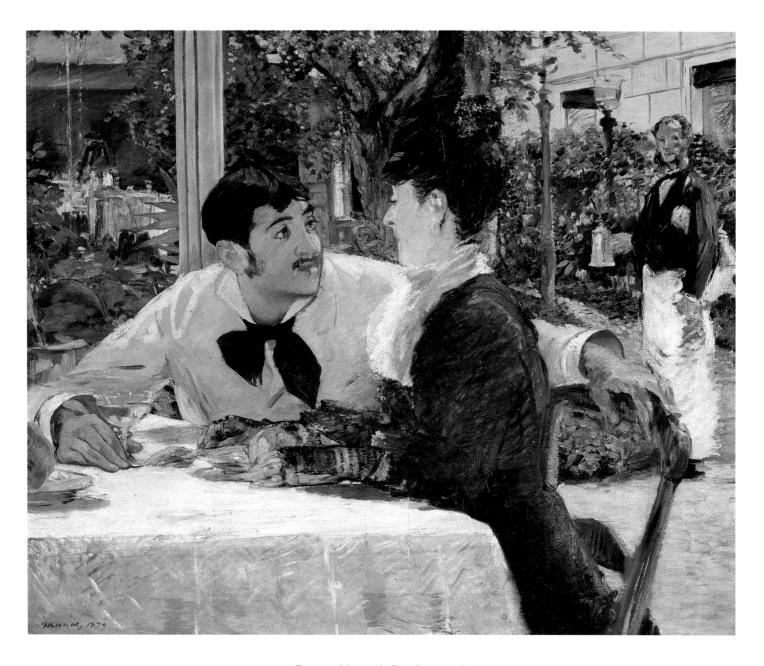

EDOUARD MANET: AT PÈRE LATHUILLE'S

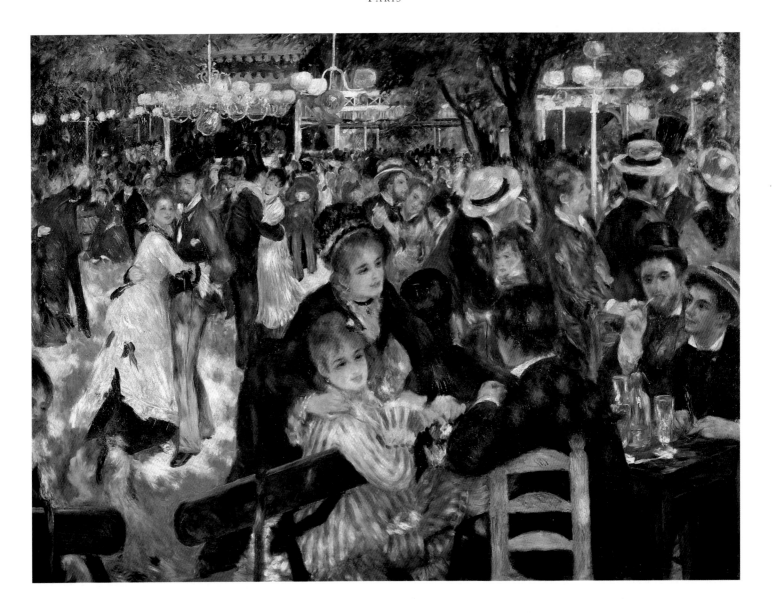

PIERRE-AUGUSTE RENOIR: DANCING AT THE MOULIN DE LA GALETTE

'The view over Paris [from the Moulin de la Galette] was splendid; to the west were the hillsides of Saint-Cloud and Mont Valérien, with a fortress sitting on its top like a lump of sugar. This panorama was only barely interesting to Lautrec who liked to see things close up, so he was much more attracted by the drinkers. . . . There we ran into some friends from Cormon's and sat down together in front of a salad-bowl of very sweet hot wine, flavoured with powered cinnamon and cloves. Lautrec declared: "Here the only thing you can drink is hot wine; it's a sacred tradition." And I think it's the only place he ever drank any.'

LAUTREC'S friend and fellow student FRANÇOIS GAUZI describing his first visit to Le Moulin de la Galette in 1888.

milliners and clerks and office boys from the north of Paris would come to dance. To go on the dance-floor for a waltz cost two sous and no one bothered to dress up. For Renoir such simple pleasures typified the 'good-natured side of the common people of Paris' and it was their careless rapture that he sought to capture on canvas.

The painting was so large that Renoir rented an apartment in Rue Cortot opposite the dance-hall. He took his meals in a tiny rustic restaurant, Chez Olivier, nearby, where, if the weather was fine, customers could eat outside in one of the arbours covered with Virginia creeper. The writer Georges Rivière, who posed for one of the figures in the painting, recalled how 'Renoir worked every afternoon on his big canvas. We used to carry it between us from his apartment to the Moulin, for all the actual painting was done on the spot. Sometimes there were anxious moments, when a strong wind was blowing and it looked as if the canvas with its chassis would tear itself from our hands and shoot up like a kite above the Butte.'

A contemporary writer, Émile Goudeau, in his *Paris qui Consomme* (1893) describes how 'from atop the platform and the annexed terrace, one could see Paris spread out under the sky like a gigantic chaos of roofs and chimneys from which the principal monuments emerged like reefs'.

As well as fascinating Renoir, the dance-halls, circuses and café-concerts which thrived in the broad new streets of the capital inspired many of Seurat's late drawings. He became infatuated with subjects drawn from them and would haunt the fairs at Neuilly and Saint-Cloud or one of the three full-time indoor circuses in Paris: the Cirque d'Hiver, the Cirque Fernando (later called the Cirque Médrano) or the Nouveau Cirque. The atmosphere inside these small one-ring circuses was intimate and relaxed. Each had a café offering drinks and snacks, and the customers could circulate and chat between the acts.

Seurat was a friend of Pissarro and Signac. He was shy, peaceable, secretive, obstinate, always immaculately dressed in dark blues and blacks, and had an upright and neat appearance that led Degas to nickname him tartly 'the notary'. His work absorbed him totally and he developed a routine which permitted a rapid lunch at the nearest restaurant and the occasional dinner with his mother. One evening Signac joined them and was surprised to meet Seurat's shadowy father, who, he reported in a letter to the critic Félix Fénéon, had an artificial arm. 'At the table he screwed knives and forks to the end of this arm and proceeded to carve with speed, and even efficiency, mutton, fillet, small game and fowl. He positively juggled these sharp, steel-edged weapons, and when I sat near him I feared for my eyes. Georges paid no attention to these acrobatic feats.'

In 1889 the Moulin Rouge, with which Toulouse-Lautrec's name will for ever be associated, opened its doors. It offered several different kinds of entertainment, beginning with a concert of comic and sentimental songs and ending with a display of a daring new dance – the can-can – performed by a regular troupe who became notorious for their raucous vitality and complete lack of inhibition. Soon the Moulin Rouge was

known as the largest 'free market' of love in Paris with a reputation for tawdry decadence and scandal. Lautrec was in his element and, with his sharp, unforgiving eye, depicted the bawdy goings-on of the brazen, hard-bitten crowd, in the intoxicating atmosphere of lasciviousness spiced with lesbianism.

Henri de Toulouse-Lautrec was an original, both as an artist and as a man. He came from one of the most distinguished families in France and was rich as well as talented, but a bone disease, possibly caused by inbreeding (his parents were first cousins and his younger brother, always sickly, died in infancy), caused the stunted growth which blighted his life. He excited loyal friendships, but also attracted hangers-on. He was eccentric and colourful in his tastes. He loved to entertain, though he once scandalized the good Léontine, his cook, when she brought in the first course of a dinner she had prepared and found a young woman, completely nude, seated at the table. Even for Montmartre this was shocking!

Lautrec was born in the old Hôtel du Bosc in Albi, in the south of France, but lived for most of his short adult life in Paris, first with a family friend, Dr Henri Bourges, then for a while with his mother, the Comtesse Adèle de Toulouse-Lautrec-Montfa, and finally on his own in Rue Caulaincourt. By then he was 27 and relishing the prospect of living alone for the first time. 'I shall have the ineffable pleasure,' he wrote to his grandmother, 'of keeping the household accounts and knowing the exact price of butter. It's charming.'

With all the enthusiasm of a child furnishing his first treehouse, he begged of his mother: 'If you could make me a present of 6 small-size tablecloths and some table napkins you would oblige me very much because I'm going to have to stock up. . . . Some very ordinary table knives would also be a great help. . . .'

'I'm going to buy pots and pans, etc., etc.,' he went on, comparing the experience to 'getting married without a wife'.

He never did marry. Instead he died young, seen off by a combination of alcoholism and advanced syphilis in 1901, aged 36. In his short life he was immensely sociable, a gregarious and even, at times, a tyrannical host. The many visitors to his famously shambolic fourth-floor studio on the corner of Rue Tourlaque and Rue Caulaincourt were obliged to drink the cocktails he would concoct from apparently random bottles of many different liqueurs which stood on a long untidy table just inside the entrance. As the distinctions between work and play began to blur, his studio became more and more the centre of his social life, while the work went on at small tables in the many, crowded clubs and cafés he frequented. He held open house on Friday evenings and, according to the painter François Gauzi, the studio was mobbed by a crowd of people who weren't necessarily friends of Lautrec, but who came along to see the show, sometimes to sneer, always to drink his extraordinary 'American' cocktails. None of this bothered Lautrec, and the parties went on for several years.

Indeed, it was Lautrec's extravagant skills as a host, coupled with a sense of mischief, that prompted Alexandre Natanson, the wealthy co-founder of *La Revue Blanche*, to ask Lautrec to organize the catering for a party he was throwing to celebrate the completion of a set of murals on the walls of his drawing-

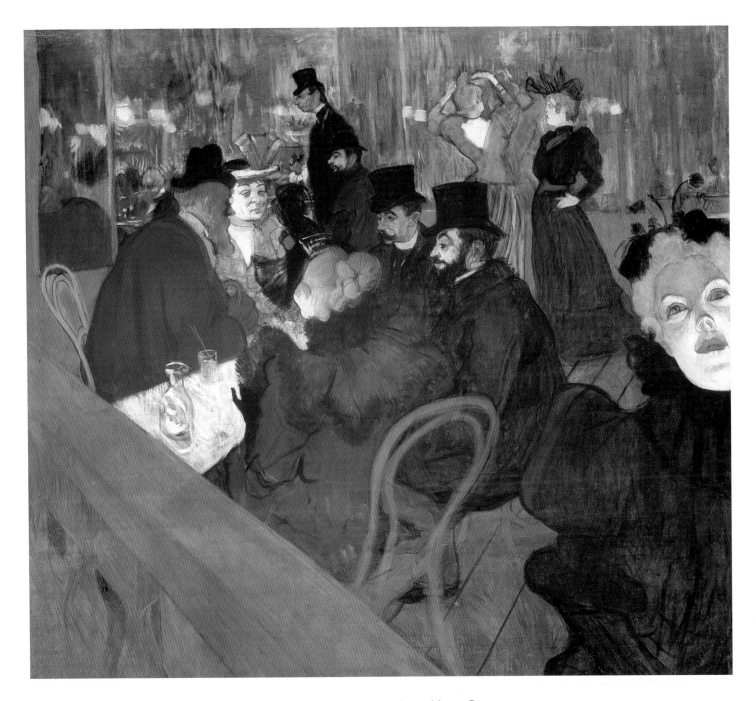

HENRI DE TOULOUSE-LAUTREC: AT THE MOULIN ROUGE

Henri de Toulouse-Lautrec in his element at the Moulin de la Galette

room, painted by Edouard Vuillard. Lautrec responded with enthusiasm. A date of 18 February 1895 was chosen and Lautrec designed an invitation, which was sent to three hundred guests, inviting them to Natanson's elegant house at 60 Avenue du Bois du Boulogne at half past eight for 'American and other drinks'. The invitation was signed with a mouse standing on its hind legs, and Lautrec's new elephant monogram. Lautrec dressed in white for the occasion and sported a shaved head and a waistcoat cut from the stars and stripes of an American flag. He claimed to have mixed and served over two thousand colourful cocktails, which were accompanied by tiny dishes of highly spiced and salted food. As the elegant assembly of writers, painters, publishers and actors dissolved into disarray, Lautrec remained perversely and proudly sober.

Sobriety was not, however, his habitual state. Lautrec led a double life, moving between his mother's elegant apartment at 9 Rue de Douai, where, in a clean white shirt and stiff collar, he ate his meals sitting at the head of the table, facing the Comtesse and entertaining her guests with the impeccable manners of a born aristocrat, and the surface glitter of the

cabarets, café-concerts, circuses and dance-halls that flourished in *fin de siècle* Paris. He liked to keep to areas where he was well known and he was a very familiar figure in Montmartre. He was among the invited guests at the opening night of the Moulin Rouge and soon had a regular table reserved for him. His posters lent fame to Le Divan Japonais, Les Ambassadeurs and Le Chat Noir, where Aristide Bruant, the charismatic star of the show, immortalized by Lautrec in his wide-brimmed hat, dashing velvet cloak and scarf the colour of oxblood, would shout, as he entered: 'Silence, gentlemen, here comes the great painter Toulouse-Lautrec with one of his friends and a punk I don't know.' Then Lautrec would make his way through the crowd, settle himself, graciously accept the beer that was offered to him and, in the crowded, smoke-filled room, pull out his sketch-pad and begin to draw. Le Chat Noir offered light meals of oysters, onion soup, omelettes, cold roast meats and sandwiches, but the customers came principally to drink rather than to eat. At the Café Weber, in Rue Royale, Lautrec's favoured tipple was port, into which he would grate a little nutmeg. Ever resourceful, he carried his own nutmeg

grater. Later, when he had sunk into alcoholism and his mother had his movements monitored, he was reputed to have purchased a hollow cane in which he concealed a pint of brandy, port or rum in a specially designed glass tube. As he made his increasingly unsteady way around his tight Parisian patch, he would unscrew the silver handle and take a swig.

Lautrec was enthusiastic about food and curious about recipes. He loved to entertain – as long as he was congratulated on the results – and he was wealthy enough to frequent the finest restaurants in Paris, dining regularly at Lucas's, one of the best of the boulevard restaurants; and also at Weber's, at the Royale, at Claudon's Café Américain, and in numerous bars. He was an accomplished if somewhat demanding cook. He took great pains over the preparation and presentation of meals, designing his own menus, as well as those for the formal banquets held in honour of the opening of the Salon des Indépendants. The lithographic menu for the 1893 banquet reveals that the guests were served two kinds of soup; *hors d'oeuvres* including radishes, sausage, shrimp and olives; a fish course; two kinds of vegetables; roast turkey with watercress; salads and ice cream, followed by assorted desserts. All this was accompanied by Madeira claret, Champagne, coffee and Cognac.

Cooking, for him, was another art form, and he invented recipes with the same flair and originality he brought to his sketches. Wines had to be of the best vintage; there was no substitute for butter; vegetables should – ideally – be picked within the hour; and no one but a son of the Midi should try to make *bouillabaisse*. His mother, back in the Midi, provided much of the produce, responding willingly to his requests asking her to send him delicacies from his native region – *pâté de foie gras*, truffles, capons, and of course wine from the vineyards of Malromé, where she had her château. Lautrec had the wine delivered in barrels and bottled it himself in Paris, a process he found 'interesting, but less interesting than drinking it'. 'According to my calculation,' he wrote to his mother at the end of 1895, 'I drink a barrel and a half a year.' So keen was he that others should share his love of wine that on one uproarious occasion hosted by his friend the photographer Paul Sescau, he sabotaged the water carafes by putting goldfish in them.

Lautrec's correspondence is peppered with gastronomic references and we learn as much about his appetite as we do his life from reading his letters. In October 1891 he thanked his mother for 'the prospective truffles', asked her to send him a fowl stuffed with the delicacy and enquired, 'Has the goose-liver season started? If it has, remember to have a dozen tins sent to me.' He frequently transferred his own obsession with food to the recipient of his letter and ended one note to his mother, 'I kiss you on your cheeks, stuffed with asparagus, at least as I suppose.'

By October 1894 that playfulness had given way to an icy formality. 'Be so kind as to send me a hamper of Chasselas and Malaga grapes,' he wrote in an imperious postscript, which reflected the new coolness in their relationship, for now, concerned about the company her son was keeping, Mme la Comtesse de Toulouse-Lautrec-Montfa was attempting, without success, to curb his sybaritic lifestyle.

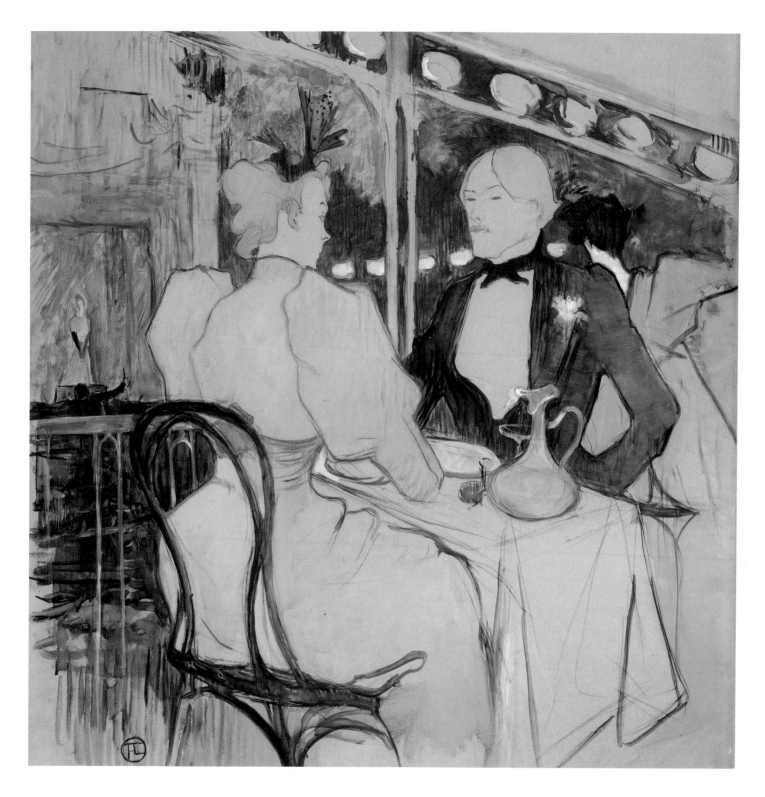

Opposite:

HENRI DE TOULOUSE-LAUTREC: FASHIONABLE PEOPLE AT LES AMBASSADEURS

Accounts of his obsessive behaviour are legion. Once, on a boat trip down the north coast of France, he had his own fresh supplies of herbs, spices, olive oil, garlic, vegetables, wine and port brought on board at Le Havre and spent most of the journey in the ship's galley, emerging only when the boat crested Brittany to select the freshest lobsters and other essential items of seafood. A typical and telling instance of Lautrec's eccentric eating habits is contained in the memoirs of the Polish pianist, Misia Godebeski. She married Thadée Natanson, brother of Alexandre, and became a good friend to Lautrec. Red-haired, self-indulgent and strong-willed, she soon became the focus of the admiring artists, poets and intellectuals who worked for *La Revue Blanche*. Lautrec spent long, intensely happy summer weekends in the Natansons' country house, sketching, drinking, clowning, boating and swimming in the river. There he felt comfortable, relaxed, playful. He drew comic menus for Misia's large informal dinners which, sadly, she blithely threw away the next day. The couple were immensely hospitable to Lautrec, and she tells of how he repaid their kindness by inviting them on a special luncheon crawl in Paris. They ate each course at a different restaurant, with special wines that Lautrec had had delivered from his family's cellar. Then, as a surprise, he walked them round to the apartment of his friend, the bassoonist Desiré Dihau, knocked on the door and asked if they could all come in. Inside Lautrec pointed to a portrait by Degas of Dihau with the other orchestral players at l'Opéra. Lautrec greatly admired Degas and, flinging out his arm, he said to his friends: 'There you are – there is your dessert.'

Finally his style of life caught up with him and he began to disintegrate, mentally and physically. He became prey to wild and extravagant mood swings. Berthe Sarrazin, the housekeeper his mother had left in charge of him, wrote to Adèle on 6 January 1899: 'Tonight we are having people to dinner, six places. I don't think it will be like last night. I'm doing a fish, a rabbit and the cold turkey and a pineapple ice. Monsieur wanted lobster à l'Américaine, bouillabaisse, goose-livers in sauce, but I made him understand that it was too complicated and that I was all by myself.' A shopkeeper reported that Lautrec was telling 'everybody' to charge purchases to his account although he had not paid his bill in two years. He began to experience paranoid delusions and hallucinations, and his behaviour became increasingly excessive, violent and disturbed. Eventually, against the advice of her family, Adèle had her son committed to a private insane asylum in the Saint-James quarter of Neuilly.

Even as he descended into madness Lautrec's requests for food and drink continued. In April 1899 he wrote to Berthe Sarrazin from Dr. Sémélaigne's sanatorium in Neuilly, begging her to bring him 'a pound of good ground coffee' and a bottle of rum in a locked valise. 'Ask to speak to me,' he cautioned. Later that same month she took him 'lavender water, chocolate, coffee, biscuits, powdered cinnamon, lime juice along with six handkerchiefs and 4 prs of socks.' He was eventually released from the asylum, but he never recovered his former high spirits. Two strokes in the spring and autumn of 1901 depleted his strength and he died on 9 September 1901 in his mother's house at Malromé.

Wednesday [1877]

'My dear Pissarro,

Will you come to dinner at my house next Monday? I am returning from London and would like to discuss matters with you relative to a possible exhibition. Degas, Monet, Renoir, Sisley, and Manet will be there. I count absolutely on you.

Monday at seven o'clock. all my best, G. Caillebotte.'

Letter from GUSTAVE CAILLEBOTTE to CAMILLE PISSARRO 1877

Degas moved in elegant circles. Daniel Halévy, the distinguished French Academician, who knew Degas from childhood, wrote a book entitled *My Friend Degas* in which he recalled that 'Degas and my parents lived in the same quarter of Paris, a Montmartre then inhabited by writers and artists. Two or three times a week Degas would leave his studio, ring our doorbell and sit down at table with us.'

The talk ranged from Ingres to photography and was always fascinating, though as Degas grew older his 'gaiety came in fits and starts' and failing eyesight darkened his days.

There are many accounts of Degas's famous crustiness, his intolerance of bores and his own eccentricity and whims, which naturally only increased his reputation as a great artist. He was a notoriously difficult dinner guest. Ambroise Vollard remembered issuing an invitation which produced the following conditional acceptance:

Certainly, Vollard. But, listen: will you have a special dish without butter prepared for me? Mind you, no flowers on the table, and you must have dinner at half past seven sharp. I know you won't have your cat around and please don't allow anybody to bring a dog. And if there are to be any women I hope they won't come reeking of perfume. How horrible all those odours are when there are so many things that really smell good, like toast – or even manure! Ah . . . and very few lights. My eyes, you know, my poor eyes.

Dining out was so fraught that Degas often preferred to eat at home, though Vollard also recalled how his housekeeper, the

redoubtable Zoé, once sent all his guests out to a restaurant because she was making her famous orange marmalade and did not wish to be disturbed.

There was a great friendship between the talented American artist Mary Cassatt and Degas. Cassatt, angular and feisty, the daughter of a wealthy Philadelphia family, had settled in France and had her first glimpse of a Degas in 1875 in the window of Durand-Ruel's gallery. Many years later she wrote to her friend, the American collector Louise Havermeyer: 'How well I remember, nearly forty years ago, seeing for the first time Degas's pastels in the window of a picture-dealer on Boulevard Haussmann. I used to go and flatten my nose against the window and absorb all I could of his art. It changed my life. I saw art then as I wanted to see it.'

If Degas's work had been a revelation to her, so had hers to him, and he was unstinting in his encouragement and support.

Another young friend, the poet Paul Valéry, reported that Degas could be 'charming or frightful', so it would be with trepidation that he presented himself at Degas's studio in Rue Victor-Massé:

I would be feeling dubious enough of my welcome, sometimes, when I rang at his door. He would open mistrustfully, and then recognize me. It was one of his good days. He would take me into a long attic room, with a wide bay window (not very clean) where light and dust mingled gaily. The room was pell-mell – with a basin, a dull zinc bath-tub, stale bathrobes, a danseuse modelled in wax, with a real gauze tutu, in a glass case, and easels loaded with charcoal sketches

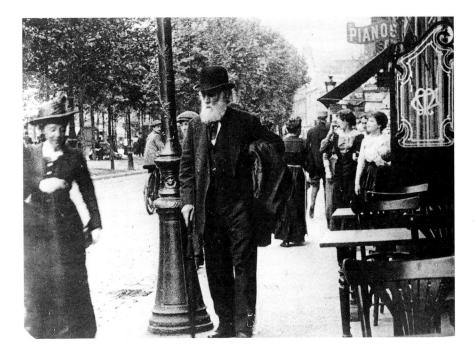

Despite his failing eyesight, Edgar Degas was a familiar sight on the boulevards of Paris. This photograph, taken around 1910, shows him strolling up the boulevard de Clichy.

of flat-nosed, twisted models, with combs in their fists, held around thick hair gripped tight in the other hand. A narrow shelf ran under the window where a ghost of sunshine lingered; it was piled with bottles, flasks, pencils, bits of pastel chalk, etching needles, and all the nameless odds and ends that may come in handy one day. . . .

The studio was on the third floor of the Victor-Massé house; on the first was Degas's 'Museum' consisting of a few pictures he had bought or acquired in exchange for his own; and sandwiched between was his apartment where Valéry had 'many a dreary dinner'. Degas's culinary palette had not improved since Vollard's time and Valéry recalled how his 'dread of intestinal obstruction or inflammation' led to 'a faultless insipidity in the all-too-innocent veal and the macaroni cooked in plain water, served, very slowly, by old Zoé.' Even her famous speciality was not appreciated by the young poet, who went on: 'After

that there was a kind of Dundee marmalade, which I found intolerable,' although later, like Proust's *madeleines*, it was revered for its evocative associations: 'Now, if I ever happen to taste that jelly threaded with carrot-coloured bits of fibre, I am once more sitting opposite a fearfully lonely old man, lost in lugubrious reflections. . . .'

In his final years Degas became a passionate collector – 'I shall die in a poorhouse,' he used to say, 'but I shall give my Ingres portraits to my country.' He would attend auctions and bid for paintings he couldn't even see, leaning over to ask his neighbours, 'Is it beautiful?' At dinner he would regale his guests with stories about his difficulties with Zoé, who demanded blue aprons like those worn by servants in Ingres paintings. Daniel Halévy recalled how, 'roaring with laughter, he tells us of his quarrels with her. And still laughing he leans back in his chair and suddenly he says: "To have no clothes and to own sublime objects – that will be my *chic*!" '

HORS D'OEUVRES
SELECTION OF CANAPÉS

Bars like the Moulin Rouge and Aux Folies-Bergère in Paris were popular with many of the Impressionist artists, including Manet, Degas, Renoir and Toulouse-Lautrec – and frequently became the subjects for their paintings and sketches. Food as well as drinks were available, and a platter of mixed *hors d'oeuvres* would have appeared regularly at these places.

SAUMON FUMÉ SUR TOASTS AUX BEURRE D'ANCHOIS
SMOKED SALMON TOASTS WITH ANCHOVY BUTTER

This is inspired by a recipe
by the nineteenth-century French chef Jules Goufflé in his book
Le Livre de Cuisine (The Royal Cookery Book).

SERVES 4

16 thin slices French bread
100g/4 oz smoked salmon, cut into 16 pieces the same size as the bread
lemon wedges, to garnish
black pepper

FOR THE ANCHOVY BUTTER
4 anchovy fillets in oil, drained
milk
50g/2 oz/4 tbsp unsalted butter, softened

MAKE THE ANCHOVY BUTTER: soak the anchovy fillets in a little milk for 10 minutes, then drain, rinse and pat dry. Chop finely and beat into the softened butter until combined. (This can be done a day in advance and kept covered in the refrigerator until required.)

To prepare the croûtes, grill (broil) the French bread slices on both sides. Spread each one with a little of the anchovy butter and top with the smoked salmon. Garnish with lemon wedges to squeeze, and grind over plenty of black pepper.

CAVIAR SUR TOASTS
CAVIAR TOASTS

For a more healthy option, lightly toast the bread rather than frying it.

SERVES 4

25g/1 oz/2 tbsp butter 12 thin slices French bread
25g/1 oz/2 tbsp Sevruga caviar
lemon wedges, to garnish

MELT THE BUTTER in a frying pan (skillet). Add the bread and fry gently until crisp and golden. Then drain on kitchen paper (paper towels). Top each slice with a spoonful of caviar. Transfer to a plate and garnish with lemon wedges.

HUÎTRES À LA COQUILLE
OYSTERS ON THE HALF SHELL

SERVES 4

24 fresh native oysters
crushed ice or sea salt, to serve lemon wedges, to garnish

FOR THE SHALLOT VINEGAR
3 tbsp red wine vinegar 2 shallots, finely chopped
salt and pepper
bunch of fresh chives, chopped, to garnish

USE AN OYSTER KNIFE to prise open the shells at the hinge, being careful not to lose any of the juices. Arrange the half shells on a bed of ice. Garnish with lemon wedges, to squeeze over each oyster.

Combine the shallot vinegar ingredients together, place in a small bowl, and serve the oysters garnished with the chives.

Opposite: SELECTION OF CANAPÉS: CAVIAR TOASTS, SMOKED SALMON TOASTS WITH ANCHOVY BUTTER, OYSTERS ON THE HALF SHELL, SERVED WITH SHALLOT VINEGAR

POTAGE SAINT-GERMAIN
SPLIT PEA SOUP

Saint-Germain, on the outskirts of Paris, lends its name to this classic pea soup, as, along with Clamart, it is famous for its peas. In this recipe dried peas (which would have been used in the winter months) provide the basis for a hearty soup.

SERVES 4

225g/8 oz/1¼ cups dried split green peas, well rinsed
25g/1 oz/2 tbsp butter
100g/4 oz smoked bacon (smoked slab bacon), diced
1 onion, chopped
900ml/1½ pints/3¾ cups vegetable stock
250ml/8 fl oz/1 cup milk
2 tbsp chopped fresh mint
salt and pepper
1 quantity croûtons (see page 28), to garnish

PLACE THE PEAS in a saucepan. Cover with plenty of water, bring to the boil and immediately drain.

Melt the butter in a saucepan. Add the bacon and fry over a high heat for 5 minutes until golden. Add the onion, lower the heat and sauté for a further 5 minutes. Add the peas, the stock and the milk and bring to the boil. Lower the heat, cover and simmer for 45–50 minutes until the peas are tender.

Transfer to a blender or food processor and blend until smooth. Return to the pan, stir in the mint and season to taste. Serve the soup garnished with the croûtons.

POTAGE BONNE FEMME ⓥ
THICK VEGETABLE SOUP

Locally grown vegetables would have been used in this old-fashioned soup made regularly by French housewives. Here garlic and herbs have been added for a deeper flavour.

SERVES 6–8

3 tbsp olive oil
1 garlic clove, chopped
450g/1 lb/3 cups potatoes, peeled and chopped
3 leeks, trimmed, chopped and rinsed
3 carrots, peeled and chopped
1.5 litres/2½ pints/6¼ cups vegetable stock
2 tbsp chopped fresh parsley
1 tbsp chopped fresh chervil
salt and pepper

TO SERVE
6–8 thick slices rustic bread
butter (optional)

HEAT THE OIL in a large saucepan. Add the garlic, potatoes, leeks and carrots and sauté for 10 minutes until just golden. Stir in the stock and bring to the boil, then lower the heat, cover and simmer for 30 minutes.

Transfer the soup to a blender or food processor and blend until smooth. Return to the pan and stir in the herbs and seasoning to taste. Reheat gently.

Place a slice of bread into each warmed soup bowl and pour in the soup. Add a small knob of butter to each one, if wished. Serve at once.

POTAGE GERMINY
SORREL SOUP

A more sophisticated soup that uses egg yolks and cream to enrich it. This would have been served in the more elegant restaurants, and this particular recipe provides four small servings. It has been inspired by a recipe by Jules Goufflé, a nineteenth-century French chef, in his book *Le Livre de Cuisine (The Royal Cookery Book)*.

SERVES 4

25g/1 oz/2 tbsp butter
225g/8 oz fresh sorrel, rinsed, dried and shredded
450ml/16 fl oz/2 cups chicken or vegetable stock
2 egg yolks
50ml/2 fl oz/¼ cup single (light) cream
salt and pepper
1 quantity croûtons (see page 28), to garnish

MELT THE BUTTER in a saucepan. Add the sorrel and sauté very gently for 5 minutes. Stir in the stock and bring to the boil, then lower the heat and simmer for 15 minutes.

Whisk together the egg yolks and cream and pour in a little of the soup. Take the soup off the heat and stir in the egg-yolk mixture. Return to a low heat and stir until thickened; do not allow the soup to boil or the mixture will curdle. Season to taste. Serve hot, garnished with the croûtons.

OMELETTE AUX FINES HERBES ⓥ
FRESH HERB OMELETTE

This classic omelette would have been eaten as a light lunch or early evening snack in many of the cafés and bistros. It is always best to eat an omelette as soon as it is cooked, which is why this recipe is for one serving: simply increase the quantities as necessary for more servings.

SERVES 1

3 eggs
1 tbsp chopped fresh herbs, including parsley, chervil, chives and tarragon
pinch salt
15g/½ oz/1 tbsp butter
extra butter (optional), to serve

BEAT THE EGGS TOGETHER in a bowl, then beat in half the herbs and the salt.

Melt the butter in an omelette pan or small frying pan (skillet) until it just starts to turn golden. Tip in the egg mixture, swirling it to the edge of the pan. Immediately scatter over the remaining herbs and stir the omelette with a fork to ensure even cooking.

When almost set, but still slightly runny in the centre, carefully tip the omelette out on to a warmed plate, folding it in half. Top with a little extra butter, if wished, and serve at once.

'The piles of vegetables on the pavement now extended to the verge of the roadway. Between the heaps, the market-gardeners left narrow paths to enable people to pass along. The whole of the wide footway was covered from end to end with dark mounds. As yet, in the sudden dancing gleams of light from the lanterns, you only just espied the luxuriant fullness of the bundles of artichokes, the delicate green of the lettuces, the rosy coral of the carrots, and dull ivory of the turnips. And these gleams of rich colour flitted along the heaps, according as the lanterns came and went.'

from *Le Ventre de Paris (The Fat and the Thin)* from ÉMILE ZOLA

TARTELETTES AU POIREAUX ⓥ
LEEK TARTLETS

SERVES 6

FOR THE *PÂTE BRISÉE*
175g/6 oz/1¼ cups plain (all-purpose) flour
½ tsp salt
85g/3 oz/6 tbsp butter, diced
25g/1 oz/¼ cup walnuts, ground
1 egg yolk

FOR THE FILLING
25g/1 oz/2 tbsp butter
1kg/2 lb leeks, trimmed, thinly sliced and rinsed
3 egg yolks
300g/10 fl oz/1¼ cups crème fraîche or double (heavy) cream
1½ tbsp chopped fresh tarragon
pinch of grated nutmeg
salt and pepper

MAKE THE PÂTE BRISÉE: sift the flour and salt into a bowl and rub in the butter until the mixture resembles fine bread-crumbs. Stir in the walnuts and gradually work in the egg yolk and 1–2 tablespoons cold water to form a soft pastry (dough). Knead lightly, then wrap and chill for 30 minutes. Divide the pastry into 6 equal pieces, then roll out on a lightly floured sur-face and use to line six 10cm/4 in tartlet tins (pans). Prick the bases with a fork and chill for a further 20 minutes.

Meanwhile, preheat the oven to 200°C/400°F/Gas Mark 6 and place a baking sheet on the middle shelf.

Line the pastry cases with baking paper and beans and bake on the heated sheet for 10–12 minutes, then remove the paper and beans and bake for a further 10–12 minutes until the pastry is golden and crisp; set aside and leave to cool slightly on a wire rack. Lower the oven temperature to 190°C/375°F/Gas Mark 5.

Meanwhile, prepare the filling: melt the butter in a large frying pan (skillet). Add the leeks and sauté for 15 minutes until soft-ened but not browned; set aside to cool slightly.

Beat the egg yolks, crème fraîche, tarragon, nutmeg and sea-sonings together, then stir in the leeks. Spoon into the pastry cases and bake for 20 minutes until risen, firm and golden. Leave to cool on wire racks and serve warm.

PÂTÉ DE PORC ET DE FOIE

PORK AND LIVER PÂTÉ

This recipe,
inspired by Elizabeth David's *French Provincial Cooking*,
is typical of those pâtés found on restaurant menus and often described
as *pâté de maison*.

SERVES 12

350g/12 oz smoked streaky bacon rashers (slices), rinded if necessary
450g/1 lb pork belly, diced
450g/1 lb lean pork, such as leg, diced
225g/8 oz pig's liver, diced
1 small onion, very finely chopped
2 garlic cloves, crushed
85ml/3 fl oz/6 tbsp dry white wine
2 tbsp brandy
1 tbsp chopped fresh thyme
2 tbsp chopped fresh parsley
½ tsp ground mace
6 juniper berries, crushed
salt and pepper

TO SERVE
crusty French bread
salad leaves

USE THE BACK OF A KNIFE to stretch all but 100g/4 oz of the bacon rashers (slices) to almost double their length. Use to line the base and sides of a 1kg/2 lb loaf tin (pan), measuring about 12.5 × 23 × 6cm/5 × 9 × 2½ in, and allowing the ends to overhang the edges; cover and set aside.

Chop the reserved bacon and place in a food processor with the pork belly, pork and liver. Blend until well minced (ground) but still retaining a little texture. Transfer to a large bowl and mix in all the remaining ingredients until evenly combined. Cover and set aside for at least 1 hour for the flavours to infuse.

Preheat the oven to 150°C/300°F/Gas Mark 2. Spoon the meat into the prepared tin, pressing down well and smoothing the surface. Fold the bacon rashers over the pâté to enclose, then cover with foil. Place in a roasting tin (pan) and pour in enough boiling water to come half the way up the sides of the tin. Cook for 1 hour, then remove the foil and cook for a further 30–45 minutes until a skewer inserted into the centre comes out piping hot.

Remove the pâté from the oven carefully without spilling any meat juices; set aside to cool. Place a piece of waxed or bakewell paper over the pâté and top with a heavy weight, then refrigerate overnight.

Unmould the pâté and cut into thin slices. Serve with French bread and salad leaves.

TURBOT AUX ÉPINARDS ET À LA SAUCE BÉARNAISE
TURBOT WITH SPINACH AND BÉARNAISE SAUCE

During the time of the Impressionists, turbot was popular at exclusive
restaurants like the Palais Royal or the Doyen, where it was simply
prepared and served with béarnaise sauce.

SERVES 4

40g/1½ oz/3 tbsp butter
4 turbot steaks, each about 225g/8 oz, rinsed and dried
salt and pepper
225g/8 oz spinach leaves, well rinsed and dried
pinch of grated nutmeg

FOR THE BÉARNAISE SAUCE
2 tbsp tarragon vinegar
1 shallot, finely chopped
2 egg yolks
150g/5 oz/10 tbsp butter, melted
1 tbsp chopped fresh tarragon
fresh tarragon sprigs, to garnish

PREHEAT THE OVEN to 230°C/450°F/Gas Mark 8 and place a foil-lined roasting tin (pan) on the middle shelf.

Melt the butter in a large non-stick frying pan (skillet). Quickly sear the steaks on each side to brown, then transfer to the prepared roasting tin and season lightly. Roast for 10 minutes until cooked through and the flesh flakes easily. Remove from the oven, cover loosely with foil, and leave to rest for 5 minutes.

Meanwhile, make the sauce: place the vinegar and shallot into a small saucepan and boil until almost all the liquid is evapor-ated; transfer to a small bowl. Beat in the egg yolks and whisk together until thick and pale, then gradually whisk in the butter in a steady stream until the sauce is thick and glossy. Pass through a fine sieve (strainer), stir in the tarragon and season.

Put the spinach into a saucepan. Cook over a low heat with just the water clinging to the leaves for 2–3 minutes until just wilted. Add the nutmeg and season with salt and pepper.

Divide the spinach between 4 warmed serving plates. Top with the turbot steaks, pour over the sauce and garnish with the tarragon. Serve at once.

Opposite: TURBOT WITH SPINACH AND BÉARNAISE SAUCE

POULET À LA BIÈRE
CHICKEN COOKED IN BEER

This dish is similar to *coq au vin*, but uses beer in place of wine, with the addition of a little gin for good measure. During the middle part of the nineteenth century the French – more precisely the Parisians – were passionate about English pale ale. Perhaps that had something to do with the popularity of this particular dish!

SERVES 4

25g/1 oz/2 tbsp butter
2 tbsp vegetable oil
1 large chicken, cut into 8 portions
4 tbsp gin
2 garlic cloves, peeled but left whole
4 sprigs fresh thyme
2 bay leaves
300ml/10 fl oz/1¼ cups pale ale or lager
225g/8 oz baby onions, peeled and left whole
2 tsp soft brown sugar
1 tbsp red wine vinegar
salt and pepper
chopped fresh tarragon, to garnish

MELT HALF THE BUTTER with half the oil in a flameproof casserole until foaming. Add the chicken pieces and fry over a high heat for 6–8 minutes until brown on both sides. Warm the gin in a separate pan and, when hot, ignite and pour into the casserole; allow the flames to subside. Add the garlic, thyme, bay leaves and beer and bring to the boil, then lower the heat, cover and simmer for 25 minutes.

Meanwhile, melt the remaining butter with the remaining oil in a frying pan (skillet). Add the onions, and sauté over a high heat for 5 minutes. Stir in the sugar and vinegar, cover and cook for a further 15 minutes, adding 2 tablespoons of water if necessary to prevent it burning. Add to the chicken, cover and continue simmering for a further 15–20 minutes until the chicken is cooked through. Season to taste and serve, garnished with chopped fresh tarragon.

GIBELOTTE DE LAPIN
FRICASSEE OF RABBIT

This is a typical fricassee of rabbit and is inspired by a recipe in Robert Fresson's beautiful book of provincial France. Chicken can be used instead of rabbit, if preferred.

SERVES 4

100g/4 oz smoked bacon (slab bacon), diced
225g/8 oz shallots, halved if large
2 garlic cloves, crushed
1 tbsp chopped fresh thyme
2 tbsp seasoned flour 2 tsp dry mustard
1 × 1kg/2 lb rabbit, cut into 8 pieces
25g/1 oz/2 tbsp butter
150ml/5 fl oz/⅔ cup dry white wine
300ml/10 fl oz/1¼ cups chicken stock
2 bay leaves
225g/8 oz button mushrooms, wiped
salt and pepper
8 triangles fried or toasted bread, to garnish

HEAT A FLAMEPROOF CASSEROLE. Add the bacon and fry over a high heat for 5–8 minutes until golden and the fat melts. Add the shallots, garlic and thyme and fry gently for 5 minutes until golden. Remove from the pan using a slotted spoon; set aside.

Combine the flour and mustard powder and put into a bowl. Dip in the rabbit and shake off any excess flour. Melt the butter in the pan. Add the rabbit, in batches, and fry over a high heat until golden on both sides; remove the rabbit pieces with a slotted spoon as they brown. Add some wine to deglaze the pan, scraping up the bits on the bottom. Return the rabbit, bacon and onions to the pan, then gradually stir in the rest of the wine, stock and bay leaves. Bring to the boil, then lower the heat, cover and simmer over a low heat for 30 minutes.

Add the mushrooms to the pan and continue to simmer for a further 15 minutes, or until the rabbit is tender. Season to taste. Serve the stew garnished with triangles of fried or toasted bread.

ENTRECÔTE BERCY
ENTRECÔTE STEAK, WITH A BERCY SAUCE

This recipe is named after the Quai de Bercy in Paris, where there was a famous wine market. Chefs have debated for many years whether red or white wine should be used to make the sauce. Serve the steak with *pommes frites* (see right).

SERVES 4

4 × 225g/8 oz sirloin steaks
2 tbsp vegetable oil

FOR THE BERCY SAUCE
4 shallots, finely chopped
120ml/4 fl oz/½ cup light red wine
450ml/16 fl oz/2 cups good beef stock
50g/2 oz/4 tbsp unsalted butter, diced
salt and pepper
fresh chervil, to garnish

MAKE THE BERCY SAUCE: place the shallots and wine in a saucepan and boil rapidly until the wine is reduced to 2 tablespoons. Add 300ml/10 fl oz/1¼ cups of the stock and return to the boil, then lower the heat and simmer until reduced by half; keep warm.

To cook the steaks, heat the oil in a heavy, non-stick frying pan (skillet) until smoking. Add the steaks and fry for 3–4 minutes on each side for a rare steak, or longer depending on how you like your meat cooked. Remove from the pan and keep warm while finishing the sauce.

Deglaze the frying pan with the remaining stock and boil rapidly until almost all is evaporated. Pour the remaining juices into the sauce, then bring to a very low simmer and gradually whisk in the butter until the sauce is slightly thicker. Season to taste. Arrange the steaks on individual plates, spoon over the shallot and wine sauce and garnish with the chervil. Serve at once with *pommes frites*.

POMMES FRITES Ⓥ
FRENCH FRIES

Just as popular during the last century as they are today, *pommes frites* were served as an accompaniment to steaks and grilled (broiled) meat or fish.

SERVES 4

4 potatoes, each about 225g/8 oz, peeled and
thinly sliced
vegetable oil, for deep-frying
salt

CUT THE POTATO slices into thin batons, about 3mm/⅛ in thick. Rinse well, then dry thoroughly on kitchen paper (paper towels).

Heat 10cm/4 in vegetable oil in a deep saucepan until it reaches 150°C/300°F on a sugar (candy) thermometer.

Use a slotted spoon or chip basket to put the potato batons, in batches, into the oil and fry for about 3 minutes until tender but not brown. Remove and drain well on kitchen paper.

Increase the heat until the oil reaches 180°C/350°F, then return the potatoes to the pan, again in batches, and fry for a further minute or so until crisp and golden. Immediately drain on kitchen paper and keep warm while cooking the rest.

Sprinkle the *pommes frites* liberally with salt and serve piping hot.

In the 1880s Manet would often paint little still lifes as occasional gifts for friends. A bunch of violets for Berthe Morisot, three apples for Méry Laurent or watercolour illustrated letters, all expressing fondness and affection in the most charming way.

CHOUCROUTE AUX SAUCISSES, ET AU PETIT SALÉ
SAUERKRAUT WITH SMOKED BACON AND SAUSAGES

Paris was one of the few places where regional dishes, like this sauerkraut from Alsace, would have been available outside their original locality, largely because the vast Les Halles market carried a huge range of produce. This recipe was inspired by one in Elizabeth David's cookery classic *French Provincial Cooking*.

SERVES 4

50g/2 oz/4 tbsp lard or butter
1 onion, finely chopped
2 large garlic cloves, chopped 1kg/2 lb sauerkraut, drained
10 juniper berries, lightly crushed
6 cloves
120ml/4 fl oz/½ cup Alsace white wine
300ml/10 fl oz/1½ cups chicken stock
1 bouquet garni (see page 38)
225g/8 oz piece pancetta or smoked bacon (slab bacon)
4 small boiling sausages
4 tbsp kirsch salt and pepper
boiled potatoes, to serve

MELT HALF THE LARD OR BUTTER in a flameproof casserole. Add the onion and garlic and sauté for 5 minutes until lightly golden. Add the sauerkraut, juniper berries and cloves and continue to fry gently for a further 10 minutes. Pour in the wine and stock, add the bouquet garni and bring to the boil. Lower the heat, cover and simmer for 30 minutes.

Melt the remaining lard or butter in a frying pan (skillet). Add the bacon and the sausages and brown on all sides, then arrange them over the sauerkraut, pressing down into the cabbage slightly. Cover and continue to simmer over a low heat for a further 1 hour until the bacon and sausage are cooked through and the sauerkraut is tender and full of flavour. Stir in the kirsch. Season to taste.

Remove the bacon and sausages and cut into thick slices. Spoon the sauerkraut on to a large warmed serving platter and arrange the bacon and sausage over the top, spooning over any pan juices. Serve hot with simple boiled potatoes.

POMMES DE TERRE À LA PARISIENNE ⓥ
POTATOES BRAISED IN BUTTER

Another simple potato dish that was a Parisian speciality, where traditionally the potatoes were braised with chicken stock until well glazed and tender (although vegetarians can use vegetable stock). Also try adding chives or chervil to the potatoes instead of parsley. These are good served with a steak or chops.

SERVES 4

25g/1 oz/2 tbsp butter
1 onion, finely chopped
1 garlic clove, crushed
675g/1½ lb tiny new potatoes, scrubbed
250ml/8 fl oz/1 cup vegetable or chicken stock
1 bay leaf
salt and pepper
2 tbsp chopped fresh parsley, to serve

MELT THE BUTTER in a frying pan (skillet). Add the onions and garlic and sauté over a medium heat for 5 minutes until golden. Add the potatoes and sauté for a further 3–4 minutes until just starting to brown. Stir in the stock and bay leaf and bring to the boil, then lower the heat, cover and simmer for 15 minutes until the potatoes are just tender.

Remove the lid and boil rapidly until the liquid is reduced to a syrupy glaze. Season to taste and serve at once, sprinkled with the parsley.

Opposite: SAUERKRAUT WITH SMOKED BACON AND SAUSAGES

CHAMPIGNONS DE PARIS Ⓥ
PARISIAN BUTTON MUSHROOMS

This name refers to the small button mushroom known throughout France as the *champignon de Paris* because of its regular appearance at the former central food market, Les Halles, in Paris. Serve this as a side dish to a simple steak or piece of grilled (broiled) fish.

SERVES 4

50g/2 oz/4 tbsp butter
1kg/2 lb button mushrooms, wiped and trimmed
2 garlic cloves, crushed
2 tsp chopped fresh thyme
4 tbsp chopped fresh herbs, including chives, chervil, parsley
and tarragon
lemon juice
salt and pepper

MELT THE BUTTER in a large frying pan (skillet). Add the mushrooms and sauté over a high heat for 3 minutes until just starting to brown.

Lower the heat and stir in the garlic and thyme, cover and cook for 5 minutes. Remove the lid and scatter over the remaining herbs. Squeeze over a little lemon juice, season well and serve.

ENDIVES BRAISÉES Ⓥ
BRAISED CHICORY (BELGIAN ENDIVE)

SERVES 4

50g/2 oz/4 tbsp butter
8 small heads chicory (Belgian endive), trimmed and halved lengthways
salt and pepper
2 tbsp lemon juice
12 sage leaves
50g/2 oz/½ cup Gruyère cheese, grated

PREHEAT THE OVEN to 170°C/325°F/Gas Mark 3. Melt the butter in a shallow, flameproof dish. Add the chicory (endive) and season well, then sauté over a medium heat for 10 minutes, turning frequently, until lightly golden.

Add the lemon juice and sage, cover and transfer to the oven. Cook for 1–1½ hours. Remove the lid, sprinkle over the cheese, cover and return to the oven for a further 10 minutes until the cheese is melted, the chicory tender and the juices buttery. Serve at once.

BRIE DE MEAUX
BRIE FROM MEAUX

French brie comes from an area east of Paris, where the three main varieties, Meaux, Melun and Coulommiers are named after nearby market towns. *Brie de Meaux* is considered to be one of the finest of all soft cheeses, and Renoir would have agreed, as he is recorded saying to his son, Jean, "Once it [brie] goes beyond the city limits, it's no good." *Brie de Meaux* is best kept until ripe – when the cheese is buttery in colour, smooth and glossy. Serve it simply on fresh, French bread.

GALETTE AUX PÊCHES ⓥ
PEACH GALETTE

One Parisian dance hall of the Impressionists' time, Le Moulin de la Galette, was named after the *galettes* that it served along with the beer, wines and spirits. Renoir was so enchanted with the dance spot that he painted his famous picture there – *Le Bal au Moulin de la Galette (Dance at the Moulin de la Galette, 1876)*. *Galettes* were made with either a yeasted dough, as this one, or with a puff pastry base.

SERVES 8

225g/8 oz/1½ cups strong plain flour (bread flour)
½ tsp salt
1 tsp fast-acting yeast (quick-rising active dry yeast)
3 tbsp caster (superfine) sugar
2 eggs
2 tbsp milk
50g/2 oz/4 tbsp unsalted butter, softened

FOR THE TOPPING
4 firm ripe peaches, halved, stoned (pitted) and thinly sliced
1 tbsp caster (superfine) sugar
15g/½ oz/1 tbsp butter, diced

TO SERVE
250ml/8 fl oz/1 cup double (heavy) cream
2 tsp icing (confectioners') sugar
1 tsp ground cinnamon

SIFT THE FLOUR AND SALT into a bowl and stir in the yeast and sugar, then make a well in the centre and gradually work in the eggs and milk. Gradually work in the softened butter until incorporated. Knead on a lightly floured surface for 5 minutes until the dough is smooth and glossy. Cover the bowl with a towel and set aside to rise in a warm place for 2–3 hours until doubled in size; the exact time will depend on the temperature of the room.

Remove the dough, knock back (punch down) and knead lightly. Wrap in cling film (plastic wrap) and chill for 30 minutes. Roll out the dough and use to line a 25–30cm/10–12 in tart tin (pan) and prick the base with a fork. Arrange the peach slices in concentric circles over the dough, cover loosely and leave to rise in a warm place for 20 minutes.

Preheat the oven to 200°C/400°F/Gas Mark 6 and place a baking sheet on the middle shelf.

Sprinkle the sugar over the peaches and dot with butter. Transfer to the heated baking sheet and bake for 25–30 minutes until the dough is risen and browned at the edges and feels firm in the centre. Remove from the oven and leave to cool on a wire rack.

Whisk the cream with the sugar and cinnamon until just holding its shape. Serve with the warm *galette*.

TARTE AUX POIRES ET AUX AMANDES Ⓥ
PEAR AND ALMOND TART

SERVES 6

1 quantity Pâte Sucrée (see page 119)
3 large, ripe pears 225g/8 oz fresh raspberries
2 tbsp icing (confectioners') sugar

TO DECORATE: 3 tbsp apricot jam (jelly) 1 tsp lemon juice

FOR THE ALMOND PASTE
100g/4 oz/1 stick unsalted butter, softened
100g/4 oz/½ cup caster (superfine) sugar
100g/4 oz/1¼ cups (finely) ground (blanched) almonds
2 eggs, lightly beaten 1 tbsp kirsch

ROLL OUT THE PÂTE SUCRÉE and use to line a 23cm/9 in fluted tart tin (pan). Prick the base and chill for 20 minutes. Preheat the oven to 200°C/400°F/Gas Mark 6.

Line the pastry case with foil and baking beans and bake blind for 10–12 minutes, remove the baking paper and beans and bake for a further 10–12 minutes until the pastry is crisp and golden. Leave to cool on a wire rack, and reduce the oven temperature to 180°C/350°F/Gas Mark 4.

Prepare the almond paste: place the butter, sugar and almonds in a bowl and beat until soft and pale. Gradually whisk in the eggs and kirsch until smooth. Spread the paste over the base of the tart case; set aside. Peel, halve and core the pears, then cut almost through into slices without cutting through the stalk (stem) end. Arrange the pears over the almond paste, fanning them out very slightly. Dot 50g/2 oz of the raspberries between the pears. Bake for 40–45 minutes until risen and firm to the touch.

Meanwhile, transfer the remaining raspberries to a blender or food processor and blend to a purée. Pass through a fine sieve (strainer) and add the icing (confectioners') sugar to taste; set aside. Just before the tart finishes baking, heat the jam and lemon juice and 1 tbsp water and boil for 1 minute, then pass through a sieve. As soon as the tart comes out of the oven, carefully brush the top with glaze, then leave to cool on a wire rack to room temperature. Serve with the raspberry sauce.

GRANITÉ AU CHAMPAGNE ET AUX FRAISES
ICED CHAMPAGNE GRANITÉ WITH STRAWBERRIES

SERVES 12

225g/8 oz/1 heaped cup granulated sugar
juice of 1 lemon

1 × 75cl bottle Champagne
450g/1 lb strawberries, hulled and finely mashed

PLACE THE SUGAR AND LEMON JUICE in a saucepan with 600ml/1 pint/2½ cups water and heat gently without stirring until the sugar is dissolved. Increase the heat and boil rapidly for 3 minutes, again without stirring. Remove from the heat and leave to cool completely. Stir in the Champagne and fold in the strawberries. Transfer to a large plastic container and freeze.

After 2 hours beat the mixture to break down any ice crystals starting to form round the edges of the container. Refreeze and repeat this procedure, beating at hourly intervals, until the mixture reaches a soft sorbet stage, then stop beating and freeze until required. To serve, spoon into chilled glasses. Inspired by a recipe by Jules Goufflé in *Le Livre de Cuisine* (The Royal Cookery Book).

Opposite: ICED CHAMPAGNE GRANITÉ WITH STRAWBERRIES

III
FONTAINEBLEAU & THE SEINE
FOOD & FRIENDSHIP

EDOUARD MANET: ASPARAGUS

Opposite: GAME TERRINE (*see page 110*)

I N SEARCH OF OPEN-AIR SITES, the young painters were initially drawn, as Courbet, Corot, Millet and Rousseau had been twenty years before, to the magnificent beauty of the Forêt de Fontainebleau. The towering trees, wild gorges and vast, fantastically shaped boulders fired them with enthusiasm and they spent long, idyllic days painting together in the forest. Small inns had sprung up to cater for the artists, notably the Auberge Ganne in Chailly-en-Bière, run by François Ganne. He had started out modestly with a grocery shop, but gradually added on rooms to provide lodgings and finally hung up a symbolic juniper branch and persuaded his wife to turn chef. The motherly Mme Ganne rose before dawn to stuff straw baskets with bread, chicken drumsticks, hard-boiled eggs, brie, apples and bottles of wine for the painters to take into the forest with them, and welcomed them back in the evenings with steaming bowls of soup and a goose roasting on a spit. Over the years they had repaid her kindness – and occasionally the bill – by decorating the walls, sideboards

and dividing panels of her dining-room with paintings of the forest.

Paintings also covered all the available wall space in Père Paillard's Cheval Blanc at Chailly, where, in April 1863, Monet and his friends found lodgings for 3 francs 75. The tall, bearded Bazille pronounced it 'excellent'. He wrote enthusiastically to his family immediately after his arrival to rhapsodize about the 'truly admirable' forest setting, so different from his native South of France. 'We can't imagine oak-trees like that in Montpellier,' he wrote.

Another favourite haunt – especially with Renoir and Sisley, who were firm friends during this early period – was Mère Anthony's inn at the nearby village of Marlotte. There, in 1866, Renoir painted his first large composition. *Le cabaret de la Mère Anthony (At the Inn of Mother Anthony)* shows the ever elegant Sisley in a dapper straw hat sitting opposite the painter Jules Le Coeur in the tiny dining-room of the inn. Behind him stands Monet, while Nana, the innkeeper's daughter, whose beautiful eyes had already caught the interest of Sisley, clears the remains of a meal. The friends are engrossed in their conversation and only the dog, Toto, stares out at the painter.

It was a golden period for them all, but especially for Sisley who, 'untroubled by money or by melancholy', was able to paint solely for his own pleasure. Later, when his father's business ran into difficulties, he would be forced to squeeze a meagre living for himself and his family through his painting.

Renoir was always at ease in Mère Anthony's inn. It was for him 'the true village auberge' and, with his great gift for enjoying life, he quickly became the favourite of the *patronne* and of Nana, 'that superb girl' who appreciated the courtesy with which he treated her. In those days, the village consisted of about a dozen houses clustered around the crossroads leading from Fontainebleau and Montigny to Bourron. The forest came almost to the first group of houses on the northern side, while the houses to the south faced the valley of the Loing, where tall graceful trees shaded the river bank. The beds were excellent at Mère Anthony's, as was the food, and soon Pissarro joined Sisley and Renoir, bringing a taciturn Cézanne with him.

A pattern was established. The young painters returned each spring, taking the train as far as Avon or Melun and walking to Chailly or Marlotte, avoiding the overpriced and overcrowded Barbizon. In 1865 Monet, while searching for the perfect woodland setting for his vast *Le déjeuner sur l'herbe (Luncheon on the Grass)*, injured his right leg and was nursed in his hotel room by Bazille who, fortunately, had not yet given up his medical studies in favour of painting. The good-natured Bazille posed for several of the male figures in the ambitious painting which consumed Monet throughout the summer of 1865. The subject was inspired by Manet's controversial *Le déjeuner sur l'herbe*, which the twenty-two-year-old had seen exhibited at the Salon des Refusés in 1863. Monet wanted to paint a similar scene – not, as Manet had done, in his studio, using sketches, but out in the open in a forest clearing. His painting was to show exactly how the light filtered through the trees and enveloped his city friends as they lounged against the trees or sat in relaxed postures on a cool cloth spread with a veritable feast, including a raised pie, a plump roast chicken, several bottles of wine and a tumble of fruit.

EDOUARD MANET: DÉJEUNER SUR L'HERBE

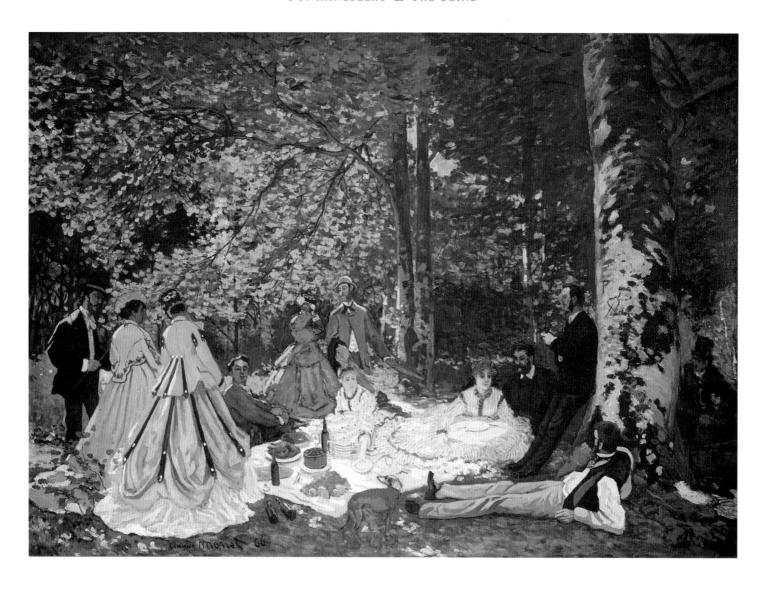

CLAUDE MONET: THE PICNIC

'When I was young, I would take my paintbox and a shirt,
and Sisley and I would leave Fontainebleau, and walk until
we reached a village. Sometimes we did not come back until
we had run out of money about a week later.'

Letter from RENOIR to ADOLPHE TAVERNIER, 19 January 1892

The painting's promise of peace and plenty gives no hint of the money problems that beset Monet at the time – indeed he was forced to leave the canvas behind in payment for his hotel bill when he returned to Paris. Rolled up and abandoned in a corner of the house, the canvas suffered from damp during the winter of 1865–6, and when Monet went back to reclaim it he found that mildew had attacked a large strip on the outer edge. Monet cut this away and preserved the central portion with the figures, but had to give up his plans to submit it to the Salon.

The sylvan Forêt de Fontainebleau was not the young friends' only refuge from the city. The advent of the railways had brought the surrounding countryside closer, and they began to explore the charming, unspoiled villages along the Seine. Old inns and country drinking places were being transformed by the ever greater numbers of Parisians seeping out of the city to enjoy a Sunday in the country. Increasing leisure brought new pursuits. Boating was a popular sport enthusiastically embraced by Monet, Sisley and Renoir. On 3 July 1865 Renoir extended a beguiling invitation to Bazille to join Sisley and himself 'for a long sea voyage in a sailing boat' down the Seine to Le Havre to join Monet for the regatta:

We plan to stay about ten days and the entire expense will be around fifty francs. If you wish to come along, this will give me great pleasure. . . . I am taking my paintbox with me in order to make sketches of any sites I happen to like. I think

it will be charming. Nothing to prevent one from leaving a place one dislikes, and nothing either to stop one from lingering on in any amusing spot. The meals will be frugal . . . We'll have a tugboat tow us to Rouen and, from there on, we'll do whatever we like. . . .

One of the places that pleased Renoir a great deal was the Restaurant Fournaise at Chatou, one of several islands sprinkled along the Seine, where Alphonse Fournaise, an expansive hotelier from Bougival, had built a three-storey riverside restaurant and hotel, which still stands today, incongruously surrounded by the untidy towering sprawl of the encroaching modern city.

Fournaise, whom Guy de Maupassant described as 'a mighty red-bearded, self-possessed individual of renowned strength', made sure that his restaurant became a magnet for this lively, gregarious and – most important – ravenous new clientele by enlarging one of his buildings and adding a landing-stage and a flourishing sideline in boat hire.

Majestic, tall poplars bordered the grey-green glinting river and added their shade to that of the gaily striped awning over the broad terrace of the restaurant. Here lively parties, like the one depicted in Renoir's joyful painting *Le Déjeuner des Canotiers (The Luncheon of the Boating Party)*, would sit long over delicious meals of tiny deep-fried river fish, freshly caught crayfish, and *matelote* – a stew prepared from the daily catch of river fish such as pike, perch, carp and eel – served with a mimosa salad and followed by the local speciality, a tart made with the delicious variety of *verte bonnes*, greengages, that grow

'Un déjeuner à Bougival is a charming work, full of gaiety and spirit, its wild youth caught in the act, radiant and lively, frolicking at high noon in the sun, laughing at everything, seeing only today and mocking tomorrow. For them eternity is in their glass, in their boat, and in their songs. It is fresh and free without being too bawdy.'

PAUL DE CHARRY, reviewing *The Luncheon of the Boating Party* at the seventh Impressionist exhibition in *Le Pays*, 10th March 1882

throughout the Seine valley. Meals were prepared by Mme Fournaise and served by her daughter, 'the lovely Alphonsine', whom Renoir painted three times, and Degas twice. The terrace provided the perfect place to linger over a cognac or a tiny cup of strong black coffee, fanned by gentle river breezes. Later, the diners could take a stroll in the surrounding fields, which were full of long, lush grass, flowers and a heavy tranquillity conducive to a light nap. Alphonse's boats awaited the more energetic.

The brightly coloured crowd offered a rare treat to the local inhabitants, who gathered on the bridge to watch Alphonse steady the frail skiffs and offer his hand to the ladies as they stepped laughing into the bobbing boats. With the ribbons on their straw hats fluttering, they allowed themselves to be rowed leisurely downriver, skirting the willow-bordered banks of the Seine, shady, still and mysterious in the afternoon warmth, to the rival, less respectable La Grenouillère, at Croissy. Both establishments attracted a colourful flotilla of canoes and rowing boats, manned by muscular oarsmen with healthy appetites, in white flannels, or bare-armed, with bulging chests, ferrying young women in their Sunday best, their silk parasols, red, green, blue or yellow, blooming like strange flowers in the sterns of the boats. Maupassant described the famous floating café in his short story *La femme de Paul (Paul's Mistress)* as 'an immense raft, sheltered by a tarpaulin roof, joined to the charming island of Croissy by two narrow footbridges'. There was a riotous atmosphere of holiday and sexual licence as the cheerful crowd of athletes, bathers and boatmen escorting their *'grenouilles'* (young women of the frog pond) sat

on the hard benches at scrubbed tables shouting encouragement to those diving from the roof or splashing about in the cool, fish-filled river water. This raffish, cheerful crowd would stay until evening, when the sinking sun glowed from beneath a sheet of red light and the smell of the grass mingled with the damp scents from the river, filling the air with a soft languor and producing that trick of light the Impressionists mastered so beautifully.

Renoir and Monet spent the summer of 1869 painting side by side at La Grenouillère, taking rapid notes of the strollers and capturing the gay animation of that easygoing, colourful crowd and the play of light on water. 'We might not eat every day,' Renoir wrote to Bazille, 'but I'm content because Monet is great company for painting.' (If only Renoir could have known that in thirty years' time his painting of La Grenouillère would sell for a record sum of 20,000 francs, making him the first of the Impressionists to achieve significant financial success.)

In October they separated. Monet went to Etretat, on the coast, where he met with Courbet, before settling with his mistress, Camille Doncieux, and their little son, Jean, at Saint-Michel, near Bougival, on the Seine. Sisley was also a family man by now. His mistress, a pretty florist named Eugénie Lescouezec, had given birth to their first child, Pierre, in 1867 and a daughter, Jeanne, was born in 1869. Monet visited them frequently and painted at least two interiors of Sisley's house, showing the family gathered around the dinner-table, eating their soup, beneath the beneficent glow of an overhead lamp.

Renoir was drawn back often to Ville-d'Avray where his father, a former tailor originally from Limoges, had retired, and

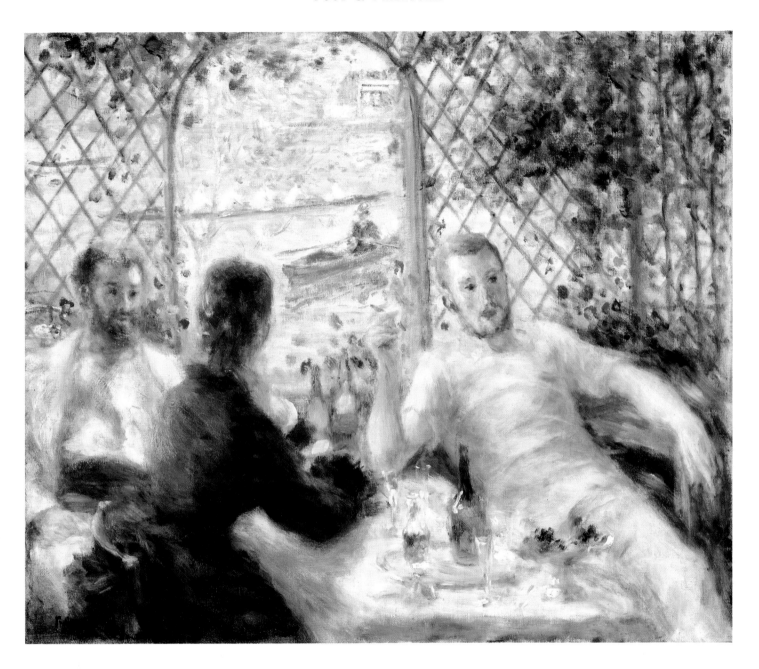

PIERRE-AUGUSTE RENOIR: THE ROWERS' LUNCH

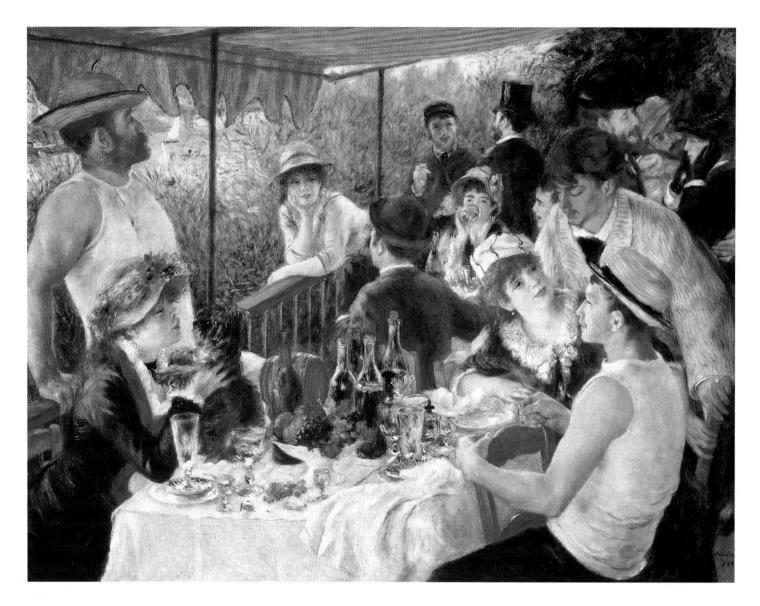

PIERRE-AUGUSTE RENOIR: LUNCHEON OF THE BOATING PARTY

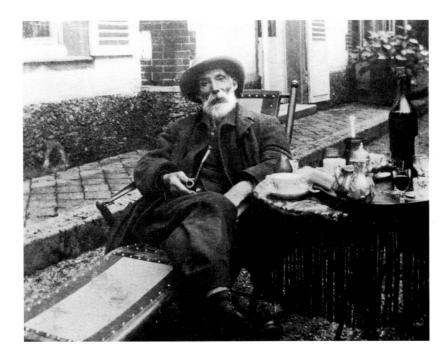

Pierre-Auguste Renoir takes his cognac and coffee outside the Pavillion de Bellune in Fontainebleau in 1901.

he was still a regular at the Restaurant Fournaise. Gradually the idea of an ambitious painting depicting his friends lunching after a boating expedition began to take shape in his mind. He made preliminary sketches, and when, in 1880, he finally felt ready, his friend, Baron Raoul Barbier, made the reservation for the terrace of the Restaurant Fournaise and gathered together the friends who were to pose as models. These included the beautiful Geneviève Halévy, Bizet's young widow; Aline, whom Renoir was finally to marry in 1890; the actresses Jeanne Samary and Ellen Andrée, who were frequent models for Renoir as well as Degas and Manet; and the collectors Charles Ephrussi and Gustave Caillebotte. The latter, a good friend of Renoir's, is now recognized as a fine painter and a key figure in the Impressionist movement, though at the time he considered himself an amateur who hoped that his paintings might one day be deemed 'good enough to hang in the antechamber of the living-room where the Renoirs and Cézannes are hung'.

The final picture is a joyful expression of Renoir's own expansive and harmonious attitude to life and betrays none of the poverty and hardship he was daily pitted against.

Enjoyment radiates from the canvas, which communicates a beguiling sense of intimacy and well-being, the feeling that comes from being with good friends and sharing delicious food and wine. The interaction of the diners, their relaxed postures and garrulous, flirtatious engagement with one another all contribute to the painting's warmth and vibrancy and draw the viewer in. There's a comfortable feeling of plenty: the table in the foreground is generously provided with three opened bottles of wine, and grapes trail casually from a laden fruit bowl. Champagne flutes, wine and cognac glasses sparkle on the shimmering white table-cloth. And the *patron* himself leans, like the most cordial and contented of hosts, on the parapet just behind Renoir's mistress, Aline, surveying the scene with all the benevolence of a man who has no intention of presenting a bill. For the good-hearted Alphonse was always happy to accept paintings instead of money, even though the nearly destitute Renoir, who was having a deal of trouble selling anything at the time, warned him they had no value. Alphonse would simply laugh it off and say that he needed another canvas to hide a damp patch on his wall.

Opposite:
BERTHE MORISOT: IN THE DINING ROOM

When we look at the painting today it fills us with a nostalgic longing for something past, but for Renoir the scene was intensely, definingly modern and represents a deliberate attempt to record contemporary, everyday life. Sundays in the country, the new enthusiasm for the outdoors and sporting amusements, the fashions of the women and their casual interaction with the men – all these things were new. Renoir was the only true working-class member of the Impressionist group and here he captures a social cosmos at the point of change, as the emerging lower middle classes blur together with the middle class. It's a theme Seurat continued five years later when he peopled his vast *A Sunday Afternoon on the Island of La Grande Jatte* with a mixture of people in top hats and cloth caps, all enjoying the stillness and tranquillity of a warm summer's day on the banks of the Seine. His preference was for the ordinary, for suburban and rural sites and for figures, usually anonymous, from the lower echelons of society. But by working on a grand scale, he gave his subjects a monumentality which elevated them to the status of high art.

Day trips were delightful, of course, but the quiet charm of the villages along the Seine drew a number of Impressionist painters away from the bustle of Paris for longer periods. In 1863 Mme Morisot, searching for a country house to rent for the summer as a base for her two gifted daughters, Berthe and Edma, found what she was looking for at Le Chou, a village close to the town of Pontoise. The girls, then in their early twenties, welcomed the freedom the tranquil rural surroundings afforded for unchaperoned painting expeditions. By now they had moved on from their first teacher, Joseph Guichard, who had rapidly recognized their talents but felt obliged to write to their mother advising extreme caution:

Given your daughters' natural gifts, it will not be petty drawing-room talents that my instruction will achieve; they will become painters. Are you fully aware of what that means? It will be revolutionary – I would almost say catastrophic – in your high bourgeois milieu. Are you sure you will never one day curse the art that, once allowed into this household, now so respectably peaceful, will become the sole master of your children?

Camille Corot, Guichard's successor, urged the girls to paint from nature. Accordingly, they rose early and set out through the farmyards and kitchen gardens of the village to the rolling fields and shady woods beyond, where they would paint until lunchtime. Both young women were talented but it was Berthe who, thanks in large part to her parents' faith and support, went on to become the heroine of the Impressionist movement at a time when it was particularly difficult for young women to be taken seriously as artists. The state-sponsored École des Beaux-Arts was closed to them. Studios such as Gleyre's, where Sisley, Renoir and Bazille had studied, or Couture's, which Monet had passed through, were bearpits and no place for respectable young women.

Corot's style of teaching was informal. He did not make the girls conform to rigid rules but rather encouraged the

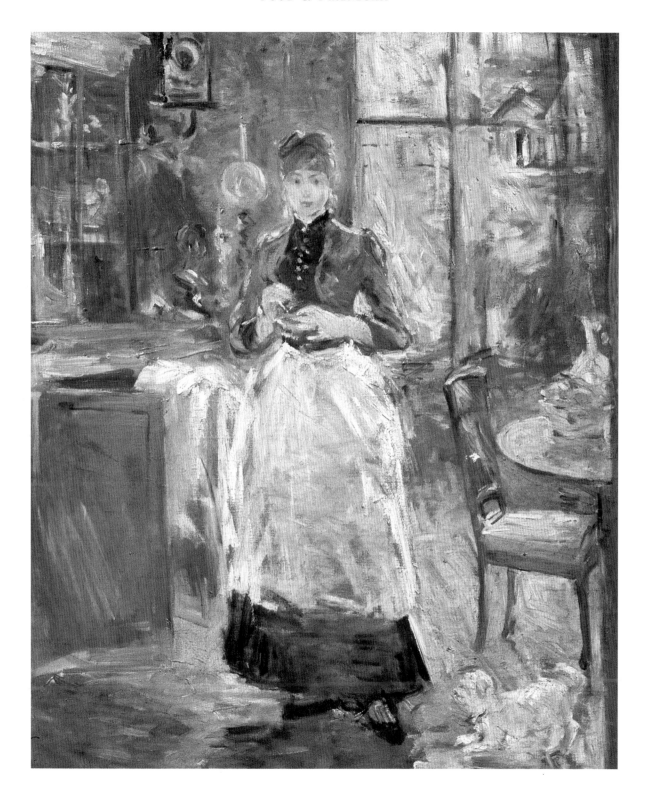

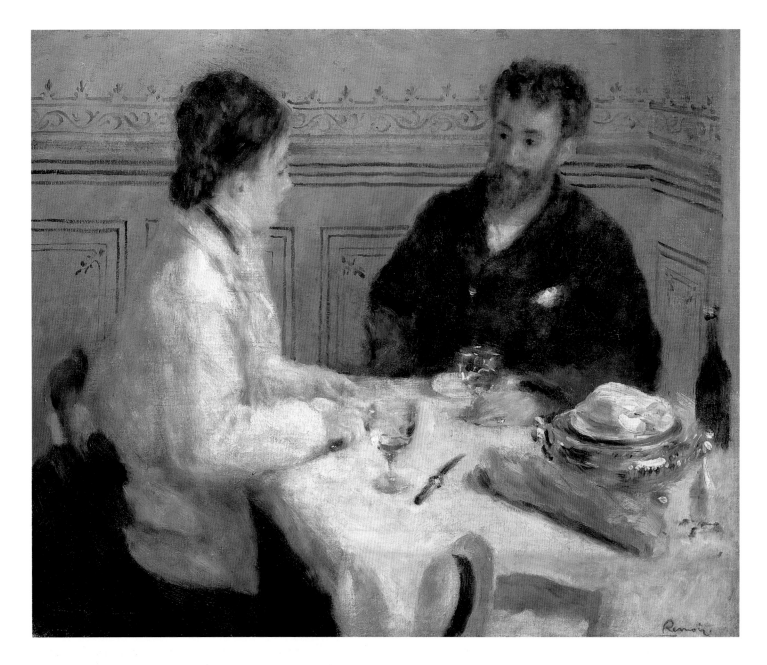

PIERRE-AUGUSTE RENOIR: THE LUNCHEON

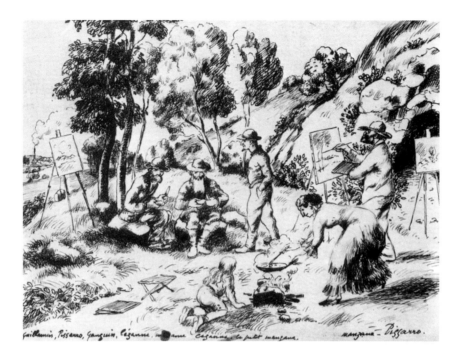

Guillamin, Pissarro, Gauguin, Cézanne and his wife, dining al fresco by Manzana Pissarro.

development of their own personal styles. He became a great family friend and was a frequent guest at the Morisots' large white house, with its elegant wrought-iron balconies, in Passy. Berthe's mother was a graceful and stylish hostess. In the afternoons she was 'at home', chiefly to other women, but on Tuesday evenings she held dinners for at least eight, often more, guests, including writers, artists and musicians. The meals she devised with her cook and served on these occasions would have been long, lavish affairs. A succession of courses, starting with *hors d'oeuvres* and proceeding, on a stream of silver dishes, to a choice of desserts, served with cheese, and finally perhaps an ice of architectural proportions, whipped up in a special hand-cranked apparatus for making ice cream, would be served on a dazzling white cloth beneath a brilliant chandelier. Far from being daunted by the opulence of these occasions, Corot always felt relaxed enough to take the liberty of smoking his favourite '*pipette*' at the end of the meal. For Berthe and Edma their mother's soirées were invaluable, for they offered an opportunity to meet and exchange ideas with professional artists.

The following year the Morisot family summer holiday was spent in Ville-d'Avray, situated on the Seine eight miles west of Paris where Corot kept a country house and was able to return their hospitality. Berthe Morisot continued to revisit the area over the next twenty years, living for a period in Mézy, a picturesque village overlooking the Seine valley, where she painted her much-loved daughter, Julie, in the large orchard attached to the comfortable mansion called La Blottière she had rented.

Unlike Edma, who gave up painting once she married, Berthe Morisot incorporated marriage and maternity into her art. Julie, whom she described as 'like a kitten, always happy; she is round as a ball; she has sparkling eyes and a large grinning mouth', was a favourite subject, and she would paint her husband, Eugène Manet (one of the artist's two brothers), whenever he could be prevailed upon to pose. Her domestic scenes, such as *La salle à manger (The Dining Room)*, are full of serenity and order, and there is also affection, as in her charming portrayal of her maid in *La petite bonne (The Little Servant)*.

She had a special friendship with Renoir, who visited her often at Mézy and was devastated when he heard of her early

CLAUDE MONET:
THE SISLEY FAMILY
AT DINNER

death in 1895. 'I had a feeling of being all alone in a desert,' he told his son Jean. Her good friend, the poet Stéphane Mallarmé, in his funeral address, described her as 'a magician whose delightful work forms an integral part of the art history of the period'.

Some of the happiest, most brilliant Impressionist paintings were done by, or on, the Seine, during the time that Monet lived at Argenteuil. With the financial help of Manet he installed Camille and their small son, Jean, in a charming, vine-covered cottage where they often entertained the other members of the group. Renoir painted Monet, curly-haired and black-bearded with a round shallow hat turned up at the brim, at his easel outside in the garden. Manet painted joyful, luminous paintings by the banks of the Seine, including one of Monet in the ingenious canopied studio boat he had built to provide shade for Camille while he captured the changing effects of light on the surface of the shifting Seine. Many of the paintings of this period convey the feeling of an idyllic summer

day, of a comfortable, leisured style of life which appears to contradict the piteous outcries of 'poverty' contained in Monet's many appeals to his friends. The suggestion of servants and a decidedly bourgeois household is felt in paintings like *Le déjeuner* (*The Luncheon*) in which the little Jean Monet plays contentedly in the shade cast by a vast blossoming tree. Two women in light fashionable summer dresses make their way along a tidy path, bordered by cascading flowers, towards an inviting round table set with a silver coffee pot, an elegant bowl of fruit and some delicate china. The whole beguiling scene is bathed in a limpid dappled light. A straw hat hangs playfully from a branch of the tree and a folded parasol awaits its owner on the wooden bench. The mood is one of irresistible serenity occasioned by the fact that finally at Argenteuil, where he painted over 170 canvases, Monet was able to realize the pleasurable middle-class life of the *bon gourmand* he had always aspired to. Like many of the Impressionists, Monet's fortunes rose and fell, but 1872 was a good year in which he sold 38 paintings for a total of 12,100 francs, a considerable income given that his agricultural neighbours would have earned

around 2,000 a year. At the time he was employing two maids and a gardener in the Argenteuil house and, as his fortunes improved, so did his table. Monet was a lavish host and the food served in his dining-room was of a high standard. Despite the fact that the surrounding vineyards, which he painted, were said to produce the best wine in the Ile de France, Monet ordered fine wines direct from Bordeaux and Montpellier and drank them with pleasure in the company of his friends.

He was less disloyal to another local product – asparagus – for which Argenteuil was famous. It was Manet, however, who immortalized the gastronomic symbol of the region. His tightly packed bundle of stippled cream asparagus, tipped with a yellowish brown mauve, flecked with green, now hangs in the Wallraf-Richartz Museum in Cologne, but in 1880 it was bought by the banker and amateur art historian Charles Ephrussi for 800 francs. In fact it was 1,000 francs, for Ephrussi overpaid Manet, who immediately dashed off another painting of a single stalk which he sent along with a note: 'Your bunch was one short.'

While Renoir preferred the prettiness of Bougival, Cézanne and Pissarro were drawn by the subtleties of light and the pastoral landscapes they found at Louveciennes, Auvers and Pontoise. For Pissarro, who, as his hair turned white and his beard grew long, came to be known as 'the wise old man of Impressionism', the suburbs had the advantage of cheaper rents and food, important considerations for a family man living on a tiny and erratic income. Also his raw material was more likely to be found in the country than the town. He was stimulated by the country landscapes and village scenes, rural lanes and unhurried streets. He loved the bustle of a local market. Pontoise was the major market centre for the whole area of the Vexin and was famous for veal and for cabbages. His honest depiction of the humble vegetable in his paintings was one of the many things that drew the scorn of the critic Louis Leroy at the first Impressionist exhibition in 1874. For Leroy such ignoble subject-matter was an affront to art. Even the sympathetic critic, Jules Castagnary, bemoaned his 'sober and strong' friend's 'deplorable liking for truck gardens', going on to complain that he 'does not shrink from any presentation of cabbages or other domestic vegetables'.

Pissarro was unrepentant. He was, he said, 'rustic by nature' and loved the tranquil, simple, rural life which revolved around the continuity of the family and the land. He lived in the landscape that he painted, and his own family was growing at an impressive rate. He and Julie had eight children altogether, though two daughters died young. The tragedy of the girls' deaths devastated the gentle Pissarro and added to the cares of the redoubtable Julie, whom Pissarro had married in the teeth of family opposition and to whom he remained devoted for the rest of his life. Pissarro came from a relatively wealthy family and met the young Julie Vellay when she was 21 years old and working as an assistant to his parents' cook at their house in Passy. His family might have forgiven him for sleeping with a servant, but to marry her put him beyond the pale.

Fortunately Julie Vellay was made of stern stuff. She had grown up in Grancey-sur-Ource, near Dijon, where her mother

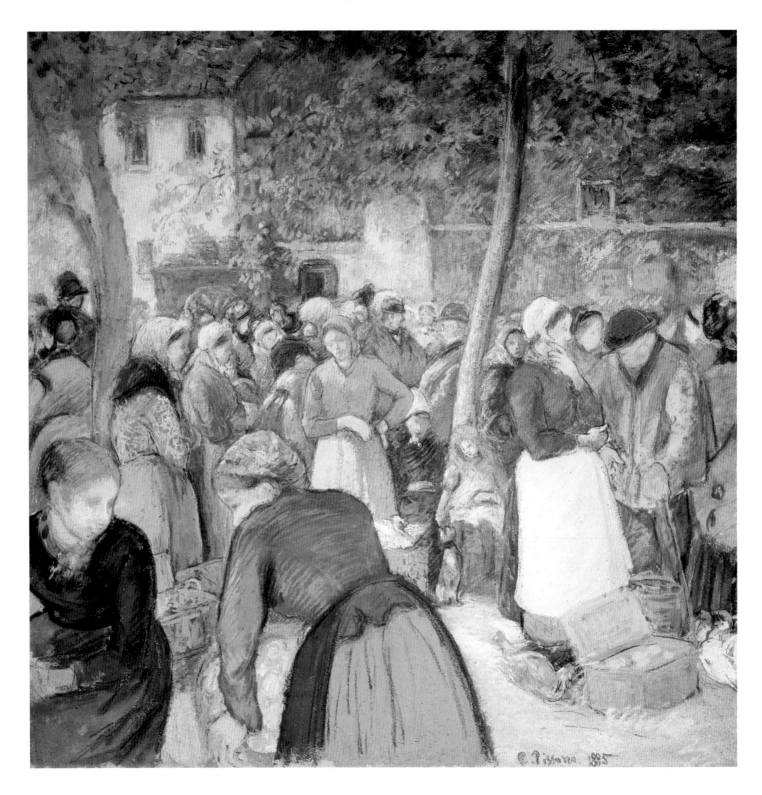

farmed a two-acre small-holding and tended two small vine-yards. Her roots were deep in the countryside and, like her mother, she was thrifty and industrious. She cultivated vegetables in the gardens of the houses Pissarro rented. She raised chickens, rabbits and pigeons to help to feed her family and the many guests Pissarro invited, including the shy and sometimes surly Cézanne, who spent the summer of 1872 at the Hôtel du Grand Cerf, across the river from Pontoise, about a twenty-minute walk from the Pissarro home.

Pissarro, a kindly father-figure to the group of young painters, championed the curmudgeonly and difficult Cézanne. To Antoine Guillemet on 3 September 1872 he wrote: 'There is hope for Cézanne. I have seen, and have at my house, a painting of remarkable strength and vitality. If, as I hope, he stays a while at Auvers, where he is now moving, he will surprise those artists who were too quick in condemning him.'

Cézanne was going through a difficult time. He was kept on a modest allowance by his father, a successful hatter turned even more successful banker, who did not approve of his son's life as a painter. Consequently Cézanne ran up debts everywhere and it was only thanks to the intervention of Dr Gachet, a warm-hearted, generous and enthusiastic supporter of the Impressionists, that he was able to calm his grocer, who was persuaded, reluctantly, to accept a few paintings in settlement of the unpaid bill. Gachet, who painted himself under the pseudonym of van Ryssel, intervened on Pissarro's behalf too and was so persuasive a proponent of Impressionism that by the start of the century the grocer, Jean-Baptiste-Armand Rondest, owned three Cézannes and three Pissarros, all of which he had accepted on the doctor's recommendation in exchange for food.

In 1884, the Pissarros moved to a substantial two-storeyed house in Eragny-sur-Epte, which was to be their home for the next nineteen years. The small garden at the front had acacias and weeping willows. At the rear, a poultry yard and pigsty, a shed and a hen-coop separated the house from the barn which Pissarro eventually converted to his studio. In 1888 Pissarro painted his *Vue de ma fenêtre (View from My Window)*, showing apple and pear trees beyond the shed, fertile fields, dense woods and low hills on the horizon. He was still beset by money troubles but otherwise cheerful. On Mondays he would go with Julie to the neighbouring town of Gisors, where she would buy cheeses and butter, and possibly barter her own goods, while he sketched the sturdy peasant women haggling over eggs and poultry in the village square or made charcoal drawings of lively scenes in the indoor market.

They often entertained friends round the oval table in their dining-room which was hung with paintings by Cézanne, Monet, Delacroix, Degas and van Gogh (who shot himself in a fit of despair in Auvers on 27 July 1890) and crowded with drawings and watercolours by Manet, Cassatt, Sisley, Seurat and Signac.

To his son, Lucien, he wrote: 'The country is magnificent, the apple trees are heavy with fruit, the field is superb with green.' The practical Julie sent Lucien a basket of apples, pears and walnuts from her orchard. In 1892, with the help of Monet, the Pissarros were able to buy the house, which the proud Julie described as 'a fine bourgeois residence'.

POTAGE ARGENTEUIL Ⓥ

ASPARAGUS SOUP

Argenteuil was famous for its asparagus, where both the green and the white varieties were grown; and in 1880 it inspired Manet into painting his still-life of white asparagus.

SERVES 6–8

45g/1½ oz/3 tbsp butter
450g/1 lb asparagus, trimmed and chopped with tips reserved
2 leeks, trimmed, chopped and rinsed
225g/8 oz/1½ cups potato, peeled and diced
1 litre/1¾ pints/4½ cups vegetable stock
85ml/3 fl oz/6 tbsp single (light) cream
2 tbsp chopped fresh chives
pinch of grated nutmeg
salt and pepper
fresh chives, to garnish

MELT THE BUTTER in a large saucepan. Add the chopped asparagus, leeks and potato and sauté for 5 minutes. Add the stock and bring to the boil, then lower the heat, cover and simmer for 20 minutes. Transfer to a blender or food processor and blend until very smooth.

Return the soup to a clean pan. Stir in the cream and chives and season with the nutmeg, salt and pepper; keep warm.

Blanch the reserved asparagus tips in boiling water for 2 minutes, then drain and refresh immediately under cold water. Pat dry with kitchen paper (paper towels).

Spoon the soup into warmed bowls and garnish each with the asparagus tips and chives.

SOUPE À L'OIGNON GRATINÉ

BAKED ONION SOUP

SERVES 6–8

25g/1 oz/2 tbsp butter
2 tbsp vegetable oil
4 large onions, thinly sliced
2 large garlic cloves, chopped
2 tsp chopped fresh thyme
1 tsp caster (superfine) sugar
1.2 litres/2 pints/4½ cups beef stock
50ml/2 fl oz/¼ cup dry red wine
salt and pepper
8 slices French bread
175g/6 oz/1½ cups Gruyère cheese, grated

MELT THE BUTTER WITH THE OIL in a deep frying pan (skillet). Add the onions, garlic, thyme and sugar and sauté over a medium heat for 30 minutes, stirring, until very soft and golden.

Meanwhile, preheat the oven to 200°C/400°F/Gas Mark 6 and oil the insides of a 1.8 litre/3 pint/7½ cup deep ovenproof dish.

Add the stock and wine to the onions and bring to the boil. Lower the heat, cover and simmer for 15 minutes. Season to taste.

Toast the bread lightly on both sides, then place half the slices in the base of the prepared dish. Sprinkle over half of the cheese, then spoon over the soup and top with the remaining bread and cheese. Bake for 15 minutes until the cheese is melted.

Meanwhile, preheat the grill (broiler) to high.

Brown the soup quickly under the grill, then allow to cool for 5–10 minutes before serving.

Opposite: BAKED ONION SOUP

SOUPE AU CHOU
CABBAGE SOUP

The writer Émile Zola, a close friend of Cézanne's, writes in his book
Le ventre de Paris (*The Fat and the Thin*), set around the former central
Paris food market at Les Halles, of how the narrow walkways between
the vegetable stalls were congested with vendors cooking huge vats of
steaming cabbage soup – 'the bright tin cauldron, full of broth, was
steaming over a little low stove . . . the woman took some thin slices of
bread and dropped them into yellow cups; then with a ladle she filled
the cups with liquor.'

SERVES 8

225g/8 oz salt pork
1 bouquet garni (see page 38)
100g/4 oz piece smoked bacon (smoked slab bacon), diced
2 tbsp vegetable oil
1 onion, chopped
2 tbsp chopped fresh thyme
6 cloves
1 small Savoy cabbage, cored and roughly shredded
2 carrots, peeled and diced
2 small turnips, peeled and diced
salt and pepper
8 thick slices rustic bread

WASH AND DRY THE PORK and place it in a large saucepan with the bouquet garni and 1.2 litres/2 pints/5 cups cold water. Bring to the boil, then lower the heat, cover and simmer for 1 hour, skimming the surface from time to time to remove the scum.

Heat a frying pan (skillet) until hot. Add the bacon and fry over a high heat for 4–5 minutes, stirring frequently, until brown and starting to release its fat. Add the vegetable oil, onion, thyme and cloves and continue frying for 10 minutes.

Add the cabbage, carrots and turnips to the salt pork with the bacon and onion mixture, adding enough extra water to just cover the vegetables. Cook for a further 20 minutes until the vegetables are tender. Remove from the heat and leave to cool completely, then cover and refrigerate overnight.

Remove the pork from the pan and carefully cut the meat into strips. Put the meat back in the pan and heat until the soup just reaches the boil. Season to taste. Place a slice of bread in the bottom of each bowl and spoon over the soup. Serve at once.

BISQUE D'ÉCREVISSE
CRAYFISH BISQUE

Freshwater crayfish, or *écrevisse*, would have been caught in the Seine
and served in the nearby restaurants, either poached with mayonnaise
or in a soup or as part of a stew, or *matelote*.
This is a rich crayfish bisque made with both the shells and the meat of
the shellfish; langoustines can be substituted for the crayfish for a
delicious seafood version.

SERVES 6

1.5kg/3 lb freshwater crayfish or langoustines
300ml/10 fl oz/1¼ cups dry white wine
1 carrot, chopped
1 onion, chopped
2 celery sticks (ribs), chopped
2 garlic cloves, chopped

2 sprigs fresh parsley
2 sprigs fresh thyme
1 bay leaf
salt and pepper
4 tbsp double (heavy) cream
1 tbsp lemon juice

RINSE AND DRY THE CRAYFISH; set aside. Put the wine, carrot, onion, celery, garlic, herbs, bay leaf and a little salt and pepper into a large saucepan. Add 900ml/1½ pints/3¾ cups cold water and bring to the boil. Lower the heat, cover and simmer for 10 minutes. Add the crayfish, return to the boil and simmer for a further 5 minutes.

Remove the crayfish with a slotted spoon and set aside until cool enough to handle; reserve 6 of the crayfish for garnish. Remove the meat from the remaining crayfish and reserve.

Put the heads and shells into the stock, cover and simmer for 20 minutes. Transfer to a blender or food processor, in batches, and blend until fairly smooth. Pass through a fine sieve (strainer) into a clean pan. Add the tail meat and cook for a further 10 minutes. Purée in a clean blender or food processor until very smooth and return to the pan.

Stir in the cream and reheat gently. Season to taste, adding the lemon juice, and transfer to warmed bowls. Garnish each bowl with the reserved whole crayfish and serve at once.

FRITURE DE LA SEINE
FRIED FISH, SEINE-STYLE

A popular dish that would have been served in many of the Seine
eateries that made good use of the locally caught, small river fish. Thin
strips of skinned trout fillets in a light beer batter provide a modern
interpretation of an old recipe. You could serve this with a pot of Aïoli.

SERVES 4

sunflower oil for frying
4 × 100g/4 oz trout fillets, skinned, rinsed and dried

FOR THE BATTER
1 egg, separated
1 tbsp olive oil
100ml/3½ fl oz/7 tbsp light beer
65g/2½ oz/heaped ½ cup plain (all-purpose) flour

1 tbsp chopped fresh chives
salt and pepper

TO SERVE
sea salt
lemon wedges, to garnish
aïoli (see page 168), (optional)

MAKE THE BATTER: beat together the egg yolk, oil, beer, flour,
chives and salt and pepper. Cover and set aside for 30
minutes.

When ready to serve, pour 10cm/4 in oil into a deep, heavy-
based frying pan (skillet) and heat until it reaches 180°C/
350°F on a sugar (candy) thermometer, or until a cube of bread
browns in about 30 seconds. Whisk the egg white until stiff,
then fold into the rested batter until evenly combined.

Use a pair of tweezers to pull out all the remaining bones,
then cut each fillet lengthways into 1cm/½ in strips and then in
half crossways.

Dip several strips of trout into the batter so they are lightly
coated, then fry for 1–1½ minutes until the batter is crisp and
golden and the trout cooked through. Continue working in
batches until all the fish is fried.

As soon as the fish is fried, drain it on kitchen paper (paper
towels) and transfer to a low oven to keep warm. Sprinkle with
sea salt and garnish with lemon wedges, to squeeze. Serve at
once with some aïoli, if wished.

SOUFFLÉ AUX FROMAGES ET AUX FINES HERBES Ⓥ
CHEESE AND HERB SOUFFLÉ

A popular light lunch or first course, soufflés were often served in the bars and cafés along the Seine. Monet liked to serve a soufflé course at dinner parties, often in individual ramekins.

SERVES 4

50g/2 oz/½ cup Parmesan cheese, grated
50g/2 oz/4 tbsp butter
50g/2 oz/4 tbsp plain (all-purpose) flour
2 tsp dry mustard powder
300ml/10 fl oz/1¼ cups milk
100g/4 oz/1 cup Gruyère cheese, grated
3 eggs, separated
4 tbsp chopped fresh herbs, including chervil, chives, dill, parsley, savory and tarragon
salt and pepper

PREHEAT THE OVEN to 200°C/400°F/Gas Mark 6 and grease a large 900ml/1½ pint/3¾ cup soufflé dish. Dust the base and side with a little of the grated Parmesan cheese, reserving the rest; set aside.

Melt the butter in a saucepan over a medium heat. Add the flour and mustard powder and cook for 30 seconds, stirring constantly to form a soft paste. Remove the pan from the heat and add the milk, a little at a time, stirring constantly. When all the milk has been absorbed, return the pan to the heat. Cook gently for 2 minutes, stirring frequently.

Remove from the heat and stir in the Gruyère and reserved Parmesan until melted, then beat in the egg yolks, herbs and seasoning. In a separate bowl beat the egg whites until stiff and fold into the cheese sauce until evenly incorporated. Spoon into the prepared dish and bake for 25–30 minutes until risen and golden. Serve at once.

OEUFS EN COCOTTE AUX ÉPINARDS Ⓥ
BAKED EGGS WITH SPINACH

SERVES 4

15g/½ oz/1 tbsp butter
100g/4 oz/1¾ cups spinach leaves, shredded
1 tbsp chopped fresh herbs, including parsley, savory and chives
25g/1 oz/2 tbsp Parmesan cheese, grated
black pepper
4 eggs
4 tbsp double (heavy) cream
toasted French bread, to serve

PREHEAT THE OVEN to 180°C/350°F/Gas Mark 4 and grease the insides of 4 ramekins. Divide the spinach, herbs and Parmesan between each ramekin, pressing down well, and season with black pepper.

Make a slight indentation in the centre of the spinach mixture, then carefully break an egg into the hollow and top with a spoonful of cream. Place the ramekins in a roasting tin (pan) and add enough boiling water to reach two-thirds of the way up the sides. Bake for 10–12 minutes until the eggs are just cooked through. Remove from the pan, cool slightly and serve with toasted French bread.

ÉMILE ZOLA likened the different smells of the cheeses in Les Halles to notes of music in his novel *Le ventre de Paris*:

'It was the Camembert above all they could smell. The Camembert with its gamy scent of venison had conquered the more muffled tones of Marolles and Limbourg . . . Into the middle of this vigorous phrase, the Parmesan threw its thin note of a country flute; while the Bries added the dull gentleness of damp tambourines. Then came the suffocating reprise of a Livarot. And the symphony was held for a moment on the high, sharp note of an aniseed Gérome, prolonged like the note of an organ.'

TERRINE DE GIBIER
GAME TERRINE

The banks of the Seine were an inspiration to many of the Impressionist painters, particularly Renoir and Pissarro. It was an ideal place to picnic, both along the river and, indeed, in the forest of Fontainebleau. The French have always enjoyed rich pâtés and terrines, and the original recipe for this terrine would most probably have included lark (from the nearby town of Étampes, which remains famous for its lark pâté).

SERVES 8–12

15g/½ oz/½ cup dried ceps
50ml/2 fl oz/¼ cup boiling water
3 duck breasts, each about 225g/8 oz, skinned
2 pigeon breasts
225g/8 oz smoked gammon (ham), diced
85ml/3 fl oz/6 tbsp brandy
25ml/1 fl oz/2 tbsp ruby Port
2 tsp ground mixed spice (apple pie spice)

1 tsp ground mace or grated nutmeg
450g/1 lb minced (ground) lean pork
2 shallots, very finely chopped
1 garlic clove, crushed
15g/½ oz black truffle, finely chopped
1 egg
rustic bread, cornichons and radishes, to serve

PLACE THE CEPS in a small bowl and pour over the boiling water; set aside to soak for 20 minutes. Drain, reserving the liquid, and finely chop the ceps and reserve. Cut 2 of the duck breasts lengthways into thin strips, then place in a shallow glass dish with the pigeon breasts and gammon. Pour over the reserved cep liquid, the brandy, Port and spices and toss well. Cover and marinate for several hours.

Roughly chop and then blend the remaining duck breast in a blender or food processor. Transfer to a bowl and mix in the minced (ground) pork, shallots, garlic, truffle, egg and the reserved ceps and season well. Strain the marinade juices into the mixture.

Preheat the oven to 180°C/350°F/Gas Mark 4 and grease a deep 1kg/2 lb terrine mould. Press one-third of the pâté mixture into the dish, top with the pigeon breasts and then another third of the pâté. Arrange the strips of duck breast and gammon over the top and finish off with the remaining pâté mixture, smoothing the surface well. Cover tightly with greased foil.

Place the dish in a roasting tin (pan) and pour in boiling water to come two-thirds the way up the sides of the mould. Bake for 1½–2 hours, or until a skewer inserted in the centre comes out hot. Remove from the oven and leave to cool.

Place a clean piece of foil over the pâté and top with a heavy weight, then leave in the refrigerator for 1–2 days for the flavours to develop. Unmould and serve the terrine with traditional accompaniments, such as rustic bread, cornichons and radishes.

TRUITE MEUNIÈRE GRILLÉE
GRILLED TROUT MEUNIÈRE

Locally caught trout were popular at the cafés and restaurants along the banks of the Seine.

SERVES 4

4 × 300g/10 oz brown or rainbow trout, gutted, rinsed and dried
4 sprigs fresh thyme
4 sprigs fresh sage
4 lemon slices
salt and pepper
olive oil

FOR THE MEUNIÈRE SAUCE
100g/4 oz/1 stick butter
grated rind (peel) and juice of 1 lemon
4 tbsp chopped fresh herbs, such as chives, tarragon and parsley

FILL THE BODY CAVITY of each trout with a sprig each of thyme and sage, a slice of lemon and salt and pepper. Slash each fish several times on each side and brush with a little oil. Either cook on a barbecue or under a hot grill (broiler) for 5–6 minutes on each side until the skin is charred and the flesh is firm.

Meanwhile, prepare the sauce. Melt the butter in a saucepan. As soon as it stops foaming, stir in the lemon rind (peel), juice and herbs. Remove from the heat. Season to taste and pour over the grilled fish. Serve at once.

POULET RÔTI AU BEURRE
BUTTER-ROASTED CHICKEN

This chicken dish would originally have been spit-roasted over an open fire. Nineteenth-century Parisians looking for a relaxing Sunday lunch by the river would search out this dish, as it was a particular favourite. The chicken can be rubbed with oil but is not as succulent, so keep this recipe for days when you feel particularly self-indulgent, as the inclusion of the butter under the breast skin leaves the bird wonderfully moist.

SERVES 4-6

1 × 1.5–2kg/3½–4 lb free-range chicken, rinsed and dried
1 onion, stuck with cloves
1 bay leaf
½ lemon
salt and pepper
100g/4 oz/1 stick unsalted butter, softened
1 garlic clove, crushed
2 tbsp chopped fresh herbs, including tarragon, chives and parsley
1 quantity Girolles à la Crème Fraîche (see page 117) and boiled potatoes with chopped parsley, to serve

PREHEAT THE OVEN to 200°C/400°F/Gas Mark 6. Fill the chicken's body cavity with the onion, bay leaf and lemon and season well.

Beat together the butter, garlic, herbs and more seasoning. Lift the skin from the neck end of the chicken away from the flesh and work your hand between the skin and breast to form pockets. Divide the butter in half and fill each pocket with half of it, spreading it as far along the breast as possible: take care not to pierce the skin. Spread any remaining butter over the skin, then sprinkle all over with salt and transfer to a roasting tin (pan).

Roast the chicken for 1¼–1½ hours until the skin is browned and the meat is cooked through. Serve the chicken with *Girolles à la Crème Fraîche* and plain boiled potatoes tossed with parsley.

POT AU FEU
POT ROAST OF BEEF

Traditionally cooked in a heavy earthenware dish called a *marmite*, this
hearty meat and vegetable soup/stew is served as two courses. The rich
broth is served first, followed by the meat and vegetables with the
bone marrow spread on toast.

SERVES 8

1.5kg/3 lb beef silverside (brisket), rinsed and dried
450g/1 lb knuckle of veal or gammon (ham), rinsed and dried
8 small leeks, trimmed and rinsed
8 small carrots, trimmed
1 celery heart
4 turnips, trimmed and halved
1 bouquet garni (see page 38)

salt and pepper
2 small pieces marrow bone
4 large potatoes, peeled and cut into chunks

TO SERVE
4 tbsp chopped fresh parsley
8 slices toasted bread

PLACE THE BEEF AND VEAL OR GAMMON in a flameproof casserole,
and cover with 3.6 litres/6 pints/3¾ quarts cold water. Bring
to the boil and skim the surface to remove any scum, then
lower the heat, cover and simmer for 30 minutes, skimming as
necessary.

Tie the leeks and carrots into separate bundles. Add to the pan
with the celery, turnips, bouquet garni and plenty of pepper.
Return to the boil, then lower the heat, cover and simmer over a
very gentle heat for a further 1 hour.

Tie up each marrow bone in a square of muslin (cheesecloth)
so as not to loose all the marrow. Add to the casserole along with
the potatoes, then continue simmering for a further 30 minutes
until the potatoes are tender. Season generously and carefully
remove the meat and vegetables to a large warmed platter, cover
with foil and keep warm in a low oven.

Strain the liquid through a fine sieve (strainer) and transfer to
a warmed tureen. Stir in the parsley and serve the soup first and
then serve the beef, veal and gammon and vegetables. Finally,
unwrap the marrow bones and spread the marrow over the
toasted bread.

Opposite:
POT ROAST OF BEEF

BÉCASSE RÔTIE
ROASTED WOODCOCK

This is one of the most highly prized French dishes, and would have
been served at many of the Seine restaurants, particularly the more
exclusive establishments. Woodcock is available in season from good
butchers, or you can use pigeon, quail or snipe at other times.
Traditionally the giblets are left in during cooking and mashed to a
paste to be served with the roasted woodcock, but here chicken liver is
used instead.

SERVES 4

4 × whole woodcocks, drawn, rinsed and dried
salt and pepper
4 large sage leaves
8 rashers (slices) streaky bacon
50g/2 oz/4 tbsp butter

225g/8 oz chicken livers, trimmed
juice of 1 lemon
2 tbsp brandy
8 pieces of bread, toasted on both sides

PREHEAT THE OVEN to 200°C/400°F/Gas Mark 6. Season each
woodcock's stomach cavity, adding the sage leaves. Wrap
and secure 2 rashers (slices) of bacon around each bird.

Melt half the butter in a flameproof casserole until foaming.
Add the birds, 2 at a time, and brown all over. Return all the
birds to the casserole and roast for 15–20 minutes until cooked
through. Place the birds on a warmed serving plate, cover with
foil and keep warm.

Melt the remaining butter in the pan. Add the chicken livers
and sauté for 1 minute until browned. Stir in the lemon juice
and brandy and heat gently for a further 1 minute, then remove
from the heat. Season to taste.

Mash the livers with a fork to form a paste and spread a little
over each piece of toast. Place a roasted woodcock on top of
each one and serve at once.

CHOU FARCIE BRAISÉ Ⓥ
BRAISED STUFFED CABBAGE

Like *pot au feu*, stuffed cabbage is a dish cooked throughout France and
the stuffing ingredients differ according to the region: for example, in
Provence, spinach is often included; in Limoges, it would be chestnuts.
This is a vegetarian dish with individual stuffed cabbage rolls braised on
a bed of vegetables and herbs and served with the thickened pan juices.

SERVES 4; MAKES 8 CABBAGE ROLLS

1 × 675g/1½ lb green cabbage
100g/4 oz/½ cup long-grain rice
25g/1 oz/2 tbsp butter
1 onion, finely chopped
1 garlic clove
2 tbsp chopped fresh sage
225g/8 oz ceps or other wild mushrooms, wiped and finely chopped
50g/2 oz/¼ cup dried wholemeal (whole-wheat) breadcrumbs
50g/2 oz/½ cup almonds, chopped and toasted
50g/2 oz/¼ cup full-fat soft cheese (cream cheese)
pinch of grated nutmeg
1 tbsp lemon juice
salt and pepper

2 tbsp olive oil 1 onion, sliced
1 leek, trimmed, sliced and rinsed
1 carrot, thinly sliced
2 garlic cloves, chopped
2 sprigs fresh thyme
2 bay leaves
50ml/2 fl oz/¼ cup dry white wine
150ml/5 fl oz/⅔ cup vegetable stock
sautéed potatoes, to serve

FOR THE SAUCE
4 tbsp double (heavy) cream
1 egg yolk

PREPARE THE CABBAGE: carefully cut and peel away the first 8 outer leaves, cutting them at the stalk (stem) and being careful not to tear them. Blanch the leaves in a large pan of boiling water for 1 minute, then drain and immediately refresh under cold water. Pat dry on kitchen paper (paper towels) and use a pair of scissors to cut away most of the thick central stalk.

Cook the rice in boiling water for 8 minutes until almost tender. Drain and immediately refresh under cold water, then dry well.

Melt the butter in a saucepan. Add the onion, garlic and sage and sauté for 5 minutes. Add the mushrooms and continue to fry over a high heat for a further 5 minutes until they begin to release their juices. Stir in the breadcrumbs and almonds. Remove the pan from the heat and stir in the rice, cheese, nutmeg, lemon juice and season to taste; set aside to cool.

Divide the mixture into 8 large balls. Working with one cabbage leaf at a time, press it flat and place a stuffing ball in the centre. Wrap the leaf round the ball to enclose it completely and secure with a cocktail stick (toothpick). Repeat to make 8 rolls.

To braise the cabbage, spoon the oil into a flameproof casserole. Add the onion, leek, carrot, garlic and herbs so they form a bed. Place the cabbage rolls on top and pour over the wine and stock. Bring slowly to the boil, then lower the heat, cover and simmer for 25–30 minutes. Transfer the cabbage rolls to a warm oven to keep warm.

Strain the cooking juices into a small pan. Whisk the cream and egg yolk together, then whisk in a little of the braising juices. Whisk back into the cooking juices and reheat gently, stirring constantly, until the sauce thickens: do not boil or the sauce will curdle. Serve 2 cabbage rolls per person with a little sauce and sautéed potatoes.

Girolles à la Crème Fraîche Ⓥ

Girolles with Crème Fraîche

The early winter months were the time to hunt for the delicious wild mushrooms, especially girolles, which flourished in the Fontainebleau forest.

SERVES 4

450g/1 lb fresh girolles
45g/1½ oz/3 tbsp butter
2 garlic cloves, sliced
grated rind (peel) of 1 lemon
2 tsp chopped fresh thyme
100g/4 oz/½ cup crème fraîche
salt and pepper
2 tbsp chopped fresh parsley

VERY CAREFULLY WIPE THE DIRT from the mushrooms but do not wash them. Melt the butter in a large frying pan (skillet). Add the garlic, lemon rind (peel) and thyme and sauté for 30 seconds until a good aroma is released. Stir in the mushrooms and sauté over a high heat for 2 minutes. Lower the heat, cover and simmer for a further 1 minute until tender.

Stir in the crème fraîche and bring to the boil. Season to taste and serve at once, sprinkled with the parsley.

Salade de Pomme de Terre Ⓥ

Potato Salad

SERVES 4

675g/1½ lb Charlotte potatoes, scrubbed
4 sprigs fresh mint, lightly bruised
1 tsp sea salt
1 tbsp whole-grain mustard
1 tbsp sherry vinegar
3 tbsp extra-virgin olive oil
1 tbsp hazelnut oil
pepper
2 tbsp chopped fresh herbs, including chervil, chives, mint and parsley

BRING THE POTATOES to the boil in a large pan of water with the mint sprigs and salt and boil for 12–15 minutes until just tender.

Meanwhile, prepare the dressing: place the mustard and vinegar in a small bowl and whisk in the oils. Season to taste and stir in the herbs.

Drain the potatoes as soon as they are cooked and combine immediately with the dressing; set aside to cool. Serve at room temperature.

'They had lunch in the kitchen and an extraordinary lunch it was. Boiled eggs followed by fried gudgeon, then last night's boiled beef done up in a salad with potatoes and a red herring. It was delicious, feasting in the strong, appetising odour of the herring which Melie had tossed on the coals, with the coffee splashing slowly but noisily through its filter on the hob. By the time dessert was brought on, strawberries fresh from the garden, cheese from a neighbouring dairy, all three had their elbows on the table, engrossed in conversation.'

from *L'oeuvre* (*The Masterpiece*) by ÉMILE ZOLA

Opposite:
GIROLLES
WITH CRÈME FRAÎCHE

SALADE MIMOSA ⓥ
MIMOSA SALAD

Renoir loved the Fournaise restaurant on one of the islands along the Seine and there painted the famous *Le déjeuner des canotiers* (*The Luncheon of the Boating Party*, 1881). Madame Fournaise often served a mimosa salad to the artist and his friends.

SERVES 4

1 Little Gem lettuce
1 Batavia (crisphead) or soft lettuce
1 head chicory (Belgian endive)
3 hard-boiled eggs, shelled and halved
½ cucumber, thinly sliced
100g/4 oz radishes, halved
100g/4 oz cherry tomatoes, halved
2 tbsp chopped fresh chives

FOR THE VINAIGRETTE
1 tbsp red wine vinegar
1 tsp Dijon mustard
½ tsp sugar
6 tbsp extra-virgin olive oil
salt and pepper

START BY MAKING THE VINAIGRETTE. In a small bowl, whisk together the vinegar, mustard and sugar. Gradually whisk in the oil until amalgamated, then season to taste; set aside.

Trim the lettuces and chicory (Belgian endive), discarding any tough or damaged outer leaves, and tear the rest into small pieces, then place in a large bowl. Roughly chop the egg whites and scatter over the leaves.

Add the cucumber, radishes and tomatoes to the leaves. Then pour over the vinaigrette and toss well. Transfer to a large serving plate or shallow bowl. Press the egg yolks through a fine sieve (strainer) over the top of the salad and serve at once, garnished with chives.

PETITS POTS AU CHOCOLAT ⓥ
CHOCOLATE POTS

Just as popular in France as elsewhere, chocolate in nineteenth-century France was most closely associated with *la cuisine bourgeoise* and with the bistros, where *pot au chocolat* would appear on practically every menu.

SERVES 6

175ml/6 fl oz/¾ cup double (heavy) cream
4 strips orange rind (peel)
120g/4½ oz dark (bittersweet) chocolate
50ml/2 fl oz/¼ cup milk
2 tbsp orange liqueur
2 egg yolks, size 4 (medium)
20g/¾ oz/1 heaped tbsp icing (confectioners') sugar

PREHEAT THE OVEN to 275°F/140°C/Gas Mark 1. Put the cream and orange rind (peel) into a small saucepan and slowly bring to the boil. Remove from the heat and set aside to infuse for 30 minutes.

Meanwhile, place the chocolate, milk and orange liqueur in a small saucepan over a very low heat until the chocolate melts. Beat the egg yolks and sugar together, then stir in the melted chocolate mixture and strain in the infused cream. Stir until evenly combined.

Pour into 6 chocolate pots or small ramekins and place in a roasting tin (pan). Pour in enough boiling water to reach half the way up the sides of the pots. Bake for 50–60 minutes until the tops are spongy and feel just firm to the touch.

Remove from the oven and leave to cool completely. Chill for several hours before serving.

Tarte aux Mirabelles et à la Crème Chantilly ⓥ
Greengage Tart with Crème Chantilly

Greengages grew throughout the Seine valley, where traditionally they
were used for tart fillings; these tarts were often served at the restaurant
Fournaise where Renoir painted *Le déjeuner des canotiers*
(*The Luncheon of the Boating Party, 1881*).

SERVES 6

FOR THE *PÂTE SUCRÉE*
100g/4 oz/¾ cup plain (all-purpose) flour
pinch of salt
60g/2½ oz/5 tbsp unsalted butter, diced
1 tbsp caster (superfine) sugar
1 egg yolk

FOR THE FILLING
550g/1¼ lb greengages or plums, halved and stoned (pitted)
25g/1 oz/¼ cup dried breadcrumbs

25g/1 oz/⅓ cup (finely) ground (blanched) almonds
25g/1 oz/2 tbsp soft brown sugar
1 tsp ground mixed spice (apple pie spice)
25g/1 oz/2 tbsp unsalted butter

FOR THE *CRÈME CHANTILLY*
150ml/5 fl oz/⅔ cup double (heavy) cream
15g/½ oz/1 tbsp icing (confectioners') sugar
¼ tsp vanilla seeds from pod (bean)
2 tbsp crushed ice

Make the pâte sucrée: sift the flour and salt into a bowl, then rub in the butter until the mixture resembles fine breadcrumbs. Stir in the sugar and then work in the egg yolk and 1–2 tablespoons cold water to form a soft pastry (dough). Knead lightly, wrap in cling film (plastic wrap) and chill for 30 minutes.

Roll out the pâte sucrée on a lightly floured surface and use to line a 23cm/9 in fluted tart tin (pan). Prick the base and chill for a further 20 minutes.

Preheat the oven to 200°C/400°F/Gas Mark 6 and place a baking sheet on the middle shelf.

Line the pastry case with baking paper and baking beans and bake for 10–12 minutes, then remove the paper and beans and bake for a further 10–12 minutes until lightly golden.

Prepare the filling: place the greengages, cut side down, in the baked pâte sucrée case. Combine the breadcrumbs, almonds, sugar and spice and scatter over the greengages, then dot with butter. Bake for 30–35 minutes until golden and the plums feel soft to the touch. Remove from the oven and leave to cool on a wire rack.

Meanwhile, prepare the *crème Chantilly*: place the cream, sugar and vanilla seeds in a chilled bowl and whisk by hand with a balloon whisk until just starting to thicken. Add the crushed ice and continue to whisk until soft peaks form. Cover and chill until required.

Serve the tart warm with the *crème Chantilly*.

FROMAGE BLANC AUX FRAISES DES BOIS FAÇON FONTAINEBLEAU Ⓥ

HOME-MADE FONTAINEBLEAU CHEESE WITH WILD STRAWBERRIES

Fontainebleau is famous for its delightful soft cheese, which is sweetened and eaten as a dessert. It was served wrapped in muslin at a buffet prepared by Toulouse-Lautrec at the opening of a gallery belonging to the art dealer Samuel Bing.

SERVES 4

300ml/10 fl oz/1¼ cups double (heavy) cream
1 vanilla pod (bean), split
50ml/2 fl oz/¼ cup whole milk
15g/½ oz/1 tbsp caster (superfine) sugar

TO SERVE
175g/6 oz wild strawberries
extra caster (superfine) sugar

PLACE THE CREAM in a plastic bowl and scrape the vanilla seeds into the cream. Cover with cling film (plastic wrap) and refrigerate for 4–5 days until the cream acquires a rich, creamy flavour but doesn't start to sour.

Return the cream to room temperature, then strain through a fine sieve (strainer) into a clean bowl and sprinkle over the sugar. Gradually whisk the cream, adding the milk a little at a time as the cream starts to thicken. As soon as it holds its shape, spoon it into individual glasses.

Sprinkle a few strawberries over the top and dust with a little extra sugar. Serve at once.

PITHIVIERS Ⓥ

ALMOND PUFF PASTRY CAKE

A classic almond puff pastry cake from the south-eastern region of the Île de France, between Fontainebleau and Orléans.

SERVES 12

450g/1 lb bought puff pastry (dough), thawed if frozen
1 egg yolk
2 tbsp milk

FOR THE ALMOND FILLING
100g/4 oz/1 stick butter, softened
100g/4 oz/½ cup caster (superfine) sugar
3 egg yolks
100g/4 oz/1 cup (finely) ground (blanched) almonds
1–2 drops almond essence (extract)
1 tbsp rum

PREHEAT THE OVEN to 220°C/425°F/Gas Mark 7. Make the filling: beat the butter and sugar together until soft and pale, then add the egg yolks, one at a time. Beat in the almonds, almond essence (extract) and rum until evenly combined.

Divide the pastry (dough) in half and roll out both pieces into a 25cm/10 in square. Place one piece on a large baking sheet, spoon the almond filling into the centre and use a palette knife (metal spatula) to spread it out into a 20cm/8 in circle.

Brush around the filling with a little water and place the second square of pastry on top, pressing down around the filling to seal together. Use a plate, or a large tart ring, as a guide and cut through the pastry to form a 23cm/9 in pie. Knock up and scallop the edges of the pie.

Beat the egg yolk and milk together and brush over the pie. Use the tip of a sharp knife to score a curved spoke pattern over the top of the pie, working from the centre outwards. Bake for 25–30 minutes until the pastry is puffed up and golden. Leave to cool on a wire rack and serve warm.

Opposite: ALMOND PUFF PASTRY CAKE

IV
BRITTANY
RICH RURAL HARVESTS

'What a shame we didn't come to Brittany before, the hotel
costs only sixty-five francs a month, full board. I can feel
myself putting on weight as I eat. . . .'

PAUL GAUGUIN to his wife, METTE, 1886

EDOUARD MANET: LEMON
Opposite: SEAFOOD PLATTER (*see page 136*)

BRITTANY HAS A SPECIAL RESONANCE for a number of the Impressionist painters. Monet found fresh inspiration in the wild and sombre, storm-tossed rock landscapes of Belle-Ile-sur-Mer during his two-and-a-half-month stay in 1886. There, in all weathers, he painted enthusiastically on canvases which had to be roped down against the wind. In the evenings he retired to a small fishermen's inn in a tiny hamlet where he feasted on *cotriade*, the local variety of *bouillabaisse*, a rich steaming fish stew which, depending on what the day's catch had thrown up, could include up to a dozen different types of local fish. He ate lobster so often he almost became weary of the treat.

Berthe Morisot spent a number of productive summers in Brittany visiting her sister, Edma, who had married a naval officer. Paul Signac discovered Saint-Briac in 1885, as did Renoir the following year. Renoir became so fond of Brittany that he spent family holidays in Pornic and Noirmoutier, on the southern Atlantic coast, where he taught his small son,

Pierre, to swim. 'I've found a nice quiet spot where I can proceed with my work very comfortably,' he wrote to his dealer Durand-Ruel, adding, 'I am very happy.'

Renoir had held on to his bachelor status for ten years after meeting Aline Charigot, not marrying her until 1890 when he was 49 and she 28. If such a long delay suggests doubts, they were completely swept away by the reality of marriage and family life, which Renoir adored. She was a perfect choice for him: 'a grape-grower's daughter' who lived to look after Renoir and 'knew how to bleed a chicken, wipe a baby's bottom and clip the vines'. She loved to travel and would particularly have enjoyed the distinctive Breton cuisine, with its unmistakable tang of the sea.

The vast granite peninsula, with its two thousand miles of jagged and dramatic coastline, juts out into the waters of the Atlantic ocean, providing a rich harvest of shore-based shellfish – succulent oysters from Concarneau, Cancale and the Morbihan; gleaming mussels; spider crabs; tiny, dark, smooth-shelled sea snails; whelks; palourdes; scallops; tiny shrimps; luscious langoustines; and, of course, lobsters. There is also abundant fresh fish – sleek sole, iridescent mackerel, silver sardines, mullet and bass. The smell, if not the sight, of the ocean pervades even the central farming country where, in the Impressionists' time, the fields were fertilized with seaweed and produced some of the finest potatoes, cabbages, cauliflowers, artichokes, tiny green peas, baby turnips, string beans and strawberries. The region is justly famed for its hearty rustic food: pâté and pies, gigantic earthenware dishes of *rillettes de porc, andouillettes*, fine salt-meadow mutton, pungent-flavoured partridge and hare, ducks and turkeys and, of course, the famous buckwheat crêpes, rolled around a savoury filling of eggs, ham or cheese, or simply served with sugar and lemon, jam or honey and washed down with strong local cider.

Of all the Impressionists, it is Gauguin who is most strongly associated with the romantic scenery and primitive life of Brittany. The time he spent in the small artists' colony at Pont-Aven and further east along the coast at Pouldu has become woven into the myth of the province along with the old Celtic legends. He first arrived in 1886 – a dark, handsome, heavy-lidded, thirty-eight-year-old father of five, in retreat from responsibility and the increasing urbanization and commercialization of the city. He wanted to throw off the artificiality of Paris and get back to a life lived close to its origins. Brittany was cheap and, with its ancient costumes and culture, had a timelessness which struck a chord in him. The blue and green harmonies of the peaceful estuary, the racing river, the rocky streams and the savage coast all appealed to him.

Pont-Aven's popularity with writers and artists dated back to the 1860s, when a group of American art students from Philadelphia, having arrived in Paris hoping to study at the École des Beaux-Arts and found it temporarily closed to foreigners, moved on, at the enthusiastic suggestion of one of their party, to Pont-Aven. They settled in the Hôtel des Voyageurs, where the speciality was an *omelette au rhum*, which was brought into the dining-room on a flaming plate, much to their delight. By the mid-1870s there were around sixty painters based in Pont-Aven and the number of hotels had swelled to three – the Lion d'Or and the Pension Gloanec

PAUL GAUGUIN: STILL LIFE WITH ORANGES

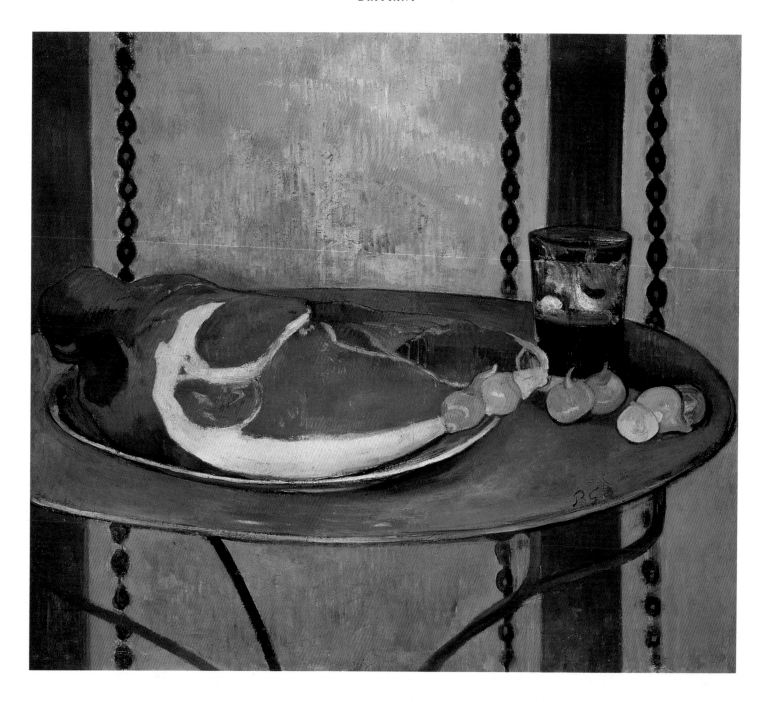

PAUL GAUGUIN: THE HAM

A photograph of the Pension Gloanec in Pont Aven with Paul Gauguin in the foreground.

joining the Voyageurs. One contemporary travel writer commented whimsically on the 'curious noise of the flickering of paint-brushes on canvases' that could be heard about the place.

Despite this influx, Pont-Aven was still relatively unspoiled when Gauguin first arrived in 1886. Then, the journey from Paris to the south side of the Brittany peninsula involved a long and tortuous train ride to the medieval city of Quimperlé, followed by a nine-mile jolt in a horse-drawn mail cart. Alighting at the picturesque hamlet, summarized by one contemporary as '*quinze maisons et quatorze moulins*' (fifteen houses and fourteen windmills), on the evening of Saturday, 28 June 1886, Gauguin was warmly welcomed by Marie-Jeanne Gloanec, the owner of a family-run *pension*. Beaming broadly, Marie-Jeanne and her maids – the attractive Louise and the plain Marie le Pape – in their crisp white aprons and collars and the pointed head-dresses of Breton women, ushered the weary traveller straight into the dining-room and revived him with food and drink – sardines straight from the sea, fried lightly in butter and garlic, and washed down with cool cider made from the local apples. No wonder Gauguin was so fulsome in his praise:

'I love Brittany,' he wrote: 'Here I've found the primitive wilderness. When my wooden shoes echo on the granite earth, I hear the dull and mighty muted sounds which I seek in my canvases.'

The Pension Gloanec was a substantial stone building in the Breton style, painted white with black surrounds to the wide central door and the windows. Sturdy wooden tables were ranged on the pavement outside, and there the artists could sit, beneath a large painting of Pont-Aven which hung above the door, drinking the strong country wine or local cider and smoking their pipes while discussing their revolutionary new ideas about pure colour, 'sensation' and technique. 'Don't copy too much from nature,' Gauguin told his young friend Émile Schuffenecker. 'Art is an abstraction, derive it from nature by dreaming in the presence of nature; think more about creation than the result.'

After the coldness he had encountered in Paris, the generosity and kindly good nature of Marie-Jeanne Gloanec were deeply comforting. She was a substantial upright figure, in her starched apron, who ensured that her maids kept the place

Randolph Caldecott made this drawing of artists sitting outside the Pension Gloanec in 1879. On the other side of the town square can be seen the rival Hôtel des Voyageurs.

spotless and who served up heartening soups and big meaty seafish. Gauguin was charmed by the warmth of his welcome and the good and plentiful quality of the food. Thanks to her willingness to extend credit, Marie-Jeanne's establishment was more popular with artists than her rivals – the slightly more expensive Hôtel des Voyageurs and Hôtel du Lion d'Or – and Gauguin found himself far from lonely in the Pension Gloanec. He flourished in the company of younger artists and the tranquil atmosphere of the place. There was no shortage of subjects to paint, and his work at this time is vibrant, joyful and full of seductive charm capturing the rugged beauty of the hillsides, cottages and lonely lighthouses in canvases of startling originality and furious colour. On wet days he used the table settings in the dining-room of the *pension* as subjects for paintings like *Nature morte, fête Gloanec* (Still-life, Fête Gloanec), and *Nature morte aux cerises* (Still-life with Cherries), which shows a table showered in a rich buttery light, on which a simple china bowl of cherries is set out beside a cream jug and a decanter of light red wine. Marie-Jeanne's high standards are reflected in the ironed creases of the white table-cloth.

Gauguin entered into the life of the people, and Marie le Pape recalled the late evenings that he and his friends spent at the Kervastor farm near the Pension Gloanec. There, the farm's owner would regale them with tales of Celtic myth and legend while the hungry artists stuffed themselves with grilled chestnuts and buckwheat cakes and lingered over mugs of apple brandy.

When Pont-Aven became a victim of its own success, 'full of abominable people' as Gauguin put it (by which he meant genteel ladies on sketching holidays and other tourists), he and his followers fled further up the coast. The little village of Pouldu has been called Gauguin's 'French Tahiti', and there is something wild and primitive about the scenery and the isolated inn facing the sea, backed by fields, where Gauguin chose to stay.

'For dramatic strangeness, that was a wonder of a place,' recalled the Scottish painter, Archibald Standish Hartrick, who met Gauguin at Pont-Aven and Pouldu. 'Imagine a country of gigantic sand dunes, like the mountainous waves of a solid sea between which appeared glimpses of the Bay of Biscay and the Atlantic rollers. All this, peopled by a savage-looking race, who

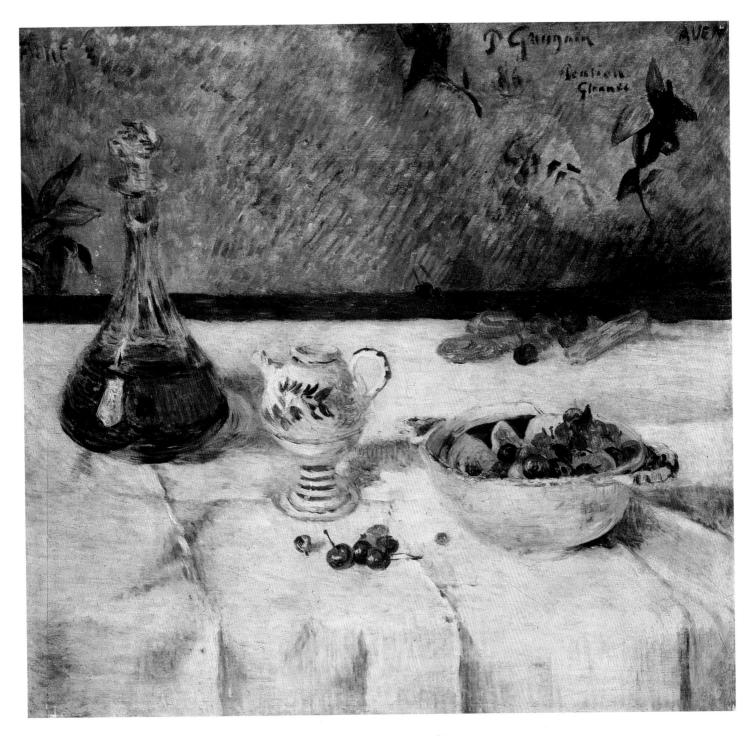

PAUL GAUGUIN: STILL LIFE WITH CHERRIES

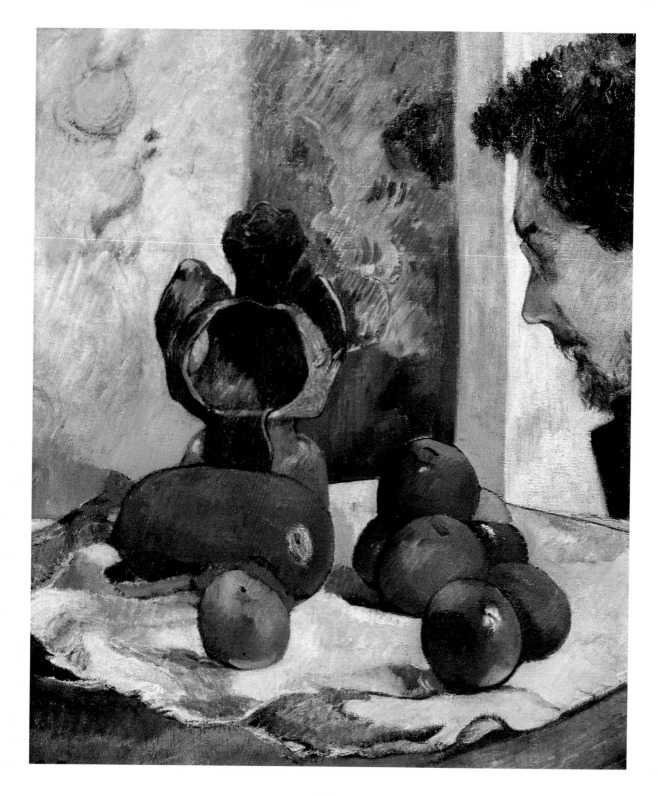

seemed to do nothing but search for driftwood, or to collect seaweed, with strange sledges drawn by shaggy ponies; and with women in black dresses, who wore the great black "coif".'

Buvette de la Plage, on the Great Sands beach, was run by a young woman called Marie Henry. The inn consisted of one large room on the ground floor, separated by a passage from the bar where the men who collected cartloads of sand from the shore gathered at the end of the day to drink with the fishermen. A converted lean-to attached to the bar served as a kitchen, and on the second floor there were three bedrooms for guests and another small room for the landlady herself.

The writer André Gide was a guest at the same time and describes the atmosphere of the place:

The village, called Pouldu, consisted of four houses, two of which were inns; the least imposing took my fancy and I entered quite thirsty. A servant girl showed me into a white-washed room and left me there with a glass of cider. The room's sparse furnishings made the numerous canvases on its walls all the more noticeable . . . I contemplated them with growing amazement. It seemed to me that they were only infantile daubings, but in such lively, unusual and joyful tones that I couldn't possibly think of leaving.

As Gide sat, transfixed by the canvases, Sérusier, Filiger and Gauguin arrived, barefoot, 'superbly untidy' and singing opera at the top of their lungs.

The inn became the group's headquarters. Marie Henry was an amiable hostess with a soft spot for painters. Émile Jourdan called her 'a real mother for artists'. She was nicknamed 'Marie Poupée' (Marie the Doll) because of her beauty, and had a child by Jacob Meyer de Haan, who collaborated with Gauguin on the vast mural that filled one wall of the dining-room. Soon all the walls of her inn were covered with paintings by the Pont-Aven School. And when they ran out of walls they moved on to the ceilings. Gauguin painted a motif of geese and onions on the dining-room ceiling in 1889. Not a surface was spared: doors, chimney-pieces, even the glass in the windows, which they painted with imitations of dazzling stained glass.

It was at Pouldu and in the deep shady forests and wild beauty of the Brittany countryside that Gauguin found peace. It was primitive and yet exotic. The villagers spoke Breton, not French, and wore a distinctive regional costume which varied from town to town. He and his followers steeped themselves in the ancient Celtic culture of the villagers – gaining their trust first through the children, whose open curiosity and good nature soon led to them sharing their hearth-baked crêpes with the colourful crowd of rowdy painters. The children's ready acceptance melted the resistance of their parents, and the artists – who employed the local people as models at 40 centimes a day for a man, 30 for a woman and one centime for a child – were invited to participate in weddings and other local festivities, at which Gauguin played his accordion. He cut a striking figure, dressed like a Breton fisherman in old canvas trousers and a blue jersey with a beret worn jauntily on the side of his head, his wooden sabots painted vermilion and cobalt and ornamented with carvings and dark lines. As he played, the Breton girls danced to his tunes, their huge skirts

'I have found quite a large, clean room with a fisherman who has a small inn and has agreed to provide my meals for only four francs a day. I expect I will live on nothing but fish, lobster especially.'

Letter from CLAUDE MONET to ALICE HOSCHEDÉ,
September 1886

billowing around them and their plain wooden sabots clattering merrily on the cobbles.

It was not all play. The artists rose early, breakfasted on *café au lait* and bread and butter, before going out to work in the countryside with their easels, brushes and paints, or sketchbooks, depending on the light. They returned to the inn around eleven-thirty for lunch at noon and then resumed their work until the light faded at about five o'clock. Dinner was at seven, and they would go to bed early, around ten, after a game of lotto or checkers.

Gauguin made his final visit to Pont-Aven in 1894, in the exotic company of Annah, his adolescent Javanese mistress, and her pet monkey and parakeet. By now the place had changed beyond recognition. Marie-Jeanne Gloanec had bought the Lion d'Or, and all three original hotels had expanded their premises. There was a new establishment, the Hôtel de Bretagne, on the main square and Paul Signac, who was there in the same year, wrote in dismay: 'Yesterday I was at Pont-Aven. It's a ridiculous countryside with little nooks and cascades, as if made for female English water-colourists . . . everywhere painters in velvet garments, drunk and bawdy.'

Marie-Jeanne's welcome was as warm as ever, but this last visit ended on a sour note. Gauguin had always brought out her maternal side and she proved her devotion by providing him and Annah with the best of everything. The villagers, however, were less impressed by his haughty mistress, and an incident which started with some jeering children developed into a rowdy fight which left Gauguin lame. It was the end of France for him. The local doctor bungled the setting of his broken ankle, and when he finally returned to Paris it was to find that the ungrateful Annah had ransacked his studio.

Renoir, too, visited Pont-Aven, staying at the Hôtel des Voyageurs, which was now known as the Hôtel Julia after the proprietor, Julia Guillou, to whom Renoir made a present of a watercolour which hung in the dining-room for twenty years.

Renoir enjoyed Pont-Aven so much that he returned for a family holiday the following year, writing to his friend Dr Paul Gachet: 'I am at Pont-Aven with the family. I tried Normandy, mushroom country, but had to get away; I was bored to death in that humid area.' He made one last trip in 1895, staying this time at Tréboul, close to the port of Douarnenez, famous for its sardine fishing, but by now the warm bright colours of the south beckoned and eventually, following his natural inclinations, he moved to Cagnes-sur-Mer in the South.

In 1886 Monet spent two and a half months in Brittany in Belle-Île-sur-Mer. In that time, and often in extraordinarily unfavourable weather, he produced 39 canvases – rock, sky and seascapes without a trace of human life, austere, stormy and isolated, reflecting in large part the style of his life and self-imposed isolation at the time. During the time he was away from his friends and family he wrote daily to Alice Hoschedé, describing not just the effects of the ocean – 'It's extraordinary to see the sea. What a sight! It's so out of control it makes you wonder if it will ever be calm again' – but also his daily life on the isolated island, a haven for the fleets of fishing boats attracted by the great schools of sardines. He found lodgings in

PAUL SIGNAC: THE BREAKFAST

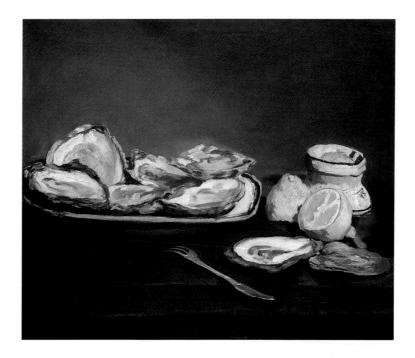

EDOUARD MANET: OYSTERS

a small inn run by a fisherman called Père Marec in the hamlet of Kervilahouen, which consisted of less than a dozen houses.

The island was so isolated and open to furious gales and violent storms that both the butcher and the baker paid only weekly visits, though Monet was able to persuade his host to vary his fish diet: 'I am getting used to my modest way of life,' he wrote on 24 September. 'Indeed, my landlord and landlady are doing their best to please me and I am eating a bit better. They have gotten in bread and meat and fruit too and I'm eating fruit at every meal.'

He wasn't totally without friends. Octave Mirbeau came out to visit him in October and, as the weather was particularly bad, they lingered over a 'real feast' of 'pancakes, which, upon my word, were delicious,' although Monet adds, almost wearily, 'Of course we had to have lobster with it.' Despite having to battle against wind and rain and hail so violent that 'at times I was afraid it would make holes in my canvases', his work was going well and his hosts, no doubt inspired by the appetite and gratitude of their illustrious guest, excelled themselves. On 21 October he wrote:

My landlord and landlady are really nice and I am completely happy here, eating all the things I like; but as you can imagine, I am enjoying all the fish. At the moment they are catching a lot of mackerel and mullet, and tomorrow I am going to have porpoise.

As autumn deepened, the game season opened and woodcock were added to the menu, together with the mushrooms Mirbeau truffled out for him. It was the kind of simple, rustic life which harked back to his days as a young painter, tramping the fields of Normandy with Bazille, or striding along the forest paths at Fontainebleau, and carried with it the exhilarating feeling of freedom Monet especially cherished. He loved spending his days painting until the light faded; the evenings lingering over dinner listening to the talk of the fishermen. When he finally left Kervilahouen 'and its good people' by boat on 24 November, it was 'with much regret'. The weather was, for once, perfect: 'It was superb,' he wrote to Alice, 'I've never seen such a beautiful sunset. It was like sailing on a sea of madder. It was wonderful.'

Soupe à la Laitue et aux Fines Herbes Ⓥ
Lettuce and Herb Soup

SERVES 4

40g/1½ oz/3 tbsp butter
2 leeks, trimmed, chopped and rinsed
2 fresh garlic cloves, chopped
1 tsp each chopped fresh thyme, rosemary and sage
50g/2 oz/1 cup mixed chopped fresh herbs, including basil, chervil, chives,
dill, mint, parsley and tarragon
450g/1 lb lettuce leaves, shredded, including escarole, batavia (a
crisphead lettuce), rocket (arugula), etc.
900ml/1½ pints/3¾ cups vegetable or chicken stock
juice of ½ lemon
salt and pepper

MELT THE BUTTER in a large saucepan. Add the leeks, garlic, thyme, rosemary and sage and sauté over a low heat for 10 minutes. Add the remaining herbs and the lettuce and stir well.

Pour in the stock and bring to the boil, then lower the heat and simmer for 10 minutes. Transfer to a blender or food processor and purée until the soup is smooth. Return to the pan, add the lemon juice and seasoning to taste and reheat gently. Serve hot or allow to cool and serve chilled.

Coquilles Saint-Jacques à la Bretonne
Scallops with Butter and Breadcrumbs

A Breton classic that uses its simplicity to delight. If possible, cook and serve the scallops in their shells, which your fishmonger should be able to supply. Alternatively, use individual gratin dishes.

SERVES 4

12 large scallops
100g/4 oz/1 stick butter, melted
1 small garlic clove, crushed
1 small shallot, very finely chopped
1 tbsp chopped fresh parsley
25g/1 oz/¼ cup dried breadcrumbs
salt and pepper
1 tbsp lemon juice

PREHEAT THE OVEN to 220°C/425°F/Gas Mark 7. Wash the scallops and cut away the tough muscle from the side. Separate the coral from the meat and cut into 1cm/½ in pieces. Dry thoroughly on kitchen paper (paper towels).

Using 4 scallop shells (the deep half) or individual gratin dishes and spoon a little melted butter into the bottom of each. Combine the garlic, shallots, parsley, breadcrumbs and seasoning to taste, then sprinkle a little of the mixture into each shell.

Divide the scallops and corals evenly between the shells and cover with the remaining breadcrumb mixture. Drizzle over the rest of the butter and add a little lemon juice to each one.

Place on a baking sheet and cook for 12–15 minutes until the scallops turn white and are cooked through. Cool slightly before serving.

PLATEAU DE FRUITS DE MER
SEAFOOD PLATTER

You can ask your fishmonger to cook the lobster and langoustine for you, if preferred. Make sure you have some claw crackers and cocktail sticks (toothpicks) handy to crack open and pick out all the meat from the shells.

SERVES 2

1 × 450g/1 lb lobster
12 langoustines
12 mussels
12 palourde clams
6 oysters
1 × 675g/1½ lb cooked crab
100g/4 oz cooked brown shrimps or Atlantic prawns (shrimps)
12 cooked winkles

TO SERVE
crushed ice (optional)
lemon wedges
1 quantity aïoli (see page 168)
1 quantity shallot vinegar (see page 70)
crusty French bread

To COOK THE LOBSTER, bring a very large pan of cold water with 150g/5 oz/¼ cup sea salt for every 4.5 litres/8 pints/5 quarts of water to a rolling boil.

Drop in the lobster and simmer for 15 minutes after the water returns to the boil. Remove from the pan and leave to cool. Using a claw cracker, crack the claws and set aside in a cool place but not the refrigerator.

To cook the langoustines, drop them into the same water that you cooked the lobster in. Simmer the langoustines for 2 minutes after the water returns to the boil. Remove from the pan and leave to cool.

To cook the mussels and clams, scrub them to remove any dirt or barnacles and pull out the straggly 'beard' that may still be attached to the mussels. Wash in several changes of cold water. Discard any open mussels or clams that do not close when sharply tapped with a knife. Place them with the water on the shells into a large saucepan over medium heat, cover and cook for 3–4 minutes, shaking the pan occasionally, until the shells are just opened. Discard any that remain closed. Strain through a colander placed over a bowl to catch the juice; set aside to cool. (If wished, reserve the cooking liquid for another recipe by freezing it after it has cooled.)

To prepare the oysters, hold the oysters in a towel and insert an oyster knife between the top and bottom shells where they are hinged, twisting until the shells open; be careful not to lose any of the delicious juices.

Ask your fishmonger to crack open the body cavity of the crab for you. Discard the grey 'hairy' fingers from the body of the crab and place back in the shell.

All the seafood is now ready to assemble. Use a large platter or shallow dish and fill with a deep layer of lightly crushed ice. On top of the ice arrange all the shellfish and crustaceans, garnishing with some lemon wedges. Serve accompanied with the *aïoli*, the *shallot vinegar* and some crusty French bread.

PALOURDES FARCIES
STUFFED CLAMS

For this recipe you need the French *palourde* or the American quahog clams. If they aren't available, use mussels or oysters. This recipe is inspired by Alan Davidson in his book *North Atlantic Seafood*.

SERVES 4

40 large clams or mussels (see Introduction)
25g/1 oz/2 tbsp butter
4 large spring onions (scallions), trimmed and finely chopped
1 garlic clove, crushed
150ml/5 fl oz/⅔ cup double (heavy) cream
25g/1 oz/¼ cup Gruyère cheese, finely grated
salt and pepper
25g/1 oz/½ cup fresh breadcrumbs

SCRUB THE CLAMS and rinse in several changes of cold water. Discard any open clams that do not close when tapped with a knife. Place in a large saucepan with just the water on their shells, cover and cook over a medium heat for 3–4 minutes, shaking the pan, until all the shells have opened. Discard any that remain closed. Strain the liquid through a fine sieve (strainer) into a clean pan, then bring to the boil and reduce over a high heat until only 2 tablespoons remain.

Reserve the clams on the half shell, discard the other half; invert the clams onto kitchen paper (paper towel) to drain.

Melt the butter in a saucepan. Add the spring onions (scallions) and garlic and fry gently for 5 minutes. Add the cream and reduced clam liquid and simmer for 1 minute. Remove from the heat and stir in the cheese, then season to taste; set aside to cool.

Preheat the grill (broiler). Transfer the clams to 4 individual gratin dishes, right side up. Spoon a little of the sauce into each one and sprinkle over the breadcrumbs. Grill (broil) for 1–2 minutes until bubbling and golden. Serve at once.

FRICASSÉE DE HOMARD
LOBSTER STEW

SERVES 2

2 × 450g/1 lb live lobster
25g/1 oz/2 tbsp butter
2 tbsp olive oil
4 shallots, finely chopped 1 garlic clove, crushed
4 large ripe tomatoes, peeled, seeded and diced
2 tbsp cognac
85ml/3 fl oz/6 tbsp dry vermouth or white wine
pinch of saffron strands infused in 2 tbsp boiling water
300ml/10 fl oz/1¼ cups fish stock
1 tbsp chopped fresh herbs, such as chervil, chives, dill and parsley
salt and pepper
crusty French bread, to serve

BRING a very large pan of salted water (see page 136) to a rolling boil. Drop in the lobster and cook for 5 minutes after the water returns to the boil. Immediately remove the lobsters and plunge into cold water to prevent them cooking further.

Separate the claws from the body and crack the shell to reveal the meat. Discard the heads and legs and cut the tail section into 4 or 5 pieces; set aside.

Melt the butter with the oil in a deep frying pan (skillet). Add the shallots and garlic and sauté over a low heat for 10 minutes. Increase the heat, add the lobster pieces and fry for a few minutes until the flesh starts to brown, then add the tomatoes and stir well. Pour in the cognac and vermouth or wine and boil rapidly until the liquid is all but evaporated.

Stir in the saffron and its liquid and the fish stock. Bring to a steady simmer, then cover and simmer for 8 minutes. Using a slotted spoon remove the lobster pieces to a warmed serving dish; set aside. Boil the liquid for about 2 minutes, until it is reduced and thickened slightly. Stir in the herbs and season with salt and pepper. Return the lobster pieces to the pan and heat through. Serve at once with crusty French bread.

COTRIADE
BRITTANY SEAFOOD STEW

Monet spent several months in Brittany staying at a small fishermen's inn, where he enjoyed the freshly made bouillabaisse known locally as *cotriade*, derived from the word *côte*, meaning coast.

SERVES 4

FOR THE STOCK
2 carrots, chopped
1 onion, chopped
2 celery sticks (ribs), chopped
1 head fennel, chopped
2 garlic cloves, peeled but left whole
2 bay leaves
4 sprigs fresh parsley
4 sprigs fresh thyme
6 white peppercorns
1 tsp sea salt
600ml/1 pint/2½ cups dry white wine

450g/1 lb mussels, scrubbed (see page 136)
225g/8 oz potatoes, peeled and cut into 2.5cm/1 in cubes
1 small head fennel, trimmed and diced
2 tbsp Pernod
675g/1½ lb mixed fish, such as huss, hake, mackerel, herring, grey mullet, scaled, cleaned and cut into large chunks
50g/2 oz/½ cup crème fraîche
50g/2 oz/4 tbsp unsalted butter, diced
4 tbsp chopped fresh chervil
salt and pepper

MAKE THE STOCK: place all the ingredients in a large saucepan with 600ml/1 pint/2½ cups cold water. Bring to the boil, then lower the heat and simmer for 30 minutes. Strain the liquid into a clean pan, pressing down on the vegetables to extract all the juices and flavours.

Meanwhile, rinse the mussels. Discard any open ones that do not close when tapped with a knife. Place in a saucepan with just the water on the shells, cover and cook for 4–5 minutes, shaking the pan occasionally, until the shells open. Discard any that remain closed. Strain the liquid through a fine sieve (strainer) and add to the stock.

Add the potatoes, fennel and Pernod to the stock, cover and simmer for 20–25 minutes until just tender. Add the fish and simmer for a further 8–10 minutes until cooked, adding the mussels for the final minute to heat through. Use a slotted spoon to transfer the fish, mussels and vegetables to a warmed plate. Cover loosely with foil and keep warm in a low oven.

Return the poaching liquid to the boil and stir in the crème fraîche, then simmer for 5 minutes to reduce slightly and thicken. Lower the heat and whisk in the butter, a little by little, then add the chervil. Season to taste and return the fish and vegetables to the pan. Heat gently and serve.

Opposite: BRITTANY SEAFOOD STEW

TRANCHES DE SAUMON GRILLÉS ET TOMATES RÔTIES

GRILLED SALMON STEAKS WITH ROASTED VINE TOMATOES

SERVES 4

4 × 175g/6 oz wild salmon steaks, rinsed and dried
4 tbsp olive oil
grated rind (peel) and juice of ½ lemon
4 sprigs fresh thyme, bruised
1 garlic clove, crushed
½ tsp fennel seeds, lightly crushed
salt and pepper

FOR THE TOMATOES
450g/1 lb small tomatoes on the vine
8 whole garlic cloves, peeled but left whole
2 shallots, sliced
4 tbsp olive oil
1 tsp sugar
2 tbsp balsamic or sherry vinegar
fresh dill sprigs and flowers, to garnish
green salad and crusty bread, to serve

PREHEAT THE OVEN to 220°C/425°F/Gas Mark 7. Place the salmon steaks in a shallow non-metallic dish. Mix together the oil, lemon rind (peel) and juice, thyme, garlic, fennel seeds and a little salt and pepper. Pour over the salmon and set aside to marinate until required.

Meanwhile, cook the tomatoes. You can leave the tomatoes on the vine or separate. Place the tomatoes closely together in a roasting tin (pan). Combine all the remaining ingredients, except the vinegar, and pour over the tomatoes.

Roast for 20 minutes until they are soft and tinged with brown. Reduce the oven to a low setting, add the vinegar to the tomatoes, cover with foil and keep warm while grilling (broiling) the steaks.

Preheat the grill (broiler). Remove the steaks from the marinade and transfer to a rack set over the grill pan. Grill the steaks, basting from time to time with the marinade, for 2–3 minutes on each side until brown and cooked through.

Transfer the steaks to warmed plates, and top with the roasted tomatoes and all their delicious juices. Garnish with the fresh dill sprigs and flowers. Serve at once with a simple green salad and some crusty bread.

Opposite: GRILLED SALMON STEAKS WITH ROASTED VINE TOMATOES

Loup de Mer au Beurre Blanc
Grilled (Broiled) Sea Bass with Butter Sauce

SERVES 4

1 sea bass, about 1.5kg/3 lb, scaled, cleaned, rinsed and patted dry
lemon juice
a little olive oil
salt and pepper

FOR THE BEURRE BLANC
2 shallots, finely chopped
2 tbsp white wine vinegar
4 tbsp dry white wine
2 tbsp double (heavy) cream
175g/6 oz/1½ sticks unsalted butter, diced
salt and pepper

PREHEAT THE GRILL (BROILER). Season the sea bass's stomach cavity and squeeze in some lemon juice. Brush the fish all over with oil and place on a foil-lined grill pan.

Transfer the fish to the grill and grill (broil) for about 10 minutes on each side until lightly charred and cooked through.

Meanwhile, make the *beurre blanc*: put all the ingredients, except the cream, butter and seasoning, in a small saucepan with 6 tablespoons water and boil rapidly until only about 1 tablespoon of liquid remains. Lower the heat, bring to a simmer and stir in the cream. With the liquid just simmering, whisk in the butter, a little at a time, making sure it has melted before adding more, until the sauce is thick and glossy. Season to taste.

Serve the fish on a warmed platter with the *beurre blanc* in a separate bowl.

Sardines Grillées
Fresh Grilled (Broiled) Sardines

SERVES 4

20 small fresh sardines
50g/2 oz/1 cup chopped fresh herbs, including parsley, chives, mint, basil and savory or thyme
1 large garlic clove, chopped
1 tbsp capers in brine, drained
1 tbsp lemon juice

1 tsp Dijon mustard
100g/4 oz/1 stick butter, softened
pepper

TO GARNISH
lemon wedges fresh herb sprigs

PREPARE THE BARBECUE or preheat the grill (broiler) to high. Rinse the sardines and then carefully cut along the belly and scrape out the insides. Rinse again and pat dry inside and out. Season the stomach cavity with a little salt and pepper.

Place all the remaining ingredients in a blender or food processor and blend until smooth and bright green. Carefully spread a little of the butter over and inside each fish.

Transfer the sardines to the hot barbecue or place on a rack over the grill pan. Cook for 2-3 minutes on each side until they are crisp, charred and cooked through. Transfer to warmed plates and top with the remaining butter.

Garnish with lemon wedges and fresh herbs and serve at once.

CANETON RÔTI AUX PETITS POIS
ROAST DUCK WITH PEAS

Nantes was famous for both the main ingredients of this dish: duck and
peas. Monet was particularly partial to Nantes ducks and reared them at
his Giverny home in Normandy.

SERVES 4

sea salt
1 × 1.75kg/4 lb duck with giblets, rinsed and dried
2 tbsp vegetable oil
225g/8 oz baby onions
100g/4 oz piece smoked bacon (smoked slab bacon), diced
4 garlic cloves, peeled but left whole
1 tbsp chopped fresh thyme
450g/1 lb fresh podded peas

FOR THE STOCK
1 onion, chopped
1 carrot, chopped
2 sticks (ribs) celery, sliced
1 bouquet garni (see page 38)
150ml/5 fl oz/⅔ cup red wine

RUB A GOOD HANDFUL OF SEA SALT all over the duck and truss;
set aside for 1 hour.

Meanwhile, prepare the stock: put the giblets and all the stock
ingredients into a saucepan with 600ml/1 pint/2½ cups water.
Bring to the boil and skim the surface, then lower the heat, cover
and simmer for 30 minutes. Strain and reserve the liquid.

Preheat the oven to 180°C/350°F/Gas Mark 4. Heat the oil in a
heavy-based flameproof casserole until smoking. Add the duck
and fry over a medium heat, turning occasionally, for 20 min-
utes until all the fat is released and the bird is brown on all sides.
Carefully remove the duck and set aside.

Drain off all but 3 tablespoons of the fat. Add the onions,
bacon and garlic to the casserole and fry gently for 10 minutes,
stirring frequently. Add the thyme and return the duck to the pan.
Pour in the stock, cover and cook in the oven for 30 minutes.

Remove the casserole from the oven and very carefully strain
off and reserve all but a few tablespoons of the pan juices; set
aside. Return the duck to the oven and roast, uncovered, for a
further 1¼ hours until the bird is cooked through. Remove the
duck, cover with foil and keep warm while cooking the peas and
finishing the gravy.

Meanwhile, bring a pan of lightly salted water to the boil, add
the peas and boil for 10 minutes, then drain and refresh under
cold water; set aside.

Skim off as much of the fat from the reserved pan juices as
possible. Return the juices to the casserole with the peas and
bring to the boil. Lower the heat and simmer for 10–15 minutes
until the peas are cooked and the gravy thickens. Spoon around
the duck and serve.

AGNEAU AUX NAVETS ET ARTICHAUTS

LAMB WITH TURNIPS AND ARTICHOKES

The salt meadows of Brittany are famous for their fabulous lamb,
known as *pré-salé*, the lamb that is traditionally used in this delicious
spring vegetable and lamb stew.

SERVES 4

4 tbsp vegetable oil
1kg/2 lb shoulder lamb, boned and cut into large chunks
350g/12 oz baby onions, halved if large
2 garlic cloves, chopped
1 tbsp chopped fresh rosemary
2 tbsp seasoned flour
600ml/1 pint/2½ cups lamb or chicken stock
85ml/3 fl oz/6 tbsp dry white wine
2 tbsp tomato purée (paste)
1 tbsp sugar
12 baby turnips, peeled
8 new potatoes, scrubbed
2 bunches baby carrots, peeled
100g/4 oz/1 cup fresh shelled peas
1 × 400g/14 oz can artichoke bases or hearts
2 tbsp chopped fresh parsley
salt and pepper

HEAT HALF THE OIL in a flameproof casserole. Add the lamb in batches and fry over a high heat for 5–6 minutes until it is brown on all sides; remove with a slotted spoon and set aside.

Add the remaining oil to the pan. Add the onions, garlic and rosemary and fry over a low heat for 10 minutes until golden. Return the lamb to the pan and sprinkle over the flour and stir well. Gradually add the stock, stirring constantly, until slightly thickened. Add the wine, tomato purée (paste) and sugar and bring to the boil. Lower the heat, cover and simmer gently for 1 hour.

Add the turnips, potatoes, carrots and peas and simmer for a further 20 minutes. Add the artichoke bases and parsley and cook for a final 10 minutes until the lamb and vegetables are tender. Taste for seasoning and serve straight from the casserole.

Opposite: LAMB WITH TURNIPS AND ARTICHOKES

RÔTI DE PORC À LA MOUTARDE ET AUX POMMES

ROAST LOIN OF PORK WITH MUSTARD AND APPLES

Ask your butcher to chine the pork for you, so that carving the meat is
far easier.

SERVES 6

1 × 1.5kg/3 lb loin of pork, chined, rinsed and dried
4 garlic cloves, sliced
2 tbsp whole-grain mustard
1 tbsp chopped fresh sage
1 tsp sea salt
1 tsp sugar
a little black pepper
2 tbsp olive oil
150ml/5 fl oz/⅔ cup dry wine or cider

FOR THE APPLES
6 russets or other sturdy eating apples
juice of ½ lemon
15g/½ oz/1½ tbsp raisins, soaked for 30 minutes in 2 tbsp cognac
15g/½ oz/3 tbsp dry breadcrumbs
½ tbsp soft brown sugar
¼ tsp ground allspice
pinch of salt
25g/1 oz/2 tbsp butter, diced

PREHEAT THE OVEN to 200°C/400°F/Gas Mark 6. Cut slits all over the pork meat and skin. Insert slivers of garlic into the slits. Mix together the mustard, sage, salt, sugar, pepper and oil, then spread all over the pork. Transfer to a small roasting tin (pan) and add the wine or cider. Roast for 30 minutes.

Meanwhile, prepare the apples: use an apple corer to core the apples, then drizzle with a little lemon juice. Drain the raisins and mix with the breadcrumbs, sugar, allspice and salt. Divide between the apples, pressing down into the hollow centres, then dot over the butter.

Lower the oven temperature to 190°C/375°F/Gas Mark 5. Add the apples to the roasting tin with the pork and continue to roast for a further 45–50 minutes, basting frequently, until the pork is cooked through and the apples are tender. Allow the pork to rest for 10 minutes before carving into chops. Arrange on a large warmed platter, surrounded by the apples. Serve the juices separately.

HARICOTS BLANCS AUX TOMATES Ⓥ
HARICOT BEANS WITH TOMATOES

A warming side dish that provides an ideal partner for roasts and is particularly good with lamb. Cooking times for dried beans depends on how old they are, so they may need longer than the time specified. Use your own judgement, but remember they are best when they just start to fall apart.

SERVES 4

225g/8 oz/1⅓ cups dried haricot beans (or cannellini beans)
1 bouquet garni (see page 38)
1 small onion, peeled, but left whole
3 tbsp olive oil
4 shallots, finely chopped
2 garlic cloves, crushed
2 tsp chopped fresh thyme
1 tsp chopped fresh sage
675g/1½ lb very ripe tomatoes, peeled and roughly chopped
1 tsp sugar
salt and pepper
2 tbsp chopped fresh basil

SOAK THE DRIED BEANS overnight in cold water to cover. The next day, drain and rinse them, then place them in a large saucepan with the bouquet garni and onion. Pour in enough cold water to cover the beans by at least 10cm/4 in, bring to a rolling boil and boil for 10 minutes. Lower the heat, partially cover the pan and simmer for a further 40–45 minutes, or until the beans are tender.

Meanwhile, heat the oil in a frying pan (skillet). Add the shallots, garlic and herbs and sauté for 5 minutes until soft and lightly golden. Stir in the tomatoes and sugar, cover and stew for 10 minutes; set aside.

Strain the cooked beans, discarding the bouquet garni and onion, but reserve 100ml/3½ fl oz/½ cup of the cooking liquid. Add the beans to the tomato sauce, along with the reserved stock and bring to the boil. Lower the heat and simmer for 10 minutes. Season to taste. Stir in the basil and serve at once.

GALETTE DE POMME DE TERRES Ⓥ
POTATO CAKE

There are several different types of potato cakes cooked in Brittany, but this one is similar to a potato rösti, and I regard it as the best. It can be made with the addition of other vegetables as well, such as celeriac (celery root) or parsnip. You can grate the potatoes if preferred, but squeeze out the excess water before frying.

SERVES 4

1kg/2 lb waxy potatoes
2 garlic cloves, crushed
1 small onion, very thinly sliced
2 tbsp chopped fresh herbs, including sage, thyme, rosemary and chervil
salt and pepper
4 tbsp olive oil

PEEL THE POTATOES and cut into thin slices, then cut the slices into thin sticks, as if you were making pommes frites (see page 79). Pat dry on kitchen paper (paper towels). Place in a large bowl and add the garlic, onion, herbs and plenty of seasoning.

Heat the oil in a deep, non-stick frying pan (skillet). Spoon in the potato mixture and press to flatten to the sides of the pan. Cook over a high heat for 5 minutes, then lower the heat, cover and cook for 20 minutes until the potatoes are very tender.

Very carefully slide the cake out on to a plate and then flip it back into the pan. Cook over a medium heat for a further 5 minutes to brown the second side. Transfer to a warmed plate and cut into wedges to serve.

POTÉE DE LÉGUMES ⓥ
MIXED VEGETABLE STEW

SERVES 4

50g/2 oz/4 tbsp butter
4 shallots, finely chopped
1 garlic clove, crushed
2 tsp chopped fresh savory or thyme
grated rind (peel) of 1 lemon
150ml/5 fl oz/⅔ cup vegetable stock
225g/8 oz/1½ cups fresh shelled peas
175g/6 oz French beans (thin green beans), trimmed and halved
2 Little Gem lettuces, trimmed and quartered
4 tbsp chopped fresh herbs, including chervil, chives, mint and parsley
pepper

MELT HALF THE BUTTER in a large, deep frying pan (skillet). Add the shallots, garlic, savory or thyme and lemon rind (peel) and sauté for 10 minutes until soft and golden. Add the stock and peas and bring to the boil. Lower the heat, cover and simmer for 10 minutes.

Add the beans and lettuces to the pan and simmer for a further 10 minutes until all the vegetables are tender.

Stir in the remaining butter, then add the herbs and pepper. Transfer to a warmed dish and serve at once.

PERCE-NEIGE AU BEURRE ⓥ
SAMPHIRE WITH BUTTER

Samphire, also known as marsh samphire or sea asparagus, grows wild along the salt marshes of the Brittany coast. If samphire is hard to find, you could substitute asparagus for this recipe.

SERVES 4

450g/1 lb samphire or asparagus
25g/1 oz/2 tbsp butter
juice of ½ lemon
salt and pepper

RINSE THE SAMPHIRE, if using, and place in a large bowl. Cover with plenty of cold water and leave to soak for several hours, then drain, rinse again and pat dry. If using asparagus, trim and peel the stalks.

Bring a large pan of water to the boil. Add the samphire or asparagus and cook for 3–4 minutes until tender. Drain, shake off excess liquid and transfer to a warmed bowl. Stir in the butter, lemon juice, salt and pepper. Serve this hot with simply grilled fish and a *beurre blanc* sauce (see page 142), if wished.

FROMAGE DE LA TRAPPE
TRAPPIST CHEESE

A group of monks from La Trappe in Normandy were exiled to Switzerland during the French Revolution. They returned to France, to the empty monastery in Entrammes, Brittany, and produced a cheese which they called Port du Salut, or Port Salut (Haven of Safety). Today Trappist monks in Brittany make other cheeses, including Cîteaux, Briquebec (a loaf-shaped Neufchâtel) and Taime. Serve one of these cheeses, thinly sliced, on toasted rye bread.

Opposite: MIXED VEGETABLE STEW

Crêpes Sucrées aux Fraises ⓥ
Sweet Pancakes (Crêpes) with Strawberries

Savoury pancakes (crêpes)
are traditionally made with buckwheat flour in Brittany,
but sweet pancakes use plain (all-purpose) flour
with a little sugar to sweeten them.
This recipe makes 12 pancakes that are folded over sweet,
ripe strawberries and a little *crème Chantilly*
and served warm.

SERVES 6

100g/4 oz/¾ cup plain (all-purpose) flour
pinch of salt
25g/1 oz/2 tbsp caster (superfine) sugar
1 egg, lightly beaten
150ml/5 fl oz/⅔ cup milk
1 tbsp Grand Marnier, Calvados or rum
almond oil or vegetable oil for frying

TO SERVE

1 quantity crème Chantilly *(see page 119)*
450g/1 lb ripe strawberries, hulled

SIFT THE FLOUR AND SALT into a bowl, add the sugar and make a well in the centre. Gradually whisk in the egg, milk, Grand Marnier and 150ml/5 fl oz/⅔ cup water, until the batter is smooth. Leave to rest for 30 minutes.

Heat a crêpe pan or heavy-based 20cm/8 in frying pan (skillet) until hot. Brush over a little oil, add 1–2 tablespoons of the batter, swirling the mixture to the edge of the pan. Cook for about 1½–2 minutes, then use a palette knife (metal spatula) to flip the pancake (crêpe) and cook the second side for about 30 seconds until brown spots appear underneath. Remove to a plate and keep warm in a low oven. Repeat to make 12 pancakes.

To serve, spoon a little *crème Chantilly* into the centre of each pancake and scatter over a few strawberries. Fold the pancake into quarters and serve 2 per person, sprinkled with a little extra sugar, if wished.

Gâteau Breton ⓥ
Traditional Brittany Cake

This is the traditional butter cake made all over Brittany, characterized by the criss-cross pattern on the top. It can also be flavoured with chopped angelica, mixed peel and rum, but this orange-flavoured version is a simple classic.

SERVES 8

275g/9 oz/1¾ cups plain (all-purpose) flour
pinch of salt
175g/6 oz/1¾ cups plus 2 tbsp caster (superfine) sugar
5 egg yolks
175g/6 oz/1½ sticks butter, softened
2 tbsp orange flower water

PREHEAT THE OVEN to 160°C/325°F/Gas Mark 3 and grease and base-line a shallow 20cm/8 in cake tin (pan). Sift the flour and salt into a bowl, then stir in the sugar and make a well in the centre. Reserve 1 tablespoon of egg yolk for the glaze and add the rest to the well with the butter and orange flower water. Gradually work together to form a soft dough.

Transfer to a lightly floured surface and knead the dough (which will be a little sticky, so you may need to wet your hands slightly) until smooth. Press into the base of the prepared tin and smooth the surface with a palette knife (metal spatula). Brush the surface of the cake with the reserved egg yolk and use a sharp knife to make a criss-cross pattern over the top. Bake for 1¼–1½ hours until golden and a skewer inserted into the centre comes out clean; cover with foil if the top starts to become too brown.

Remove from the oven and leave to cool for 10 minutes, then turn out on to a wire rack to cool completely. Serve cut in wedges with jam and cream.

TARTE AUX CERISES ET À LA CRÈME ANGLAISE
CHERRY TART WITH CRÈME ANGLAISE

While staying at the *pension* Gloanec, on wet days Gauguin would sit
inside and paint still-lifes. He loved cherries and it was here that he
painted *Nature morte aux cerises (Still-life with Cherries)*.

SERVES 8

1 × quantity pâte sucrée *(see page 119)*
1kg/2 lb red cherries, stoned (pitted), or 350g/12 oz stoned (pitted)
cherries
150ml/5 fl oz/⅔ cup milk
150ml/5 fl oz/⅔ cup double (heavy) cream

1 vanilla pod (bean), split open
3 eggs
100g/4 oz/½ cup caster (superfine) sugar
3 tbsp plain (all-purpose) flour

ROLL OUT THE PREPARED PÂTE SUCRÉE and use to line a deep
23cm/9 in fluted tart tin (pan). Prick the base with a fork
and chill for 20 minutes. Preheat the oven to 200°C/400°F/Gas
Mark 6 and place a baking sheet on the middle shelf.

Line the pâte sucrée case with baking paper and beans and
transfer to the heated sheet. Bake for 12 minutes, then remove
the paper and beans and bake for a further 10–12 minutes until
crisp and golden.

Arrange the cherries over the base of the tart case. Make the
crème anglaise: put the milk, cream and vanilla pod (bean) in a
saucepan and heat gently until just boiling. Remove from the
heat and leave to infuse for 10 minutes, then remove the vanilla
pod.

Beat together the eggs and sugar until pale and frothy, then
beat in the flour and then stir in the milk and cream mixture
until evenly combined.

Pour the crème anglaise over the cherries. Bake for 20 min-
utes, then lower the oven to 160°C/325°F/Gas Mark 3 and bake
for a further 30–35 minutes until firm. Leave to cool on a wire
rack and serve warm.

V
PROVENCE
IN SEARCH OF IMPRESSIONS

'When you were born there, nothing else has any meaning.'
PAUL CÉZANNE

VINCENT VAN GOGH: STILL LIFE: BLUE ENAMEL COFFEE POT, EARTHENWARE AND FRUIT
Opposite: SALAD NIÇOISE (*see page 186*)

ROVENCE, WITH ITS POWERFUL LANDSCAPE, dazzling, clear light and strong, luminous colours, was a source of inspiration to many Impressionist painters. When van Gogh arrived in Arles in 1888, his canvases exploded with light, and the dull, muddy palette of his Dutch days was never seen again. The raw beauty of the countryside captured him entirely and, he worked feverishly, producing scores of canvases, all glowing with the airy grace of sunlight. He cherished a dream of setting up an artists' community in the South and persuaded Paul Gauguin to join him in the Yellow House at Arles, but the experiment ended disastrously.

Renoir, too, fell under the spell of the South. He loved the rosy light and lived and painted at the coastal village of L'Estaque before moving permanently to Cagnes-sur-Mer, just west of Nice, where he spent the final dozen years of his long life. Monet painted in the South from time to time – in 1881 he and his family stayed at the Hôtel Richemont in Nice – but

increasingly he found all the inspiration he needed in his garden at home in Giverny. For Paul Signac a small unknown fishing village called Saint-Tropez provided a haven, while Berthe Morisot found inspiration and the fulfilment of a long-standing dream in November 1888 when she rented a spacious villa with a garden at Cimiez, just outside Nice, for the winter. The vast garden of the green-and-white Villa Ratti was filled with fig, orange, aloe and olive trees, which reflected the light 'in a spectacular way' and, in a brimmingly happy letter to her sister Edma, Morisot attributed the glowing health of her family to their habit of lunching outdoors each day on 'bella sardina'.

Three Impressionist painters were natives of the South: Frédéric Bazille, who died tragically young in the Franco-Prussian war of 1870, was born in Montpellier; Paul Cézanne in Aix-en-Provence; and Henri de Toulouse-Lautrec in Albi. When Toulouse-Lautrec, heir to one of the oldest French families, was born on 24 November 1864, the baptismal feast lasted a week. 'The Toulouse stomach' was famous for miles around and vast quantities of food were prepared in the big kitchens of his parents' house, the old Hôtel du Bosc, and consumed by family and guests who came from all over the Midi to feast on deer and pheasant, salmon and trout, jellied eel, pâté de foie gras, and rare cheeses sent from Paris.

Of the three painters, the most powerful southern stamp is found in the work of Cézanne. The small pink and peach houses, the sun-bleached, gently sloping terracotta roofs, the steep terraced slopes of rich, red earth, the orange and lemon trees and ancient olive orchards were so much a part of Cézanne that whenever he tried to live and paint in the northern light of Paris he found that 'the sun dragged me back'.

As a boy he and his friends, Émile Zola, Baptistin Baille and Paul Alexis, embarked on 'mad treks across the countryside'. They roamed through the olive groves and lay on warm, stony hillsides, fragrant with thyme, mint, marjoram and the ticklish fronds of fennel. Zola recalled how they 'needed plenty of air' as they searched 'for hidden paths at the bottom of ravines'.

The boys fished and swam in cool rivers and dried off in the hot sun while eating their portable lunch of pan bagnat – a round bun cut in half, soaked in olive oil and filled with tomatoes, green pepper, anchovies, black olives, and slices of onion, hardboiled egg and crisp radishes – prepared by Mme Cézanne, who was an excellent cook. But then Provence produces fine cooks. The raw materials are so close to hand, so abundant, so insistent that truly splendid meals can be produced from even the simplest kitchen. And by the youngest cooks. Paul Alexis described how the young friends, out on an ineffectual hunting trip, prepared their midday meal: 'We cooked lunch out in the open. Baille lit a wood fire and hung the leg of lamb, seasoned with garlic, from a string above it. Zola turned it as it cooked while Cézanne dressed the salad in a damp towel. After lunch we took a siesta and then set off once more, our shotguns over our shoulders, ready for the big hunt.' The boys were more competent cooks than hunters, however, and ended the day, having caught nothing, reading their books under the trees while around them sheep grazed placidly on the wild herbs that give such a succulent and distinctive flavour to Provençal lamb.

Paul Cézanne: Still Life with Basket

PIERRE-AUGUSTE RENOIR: MEDITERRANEAN FRUITS WITH AUBERGINE

'I am becoming more and more rustic, and I realize a little late that winter is the really good time: the fire in the large fireplaces never gives you a headache, the blaze is cheerful, and the wooden sabots keep you from being afraid of cold feet, not to mention the chestnuts and potatoes cooked under the ashes, and the light wine of the Côte d'Or.'

RENOIR to EUGENE MANET, 29 December 1888

The beauty of the countryside, the warmth, the heady scent of wild herbs and Mediterranean pines all lend themselves to outdoor eating and a great many Provençal specialities have a picnic air about them. As well as *pan bagnat*, the region is famous for its small pizza *tartelettes*, filled with a mixture of onion and garlic, tomatoes, sugar and fresh herbs, softened gently in oil and criss-crossed with anchovy fillets. Superbly fresh sardines can be wrapped in vine leaves and barbecued over a simple wood fire. And there's always an abundance of fruit – apples, peaches, apricots, grapes and succulent sweet oranges, or figs and small cream cheeses, very slightly salted – to complete the meal.

We can imagine the painters breaking off for a simple meal of black olives, a few fine tomatoes, some *saucisson d'Arles* and a fresh, crisp, golden *pain long*, followed by a slice of water melon and a handful of little green figs baked by the sun, or sitting down to a ratatouille made with the ripest red tomatoes, smooth-skinned aubergines, courgettes, onions and freshly harvested garlic combined with thick, fragrant olive oil in an earthenware pot over a wood-burning stove.

Provence is deservedly famous for its Mediterranean fish dishes, especially *bourride, brandade* and bouillabaisse. Gustave Caillebotte once complained that, despite having a professional cook, the bouillabaisse made at his house never tasted as good as that at Renoir's. . . . 'And I have a real cook too,' he complained. 'All that Renoir asks of a cook is that she have a "skin that takes the light"!'

In December 1883 Monet took the train south with Renoir. Renoir later described to his son, Jean, how the first-class pas-sengers did their best to look bored or preoccupied as the two painters, taking their seats among them with their umbrellas and paintboxes, appeared like 'coal-men who had accidentally wandered into a fashion show'. They tried second class, but that was even more unpleasant, 'for the affectation of the pas-sengers was all the worse because they could not afford to travel first class.' So they ended up among the gregarious and generously provisioned passengers travelling third, who shared their meals with the lean and hungry painters, feeding them up on 'Provençal pot roast and Burgundy cheesecake' washed down with young Côte d'Or wines or fruity rosés from the banks of the Rhône. Renoir recalled how 'after a mouthful or so, one ample farm woman could not stand it any longer, and, begging our pardon, undid her underthings and asked the woman beside her to unlace the back of her corset'. Naturally this delighted Renoir, who was a man who liked to see ample acres of liberated female flesh, and pleased the woman, who was now able to tuck into her meal properly – 'and the pâté of hare finally tasted as good as it ought'.

While painting with Cézanne at L'Estaque, Renoir fell ill and Cézanne took him back to Jas de Bouffan, his family home, where he could convalesce under the benevolent care of his mother. Renoir's letters home are filled with ecstatic accounts of the meals he was served. In a letter dated 2 March 1882 to his friend Victor Choquet he wrote: 'Mme Cézanne made a brandade of cod for my lunch and I think I have rediscovered the ambrosia of the gods. One should eat it and die.' And later in conversation with the dealer, Ambroise Vollard, he recalled: 'The excellent fennel soups Cézanne's mother made for us!

I can still hear her giving me the recipe as though it were yesterday: "Take a branch of fennel, a small spoonful of olive oil. . . ." She was a fine woman!'

Renoir was so enchanted by Jas de Bouffan's high-ceilinged rooms and huge fireplaces that he stayed on in Provence, renting a house from Cézanne's brother-in-law, Montbriand, for several months. During this time the two painters drew closer than they had ever been in Paris. The lively, intelligent, fun-loving Renoir discerned a sensitive, kindly man beneath Cézanne's rough exterior. And, like Pissarro, he recognized Cézanne's genius. 'How is it,' he mused, 'that whenever he puts two strokes of paint on a canvas they are always very good?'

Cézanne's unerring skill on canvas was matched by his mother's in the kitchen. There were vineyards, olive trees and orchards attached to Jas de Bouffan, as well as an extensive vegetable garden which meant that Mme Cézanne had a fresh supply of some of the very best produce immediately to hand. She put them all to expert use in the good, simple country cooking that her wealthy, though prudent, husband preferred, serving rich, aromatic casseroles; bouillabaisse fragrant with saffron and garlic; or a roast leg of lamb studded with fat juicy cloves of garlic.

Cézanne's relationship with his father – a successful banker – was fraught and difficult. He kept from his father the fact that he had had a child by a young model, Hortense Figuet, and, even though he was by now a man of forty, he tucked his 'secret family' away in a flat on Rue de Rome in Marseilles and continued to spend long periods at Jas de Bouffan, where the arrangements suited him admirably. There he had a huge studio and could use the gardener and some of the farm labourers – who posed for *The Card Players* – as models.

Cézanne finally married Hortense after the death of his father, but, as she preferred to live in Paris, they were often apart and his old age was increasingly lonely and isolated. His surly exterior masked a painful shyness and his moods alternated between exuberance and despair. He was only happy in his studio at Jas de Bouffan and in the countryside around Aix. There, away from the bustle of the towns and inquiring stares, he could concentrate on his work. One theme obsessed him: his beloved Mont-Sainte-Victoire. Cézanne would set out at dawn, with his materials on his back, and not return until evening, exhausted; or he might spend the night in Rosa Berne's modest inn at Le Tholonet, sleeping in the attic to save money. Rosa Berne also ran the local shop and was an excellent cook, providing hearty rustic meals of truffle or mushroom omelettes and duck with olives, served with local white wine. Occasionally Cézanne might be accompanied by a friend – the younger painter, Émile Bernard, or the sculptor Philippe Solari – for he developed a particular affinity with the young, encouraging them in their work and occasionally inviting them to Sunday lunch in the smaller house in Aix that he bought after the death of his mother. Here he was looked after by a housekeeper, Mme Brémond, who served exquisite little pâtés bought from the local patisserie, and her own home-made chicken fricassé with olives and mushrooms.

It has been said of Cézanne that he had the heart of a child and was easily moved. He could be 'as carefree as a truant schoolboy' in the company of Solari on his way to Mont-

PAUL CÉZANNE: STILL LIFE WITH ONIONS

PAUL CÉZANNE: APPLES AND ORANGES

Cézanne tried to persuade Pissarro to come south to Aix
more than once, writing from L'Estaque in July of 1876:

'I imagine that the country where I am would suit marvellously
. . . The sun here is so tremendous that it seems to me as if the
objects were silhouetted not only in black and white, but in
blue, red, brown and violet . . . How happy our gentle
landscapists of Auvers would be here.'

Sainte-Victoire, and his young friend Joachim Gasquet, the poet, described how on one of their walks, in April 1896, he cried out with childish delight: 'This is the first time I've seen the spring!'

Once when Edmond Jaloux was lunching with the Gasquets, Cézanne entered unannounced and sat down at the table. At that moment a ray of light fell on a plate of peaches and apricots. 'Look!' he cried, with a gesture of delight, 'how tenderly the sun loves those apricots! It envelopes them all, illuminating them from all sides. But see how mean it is with the peaches and how it only lights up one side of them!'

The still-life had a special significance for Cézanne and he loved to paint the fruit that was, for him, as much a part of nature's magnificent beauty as the trees and hillsides of Provence. These apparently simple studies were in fact the result of long deliberation and intricate arrangement. One friend, watching Cézanne painstakingly arranging a group of apples, pears and cherries, came to the conclusion that he was preparing 'a feast for his eye'.

Despite the considerable inheritance from his father, Cézanne went on living as though he were poor, renting modest flats, eating simply and dressing shabbily. In his youth, he had often spent the night on a bench in the waste land round the Jardin du Luxembourg, placing his shoes under his head as a pillow for fear that a tramp might steal them while he slept. Now in his old age and with a large income, he was not averse to sleeping in the attic of the Restaurant Berne and sometimes even in a barn. He would only sit down to one of Rosa Berne's generously proportioned meals if he had Solari or Bernard with

him, otherwise he preferred to eat a simple meal of bread, cheese and nuts, outside the small cottage he had rented to store his materials in the Bibémus quarry.

When his diabetes made the walk to Mont-Sainte-Victoire painful, he would go by carriage, and Gasquet remembered the kindness and concern he extended to the coachman. One afternoon 'the sun was beating down; we were half-way up a steep slope and the horse and driver, exhausted, had fallen asleep. Cézanne sat in the full sun, without a word, without moving, so as not to disturb them, and waited for them to wake up, innocently rubbing his eyes so that it should appear that it was he who had fallen asleep.'

Depressed about the alarming progress of his diabetes, he wrote to Émile Bernard: 'I am old and ill, and I have promised myself that I will die at my easel.' On 15 October 1906 he set out to paint in the open as usual, but a storm blew up and he worked on, soaked through, until he finally collapsed on the side of a road. He was eventually discovered, in a coma, by the driver of a passing laundry cart and carried home to Rue Boulegon. A doctor was called but pneumonia had set in and Cézanne died a week later on 22 October.

'It's not a bad place, the south.'

Vincent van Gogh to his brother, Theo, mid August 1888,
Arles

On a wintry Sunday in February 1888 Vincent van Gogh left Paris for Provence. A troubled man at the best of times, winter

The restaurant Carrel where Vincent van Gogh first lived on arriving in Arles. It was destroyed by bombing during the Second World War.

always reduced him to his lowest ebb, but the radiant light and vivid colours of Provence's sky and scenery revived him and inspired some of his finest work. He found himself lodgings at the Hôtel-Restaurant Carrel – no more than a hostel – and then took a stroll, ending up in a café from which he painted the *charcuterie* shop opposite. With a spontaneity and eagerness that characterized his paintings of this period, he dispensed with preliminary pencil or charcoal sketches, drawing freely with his brush the shop front, a section of pavement and a passer-by, all in the frame of the café window.

Money was always a source of anxiety for van Gogh. His brother, Theo, an art dealer in Paris, sent him a monthly allowance, but he would rather spend money on paint than food, and towards the end of the month his diet would consist of bread and cheese. In his letters to Theo he talked of 'devouring' landscapes or being 'permanently drunk on orchards'. The almond trees which had been in leaf when he arrived had burst into blush-pink blossom, and were quickly followed by the intoxicating creamy white and soft subtle pinks of the cherry, peach, apricot, pear, apple and plum. By 20 April he had com-

pleted ten paintings and was still working furiously. 'There is nothing else I can do,' he told his brother, 'I must strike while the iron is hot. I shall be completely exhausted after the orchards.' He was, however, living erratically again, overspending his budget to buy more paints and canvases and going short on food. Despite suffering 'sick turns' he existed for four days on 43 cups of coffee and crusts of bread. At the end of May he consolidated his position, renting the right wing of a narrow two-storeyed house on Place Lamartine. The outside was painted yellow – the Yellow House of his paintings – and the inside white-washed. The rent was only 15 francs a month, as the lavatory was in an adjacent hotel, and he began to see the house in visionary terms 'as the studio and storehouse for the whole campaign, as long as it lasts in the south'. While the work went on in the Yellow House, Vincent took his meals at the Café de la Gare, run by the Ginoux family, and slept at the Café de l'Alcazar – the famous 'Night Café' of the painting to come, which Vincent, in a letter to his brother, described prophetically as 'a place where one can ruin oneself, go mad, or commit a crime'. .

VINCENT VAN GOGH: INTERIOR OF A RESTAURANT

Opposite:

Vincent van Gogh: Café Terrace on the Place du Forum, Arles

He visited the coast at Saintes-Maries-de-la-Mer in June and wrote to Theo to report that the Mediterranean, which he was seeing for the first time, had 'the colouring of mackerel', adding, 'you get better fried fish here than on the Seine. Only there is not fish to be had every day, as the fishermen go off to sell it at Marseilles. But when there is some it is frightfully good.'

He was a solitary figure, and his regular letters to Theo were often a substitute for conversation. Intensely communicative in their immediacy, they paint colourful pictures, filled with the detail of his life. In August he described the 'very queer' restaurant he found himself in:

Little tables, of course, with white cloths. And behind this room, in Velásquez grey you can see the old kitchen, as clean as a Dutch kitchen, with a floor of bright red bricks, green vegetables, oak chest, the kitchen range with shining brass things and blue and white tiles, and the big fire a clear orange. . . . In the kitchen, an old woman and a short, fat servant also in grey, black, white. I don't know if I describe it clearly enough to you, but it's here, and its pure Velásquez.

Correspondence did not, however, assuage van Gogh's intense loneliness, and he cherished a dream of founding an artists' community. He had a vision of a shared domestic and artistic life and was eager that Gauguin should come out and join him. Gauguin was eventually persuaded and wrote to his wife from Pont-Aven, 'I'm leaving at the end of the month for Arles, where I will stay a long time, I believe.' He arrived on 23 October 1888, but only stayed at the Yellow House with van Gogh for two months. At first the painters were inseparable and all went well. 'Gauguin is a truly great artist and a truly excellent friend,' van Gogh wrote to his brother.

He was also, much to van Gogh's delight, an admirable cook. A former seaman, Gauguin was practical and resourceful: 'With the aid of a little gas stove, I did the cooking while Vincent, without going very far from the house, did the shopping. Once, however,' he recalled, 'Vincent wanted to make a soup, but I don't know how he mixed it – no doubt like the colours on his paintings – in any event we couldn't eat it.'

Tragically, the dream of cooking, eating and painting together began to turn sour and, on Christmas Eve, came to a traumatic end. They were both volatile and passionate men, and an argument in a café led to van Gogh throwing a glass of absinthe in Gauguin's face and later, in a temporary fit of insanity, cutting off his own left ear with a razor. Gauguin was appalled and quit Arles the following morning, leaving van Gogh to suffer alone. They never spoke to one another again, although another Impressionist, Paul Signac, rallied to van Gogh's aid during this difficult time and helped him to gain access to his studio, which had been closed up by the local gendarmes. Van Gogh wrote to his brother of Signac's kindness, adding: 'I gave him as a keepsake a still-life which had annoyed the good gendarmes of the town of Arles, because it represented two bloaters, and as you know they, the gendarmes, are called that.'

After Vincent's spell in the asylum in Saint-Rémy, Theo van Gogh, following Pissarro's advice, installed his brother in

Auvers-sur-Oise under the care of Dr Paul Gachet. There in a fit of despair he shot himself on 27 July 1890. He died in a small room in the Pension Ravoux two days later with Theo at his side. 'He has found the peace he never found on earth,' Theo wrote to his mother, adding, 'He was such a brother to me.' Both are buried in the cemetery nearby in a double grave, for Theo, distraught after Vincent's death, fell ill and died a few months after his brother.

As a young man, Renoir had been inspired by the bluish green groves of Fontainebleau, but now he felt increasingly drawn to the silvery olive trees of Provence and his trips to the South of France grew longer each year. He decided to settle his family in Cagnes, a thriving village of prosperous peasants whose gentle, unhurried style of life appealed to him greatly. The painter and his family were popular with the locals, who would bring Aline rabbits or thrushes and taught her how to stew them with herbs in the authentic Cagnois style. The local wine, despite its sharp flavour, was excellent and went particularly well with the little silvery sardines, which Renoir pronounced the best in the world.

When they moved out to Les Collettes on the far side of the River Cagne, Aline revived her Saturday night ritual of *pot-au-feu*, for Renoir loved company and complained that the villa was too secluded. She found another way round this too. The house was surrounded by orange and olive trees, through which Cap d'Antibes and the Estérel range could be glimpsed,

and Aline employed young girls to harvest the orange blossom in spring and to help later in the year with the olives in the groves she had carefully restored. Renoir, by now in a wheelchair, loved to watch them spread a vast tarpaulin under the trees and begin knocking the ripe olives down with their long poles. They always sent their olives to the local mill to be crushed, and Renoir would await with impatience the first pressing of the clear, fragrant, straw-coloured oil, which he would sample on a piece of toasted bread, sprinkled with a little salt. 'A feast for the Gods' was his annual verdict.

In countless ways, Aline improved the garden and the house, all in an effort to please Renoir. She planted hundreds of tangerine trees, and a vegetable garden, and supervised the building of a henhouse and the installation of central heating, running water and a telephone in the house. For Renoir was by now crippled with rheumatism and had to grip his brushes with fingers as gnarled and bunched as an old olive branch. Nevertheless he continued to paint, for it was second nature to him. 'He paints as the bird sings, as the sun shines, as buds blossom,' the German art historian, Julius Meier-Graefe, observed. Uncomplainingly, Renoir had himself carried in an armchair to various favourite, light-filled points around Les Collettes – the patch of rose-bushes, the plots full of luxuriant mandarin and orange trees, the grape vines, the cherry-orchard, or the olive trees all in silver – set his easel up and began to paint. His boundless love of life, food, family and friends continued right up to the end, which came for him in 1919 at the age of 78.

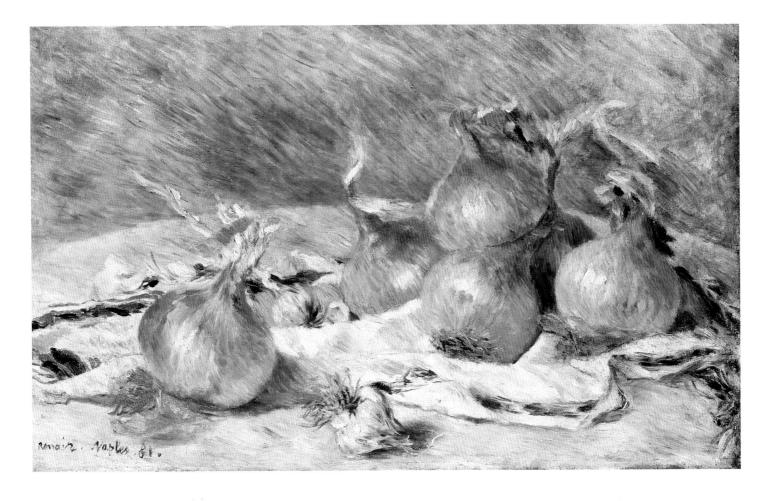

PIERRE-AUGUSTE RENOIR: ONIONS

SÉLECTION DE HORS-D'OEUVRES

MIXED APPETIZERS

A table laden with appetizers is typical of Provence; tapenade was a particular
favourite of Cézanne's, and it was often served at his home in
Jas de Bouffan. One could also serve the *brandade de morue* (see page 172)
and the *artichauts farcis* (see page 170) with the following dishes.

TAPENADE

TAPENADE

SERVES 4

100g/4 oz/1 cup stoned (pitted) black olives
2 garlic cloves, chopped
2 tbsp salted capers, rinsed and drained
2 anchovy fillets in oil, drained and chopped
2 tbsp chopped fresh parsley 1 tsp chopped fresh thyme
4 tbsp extra-virgin olive oil
pepper

PUT ALL THE INGREDIENTS, except the oil and seasoning, in a blender or food processor and blend until a fairly smooth paste forms. Transfer to a bowl, stir in the oil and season to taste; set aside.

AÏOLI Ⓥ

GARLIC MAYONNAISE

SERVES 4

4–6 garlic cloves, crushed
½ tsp sea salt
2 egg yolks
1 tbsp lemon juice
300ml/10 fl oz/1¼ cups French olive oil
salt and pepper

PUT THE GARLIC, SALT, EGG YOLKS AND LEMON JUICE in a blender or food processor and blend for 1 minute until pale and frothy. With the motor running, pour in the oil through the funnel in a steady stream until the sauce is thick and glossy. Season to taste and transfer to a bowl.

OLIVES MARINÉES Ⓥ

MARINATED OLIVES

SERVES 4

225g/8 oz/2 cups mixed small green and black olives
2 garlic cloves, chopped
1 tsp fennel seeds, lightly crushed
2 strips orange rind (peel)

2 strips lemon rind (peel)
4 small dried red chillies
1 tsp chopped fresh thyme
150ml/5 fl oz/⅔ cup extra-virgin olive oil

PLACE ALL THE INGREDIENTS in a bowl or jar, cover and store for up to 1 week. It is best to leave the olives for at least 3 days before eating so that they absorb all the flavours.

SAUCE CHAUDE AVEC SES CRUDITÉS
HOT SAUCE WITH CRUDITÉS

This is another typical Provençal dish, which many people think of as Italian in origin, where it is called *bagna cauda*. The sauce here has been popular in Provence for centuries and is always accompanied by raw vegetables to dip into it while hot. As it is made with large quantities of olive oil, it was very popular with Renoir, who would eagerly await the first pressing of the local oil.

SERVES 6

6 baby artichokes
1 lemon, halved
1 bunch young asparagus
2 small bunches baby carrots
1 bunch radishes
1 bunch baby leeks
1 bunch tomatoes on the vine

a handful of lettuce leaves
French country bread, cut into pieces, to serve

FOR THE SAUCE
25g/1 oz/2 tbsp unsalted butter
1 large garlic clove, crushed
25g/1 oz anchovy fillets in oil, drained and chopped
120ml/4 fl oz/½ cup extra-virgin olive oil

IF THE ARTICHOKES are very young they can be eaten raw; but this is rare, so for slightly older and larger ones follow this method: place in a pan of lightly salted, boiling water to which you have added a halved and squeezed lemon and simmer for 20–25 minutes until tender. Refresh in cold water, then cut in half lengthways and discard any spiky chokes. Rub with a little more lemon juice; set aside.

Trim and rinse the remaining vegetables, blanching the asparagus if they are large. Arrange all the vegetables and lettuce leaves on a large platter.

Prepare the sauce: melt the butter with the garlic in a small saucepan over a low heat, then simmer for 2 minutes until the garlic is soft but not browned. Stir in the anchovies and gradually whisk in the oil. Continue to simmer over a very low heat for 10 minutes, stirring occasionally to prevent the sauce sticking. Serve immediately, either in the pan or transferred to a warmed bowl, with the vegetables and bread to dip.

ARTICHAUTS FARCIS
STUFFED ARTICHOKES

Provence is a haven for many wonderful vegetables, including several
varieties of artichoke, from the large green ones used here, which are
suitable for stuffing, to the tiny purple ones eaten raw in salads. This is
a typical Provençal method of serving them.

SERVES 4

2 lemons, halved 4 globe artichokes
extra olive oil, to serve (optional)

FOR THE STUFFING
150ml/5 fl oz/⅔ cup olive oil
1 red onion, finely chopped 2 garlic cloves, crushed
50g/2 oz smoked bacon (smoked slab bacon), diced
2 ripe beef tomatoes, peeled, seeded and diced
50g/2 oz/1 cup fresh breadcrumbs
2 tbsp chopped fresh parsley 2 tbsp chopped fresh basil
25g/1 oz/½ cup freshly grated Parmesan cheese
salt and pepper

FILL A LARGE BOWL two-thirds full with cold water. Squeeze the juice of 1 lemon into the water, adding the rind (peel). Snap off the artichoke stalks (stems) about 2.5cm/1 in from the base, then trim 2.5cm/1 in off the leaves at the top. Pull off and discard the tough outer leaves and immediately place the artichokes in the acidulated water.

Bring a large saucepan of lightly salted water to the boil. Add the artichokes with the 2 remaining lemon halves and simmer for 20 minutes. Remove the artichokes from the water and invert on to kitchen paper (paper towels) to drain and cool.

Meanwhile, preheat the oven to 180°C/350°F/Gas Mark 4.

Prepare the stuffing: heat 4 tablespoons of the oil in a frying pan (skillet). Add the onion and garlic and sauté for 5 minutes. Add the bacon and sauté over a high heat for 3–4 minutes until starting to turn golden. Stir in the tomatoes and remove from the heat.

Cut the artichokes in half lengthways and scoop out the spiky choke from the centre. Transfer to an ovenproof dish, cut side up, drizzle over a little of the remaining oil, and add 4 table-spoons of water to the base of the dish.

Spoon the tomato mixture over the artichokes. Combine the breadcrumbs, herbs, Parmesan and seasonings together, then sprinkle over the top. Drizzle over the remaining oil, cover and roast for 30 minutes. Remove the cover and continue cooking for a further 25–30 minutes until the breadcrumbs are golden. Keep an eye on the water, adding a little more if necessary.

Remove from the oven and allow to cool to room temperature. Serve drizzled with more oil, if wished.

Opposite: STUFFED ARTICHOKES

BRANDADE DE MORUE
SALT COD PÂTÉ

A rich pâté of salt cod blended while still warm with olive oil, milk,
cream and garlic that has been heated to boiling point.
It is usually served as an *hors d'oeuvres* with bread or vegetables,
and was a favourite of Renoir's,
who is quoted as saying in a letter dated 2 March 1882
to Victor Choquet:
'Mme Cézanne made a brandade of cod for my lunch and
I think I have rediscovered the ambrosia of the gods.
One should eat it and die.'

SERVES 6–8

150g/5 oz salt cod (about 100g/4 oz fresh)
120ml/4 fl oz/½ cup olive oil
50ml/2 fl oz/¼ cup milk
50ml/2 fl oz/¼ cup double (heavy) cream
3 garlic cloves, chopped
lemon juice
black pepper
plenty of crisp, freshly cut French bread, or a selection of
vegetables, to serve

PUT THE SALT COD in a large bowl, cover with plenty of cold water and leave to soak for at least 24 hours in a cool place, changing the water about every 6 hours. Drain the cod, rinse well and pat dry.

Place the cod in a shallow pan, cover with cold water and bring to the boil. Lower the heat and poach gently for about 10 minutes, or until it is cooked through and tender. Drain the fish, pat dry and carefully remove the skin and bones. Place the flesh in a blender or food processor.

Put the olive oil, milk, cream and garlic into a saucepan and heat gently until they just reach the boil. Start blending them with the cod and, with the motor of the blender running, pour in the liquid through the funnel in a steady stream, until the cod becomes a thick creamy purée. Season with lemon juice and black pepper. Serve with some fresh bread or vegetables.

AUBERGINES AUX CHÈVRE Ⓥ
AUBERGINE (EGGPLANT) AND GOAT'S CHEESE

SERVES 4

2 aubergines (eggplants), trimmed
sea salt
1 garlic clove, crushed
1 tbsp balsamic vinegar
8 tbsp olive oil
100g/4 oz fresh goat's cheese

TO SERVE
French bread
Provençal rosé wine

CUT THE AUBERGINES (EGGPLANTS) lengthways into 0.5cm/¼ in thick slices. Sprinkle with sea salt and leave to drain in a colander for 30 minutes. Meanwhile, preheat the grill (broiler). Rinse, drain and pat the aubergines dry. Combine the garlic, vinegar and olive oil in a small bowl and brush over one side of the aubergine slices. Transfer to a foil-lined grill pan and grill (broil) the aubergines for 3–4 minutes until charred. Turn them over, brush with the remaining oil mixture and grill for a further 3–4 minutes.

Leave to cool to room temperature, then scatter over the cheese and serve generously dressed with more olive oil.

Serve all the *hors d'oeuvres* dishes together as one large spread with plenty of sliced bread and a bottle of chilled rosé.

PISSALADIÈRE
NIÇOISE ONION TART

This Niçoise tart got its name from *pissala,* a fish paste that originally was smeared over the cooked onions before it was baked. The base is a yeasted dough similar to a pizza base, but a *pissaladière* can also be made in a shortcrust pastry (piecrust dough) case.

SERVES 4–6

4 tbsp olive oil

1.5kg/3 lb onions, thinly sliced

3 garlic cloves, crushed

1 tbsp chopped fresh sage salt

12 anchovy fillets in oil, drained

24 Niçoise olives 1 tbsp snipped thyme leaves

FOR THE DOUGH

225g/8 oz/1½ cups strong plain (bread) flour

1 tsp fast-acting yeast (quick-rising active dry yeast)

½ tsp salt

1 tbsp olive oil

HEAT THE OIL in a large, heavy-based frying pan (skillet). Add the onions and garlic and fry over a medium heat for 15 minutes. Stir in the sage and a little salt and fry for a further 15–20 minutes until the onions are really soft and golden. Remove from the pan and leave to cool.

Prepare the dough: sift the flour into a bowl, stir in the yeast and salt, make a well in the centre. Gradually work in the oil and 120ml/4 fl oz/½ cup lukewarm water to form a soft dough. Knead on a lightly floured surface for 8–10 minutes until smooth and elastic. Place in a lightly oiled bowl, cover with a towel and leave to rise in a warm place for 1 hour until doubled in size.

Meanwhile, preheat the oven to 230°C/450°F/Gas Mark 8 and place a baking sheet on the top shelf.

Knock back (punch down) the dough and roll out on a lightly floured surface. Use to line a 30cm/12 in tart tin (pan), or roll out into a 30cm/12 in round to bake freeform and prick the base with a fork.

Spread the cooled onion mixture over the base, leaving a border round the edge. Arrange the anchovy fillets over the top, criss-crossing them. Scatter over the olives and thyme leaves and transfer to the heated baking sheet. Bake for 15–20 minutes until the dough is risen and the topping is golden. Leave to cool on a wire rack and serve warm.

SOUPE AU FENOUIL Ⓥ
FENNEL SOUP

A version of this soup was prepared for Renoir by Cézanne's mother, as
he recalled in a conversation with the art dealer Vollard during his stay
at Jas de Bouffan: 'And the excellent fennel soups Cézanne's mother
made for us! I can still hear her giving me the recipe as though it were
yesterday. "Take a branch of fennel, a spoonful of olive oil. . . ."
She was a fine woman!'

SERVES 6

4 tbsp olive oil
1 onion, chopped
2 garlic cloves, chopped
1 tsp fennel seeds, ground
2 heads fennel, thinly sliced crossways
450g/1 lb ripe tomatoes
900ml/1½ pints/3¾ cups vegetable stock
pinch of sugar
2 tbsp chopped fennel fronds or dill
salt and pepper
6 tbsp extra virgin olive oil, to serve

FOR THE CROÛTES
6 slices crusty French bread
1 garlic clove, peeled

HEAT THE OIL in a large saucepan. Add the onion, garlic and
ground fennel and sauté for 5 minutes. Add the fennel
heads and continue to sauté, stirring occasionally, for a further
10 minutes.

Meanwhile, peel the tomatoes by plunging them in boiling
water for 30 seconds or so to split the skins, then peel these off
and discard. Over a bowl to catch the juices, scoop out and dis-
card the seeds. Dice the flesh and add to the pan with the
tomato juices, stock and sugar and bring to the boil. Lower the
heat, cover and simmer for 20–25 minutes until the fennel is
really tender. Add the fennel fronds. Season to taste, cover and
keep warm.

To make the croûtes, toast the bread on both sides, then rub
all over with the garlic clove.

Spoon the soup into bowls, top with the garlic croûtes and
drizzle over the olive oil. Serve at once.

SOUPE AU PISTOU Ⓥ
VEGETABLE SOUP WITH SAUCE PISTOU

This Provençal soup always contains pasta and olive oil, and Cézanne
wrote to his great friend Émile Zola, 'I am just making a soup of pasta
and olive oil, the kind Lantier liked so much', referring to the character
that Zola created, based on Cézanne, in his novel *Le ventre de Paris*
(*The Fat and the Thin*).

SERVES 8

*100g/4 oz/1 cup dried haricot (or cannellini) beans, soaked overnight
in cold water*
4 tbsp olive oil
1 onion, chopped
1 leek, trimmed, sliced and well rinsed
2 garlic cloves, crushed
2 tsp chopped fresh rosemary
1 large potato, peeled and diced
2 large ripe tomatoes, peeled and chopped
2 bay leaves
2 courgettes (zucchini), diced

100g/4 oz French beans (thin green beans), trimmed and halved
100g/4 oz fresh broad (fava) beans
100g/4 oz/1 cup fresh shelled peas
50g/2 oz spaghettini, broken into short lengths

FOR THE SAUCE PISTOU
85g/3 oz/1½ cups basil leaves
1 garlic clove, crushed
50g/2 oz/1 cup Parmesan cheese, freshly grated, plus extra to serve
120ml/4 fl oz/½ cup extra virgin olive oil
salt and pepper

DRAIN THE SOAKED BEANS and place in a saucepan with 1.75
litres/3 pints/7½ cups cold water and bring to the boil,
skimming the surface. Boil for 10 minutes, then lower the heat,
cover and simmer for 40–45 minutes until the beans are tender.

Meanwhile, heat the oil in a large saucepan. Add the onion,
leek, garlic, rosemary and potato and sauté for 10 minutes. Add
the tomatoes, bay leaves, the beans and their liquid and bring to
the boil, then lower the heat, cover and simmer for about 20
minutes until the potato is tender.

Make the *sauce pistou*: put the basil, garlic and Parmesan
cheese in a blender or food processor and blend until smooth.
Add the oil and blend until amalgamated. Season to taste.

Add the remaining vegetables and spaghettini to the soup and
cook for a further 10 minutes until all the vegetables and pasta
are tender. Season to taste and serve in warmed soup bowls,
topped with a spoonful of the *sauce pistou* and extra Parmesan
cheese.

BOUILLABAISSE ET SA ROUILLE

MEDITERRANEAN FISH SOUP WITH ROUILLE

You could omit the fish heads in this recipe and just use the bones,
but increase the cooking time to 45 minutes to ensure a good
depth of flavour.

SERVES 4

1kg/2 lb mixed fish, including rascasse, wrasse, monkfish and red mullet,
scaled and cleaned
450g/1 lb conger eel
225g/8 oz raw tiger prawns (jumbo shrimp)
6 tbsp olive oil
2 onions, chopped
4 garlic cloves, chopped
1 large head fennel, trimmed and chopped
50ml/2 fl oz/4 tbsp cognac
450g/1 lb/3 cups ripe tomatoes, roughly chopped
2 tbsp tomato purée (paste) or sun-dried tomato paste

2 sprigs fresh thyme 2 bay leaves
¼ tsp saffron strands ¼ tsp cayenne pepper

FOR THE ROUILLE
25g/1 oz day-old bread
1 tbsp red wine vinegar 2 garlic cloves, chopped
1 small red chilli, seeded and chopped
1 egg yolk pinch of salt
250ml/8 fl oz/1 cup French extra virgin olive oil

TO SERVE
4–8 thin slices French bread, toasted freshly grated Parmesan cheese

CUT THE MIXED FISH, conger eel and prawns (shrimp) into large chunks. Heat half the oil in a heavy-based frying pan (skillet). Add the fish in batches and fry over a high heat until brown. Use a slotted spoon to transfer the fish to a large saucepan.

Add the remaining oil to the frying pan. Add the onions, garlic and fennel and fry for 10 minutes until golden. Add the Cognac and boil rapidly until most of the liquid is evaporated. Add to the fish with the remaining ingredients and pour in 1.5 litres/2½ pints/6¼ cups water. Bring slowly to the boil, skimming the surface to remove the scum, then lower the heat, cover and simmer for 30 minutes (see Introduction).

Meanwhile, make the rouille: crumble the bread into a bowl and add the vinegar. Transfer to a blender or food processor, add the remaining ingredients, except the oil, and blend briefly until pale. With the motor running, pour in the oil through the funnel in a steady stream until the sauce is thick; add a little boiling water to the sauce if it is too thick. Season to taste and cover the surface with cling film (plastic wrap); set aside.

Transfer the soup to the washed blender or food processor and blend in batches until fairly smooth. Pass through a fine sieve (strainer) into a clean pan, pressing down to extract all the liquid. Return to the boil, then simmer fast for about 20 minutes until reduced by one-third. Spoon the soup into warmed soup bowls. Spread a little rouille over the toasted bread and sit 1 or 2 slices on each bowl of soup. Sprinkle over a little grated Parmesan cheese and serve.

NOTE: Both wrasse and rascasse (scorpion fish) are traditionally used to make a Provençal fish soup and are rarely used in other dishes. Parrot fish are similar to wrasse and can be substituted. Gurnard or red mullet could replace the rascasse.

Opposite: MEDITERRANEAN FISH SOUP WITH ROUILLE

LOUP DE MER AU GROS SEL
SALT-CRUSTED SEA BASS

This is an amazing way to cook this fabulous fish; a layer of sea salt
moistened with egg whites is pressed over the fish before it is cooked.
Once cooked, the salt crust can be broken to reveal a tender, succulent
fish cooked to perfection beneath.

SERVES 4–6

1 × 1.5kg/3 lb sea bass, scaled and cleaned
1 garlic clove, sliced
2 bay leaves
2 fennel or dill fronds
2 sprigs fresh thyme
2 lemon slices
black pepper
5 egg whites
575g/1¼ lb sea salt

TO SERVE
lemon wedges, to garnish
aïoli (see page 168), (optional)

PREHEAT THE OVEN to 190°C/375°F/Gas Mark 5 and oil an
ovenproof dish that will hold the whole fish. Rinse and dry
the fish inside and out. Fill the stomach cavity with the garlic,
herbs, lemon slices and black pepper, then transfer to the pre-
pared dish.

Lightly whisk the egg whites until frothy, then stir in the sea
salt until evenly combined; the salt should almost be paste-like.

Spread all over the sea bass, pressing well down to coat the fish
completely. Bake for 40 minutes until the salt is uniformly
golden.

Remove from the oven and set aside for 10 minutes. Use a
mallet to crack open and remove the hard sea salt crust. Serve
the fish garnished with lemon wedges and accompanied by some
aïoli, if using.

'I am hard at it, painting with the enthusiasm of a Marseillais eating
bouillabaisse, which won't surprise you when you know that what
I'm at is the painting of some great sunflowers.'

VINCENT VAN GOGH to his brother, THEO, late August 1888, ARLES

Opposite: SALT-CRUSTED SEA BASS

PROVENCE

Le Grand Aïoli
POACHED FISH AND VEGETABLES WITH GARLIC MAYONNAISE

Salt cod is traditionally used in this recipe for poached fish and
vegetables served with Aïoli. Although fresh cod is not a Mediterranean
fish, it is used here as an alternative to salt cod,
which can be difficult to find.

SERVES 4

1.5kg/3 lb whole cod, scaled and cleaned, with head and tail removed
2 bunches baby fennel, trimmed
2 small bunches baby carrots, scrubbed
225g/8 oz new potatoes, scrubbed
225g/8 oz French beans (thin green beans), trimmed
225g/8 oz young asparagus spears
salt and pepper
12 cooked baby artichokes (see page 169), cooled
4 hard-boiled eggs, shelled and quartered
1 quantity aïoli (see page 168)

FOR THE COURT BOUILLON
1.75 litres/3 pints/7½ cups dry white wine
6 tbsp white wine vinegar
4 carrots, chopped
2 onions, chopped
4 sticks (ribs) celery, sliced
4 leeks, trimmed, sliced and well rinsed
4 garlic cloves
4 bay leaves
8 sprigs fresh parsley
8 sprigs fresh thyme
12 white peppercorns
2 tsp sea salt

PREPARE THE COURT BOUILLON: place the wine in a large saucepan with an equal quantity of cold water. Add the rest of the ingredients and bring to the boil. Lower the heat, cover and simmer for 30 minutes. Strain through a fine sieve (strainer) into a clean pan and boil rapidly for about 10 minutes until reduced by one-third. You will need approximately 2.25 litres/ 4 pints/2½ quarts liquid.

Transfer the court bouillon to a fish kettle or a large flame-proof casserole and return to the boil. Add the cod and as soon as the liquid boils, lower the heat and simmer the fish for 5 minutes. Remove the pan from the heat but allow the fish to cool

in the bouillon for 30 minutes. Use a slotted spoon to transfer the cod to a plate and cover loosely with foil; set aside to cool to room temperature.

Return the liquid to the boil. Add the fennel, carrots and potatoes and simmer for 10 minutes. Add the beans and asparagus and simmer for a further 5–6 minutes until all the vegetables are tender. Season to taste. Drain the vegetables and refresh under cold water, then pat dry; set aside to cool.

Carefully peel away and discard the skin from the cod and transfer to a serving plate. Arrange the vegetables, including the artichokes, and egg round the fish. Serve the aïoli separately.

RÔTI DE PORC À LA SAUGE
ROAST PORK WITH SAGE

The anchovy sauce that accompanies the roast pork is very Provençal in
origin and complements the meat well. Check the pork after 1½ hours
by inserting a skewer into the meat; when the juices run clear
the meat is cooked.

SERVES 4

1 × 1.5kg/3 lb piece of pork loin, boned, rolled, rinsed and dried
24 sage leaves
2 tbsp olive oil
salt and pepper
85ml/3 fl oz/6 tbsp dry white wine
2 garlic cloves, crushed
2 bay leaves

FOR THE ANCHOVY SAUCE
25g/1 oz anchovy fillets in oil, drained and chopped
1 tsp grated lemon rind (peel)
1 tbsp lemon juice
2 tbsp chopped fresh parsley

USE A SHARP KNIFE to cut deep slits into the pork's flesh and
into the fat. Carefully insert the sage leaves into the slits,
then rub oil and salt and pepper all over. Place in a flameproof
casserole, add the wine, garlic and bay leaves, cover and mari-
nate overnight.

Preheat the oven to 180°C/350°F/Gas Mark 4. Roast the pork,
uncovered, in the casserole for 1½–2 hours, basting occasion-
ally. Carefully remove the pork, wrap loosely in foil and set aside
to rest while making the sauce.

Transfer the casserole to the hob (range) and skim off the
excess fat from the cooking juices. Stir in the anchovies and
lemon rind (peel) and simmer, mashing them with a wooden
spoon until dissolved. Add the lemon juice and parsley and boil
to reduce slightly. Season to taste and serve separately from the
pork.

DAUBE DE BOEUF À LA PROVENÇALE
PROVENÇAL BEEF STEW

A classic Provençal stew of beef with tomatoes and olives.

SERVES 4

4 tbsp olive oil

1kg/2 lb beef silverside (brisket), rinsed, dried and cut into large cubes

100g/4 oz piece smoked bacon (smoked slab bacon), diced

2 sprigs fresh thyme

1 sprig fresh rosemary

2 garlic cloves, chopped

1 onion, chopped

3 celery sticks (ribs), chopped

2 red peppers, cored, seeded and chopped

2 carrots, chopped

4 ripe tomatoes, chopped

2 strips orange rind (peel)

1 strip lemon rind (peel)

600ml/1 pint/2½ cups red wine

sea salt and pepper

225g/8 oz button mushrooms

12 black olives

FOR THE GARNISH

4 tbsp chopped fresh parsley

4 anchovy fillets in oil, drained and chopped

2 garlic cloves, crushed

PREHEAT THE OVEN to 140°C/300°F/Gas Mark 1. Pour the olive oil into the bottom of a heavy flameproof earthenware dish or casserole. Add the beef and bacon. Push the herbs and garlic down into the meat and arrange the onion, celery, peppers carrots, tomatoes and citrus rinds (peel) on top. Pour over the wine and sprinkle with a little salt and pepper.

Bring slowly to the boil, then lower the heat, cover and transfer to the oven and cook for 3 hours. Check occasionally that the stew is not drying out and add a little extra water if necessary.

After 3 hours, stir in the mushrooms and olives. Return to the oven and cook for a further 1 hour until the stew is thick and the meat literally falls apart to the touch. Season to taste. At this stage the stew is best left to cool and then refrigerated overnight to improve the flavours. Alternatively, transfer straight to the table and scatter over the parsley, anchovies and garlic garnish before serving.

RATATOUILLE Ⓥ

BAKED RATATOUILLE GRATIN

A *tian* is an earthenware dish used in the Mediterranean to bake
vegetables, usually in layers. A ratatouille forms the basis of this dish,
which is then topped with a layer of tomatoes and courgettes (zucchini)
under a Parmesan crust, making it a rich vegetable accompaniment or
vegetarian supper dish.

SERVES 6

6 tbsp olive oil
1 onion, chopped
2 garlic cloves, crushed
2 tsp each of fresh thyme and fresh rosemary, chopped
1 small red (bell) pepper, cored, seeded and diced
1 small yellow (bell) pepper, cored, seeded and diced
1 small courgette (zucchini), diced
1 small aubergine (eggplant), diced
1 × 400g/14 oz can chopped tomatoes
1 tsp sugar 1 bay leaf
salt and pepper

FOR THE TOPPING
6 tbsp olive oil
1 garlic clove
2 large courgettes (zucchini), thinly sliced on the diagonal
450g/1 lb plum tomatoes, sliced
15g/½ oz/¼ cup Parmesan cheese, freshly grated
1 tbsp snipped thyme leaves
1 tbsp snipped rosemary leaves

HEAT 2 TABLESPOONS of the oil in a large saucepan. Add the
onion, garlic and herbs and fry gently for 10 minutes until
soft and lightly golden. Add the peppers and continue to fry for
a further 10 minutes.

Meanwhile, heat the remaining oil in a frying pan (skillet).
Add the courgette (zucchini) and fry for 5 minutes until golden.
Transfer to the saucepan with a slotted spoon. Add a little more
oil if necessary to the frying pan and sauté the aubergine (egg-
plant) over a medium heat for 6–8 minutes until brown. Add to
the saucepan along with the tomatoes, sugar, bay leaf and salt
and pepper. Bring to the boil, then lower the heat, cover and
simmer for 30 minutes.

Preheat the oven to 200°C/400°F/Gas Mark 6 and oil a large
earthenware or ovenproof dish. Mix the oil and garlic for the
topping together.

Transfer the ratatouille mixture to the prepared dish and
spread over the base. Arrange the courgettes and tomatoes
over the top in alternate rows to cover the stewed vegetables
completely. Brush all over with the garlic oil and bake for
40 minutes.

Sprinkle over the Parmesan and snipped herbs. Return to the
oven for a further 20–30 minutes until golden and bubbling.
Allow to cool slightly and serve warm.

GRATIN DE CITROUILLE Ⓥ
PUMPKIN GRATIN

Somehow it seems apt that pumpkin should be included in this chapter
on Provence, as its vibrant orange flesh is so often echoed in the colours
of Cézanne's evocative paintings of his native countryside. This is a
simple dish, both hearty and comforting, and is ideal for the cooler
nights of autumn and winter.

SERVES 6

675g/1½ lb pumpkin, peeled, seeded and cut into bite-size chunks
1 red onion, thinly sliced
2 tbsp extra virgin olive oil
2 garlic cloves, crushed
1 tbsp chopped fresh thyme

FOR THE BÉCHAMEL SAUCE
50g/2 oz/4 tbsp butter
40g/1½ oz/3 tbsp plain (all-purpose) flour

450ml/16 fl oz/1½ cups milk
150ml/5 fl oz/⅔ cup double (heavy) cream
40g/1½ oz/3 tbsp Parmesan cheese, freshly grated
¼ tsp cayenne
salt and pepper

FOR THE TOPPING
25g/1 oz/2 tbsp pine nuts, toasted and finely chopped
15g/½ oz/1 tbsp dried breadcrumbs

PREHEAT THE OVEN to 220°C/425°F/Gas Mark 7. Place the
pumpkin in a 1.75 litre/3 pint/7½ cup ovenproof dish and
scatter over the onion. Combine the oil, garlic and herbs, add to
the pumpkin and toss until well coated. Bake for 30–35 minutes
until the pumpkin is soft and tinged with brown. Lower the
oven temperature to 200°C/400°F/Gas Mark 6.

Meanwhile, make the béchamel sauce: melt the butter in a
saucepan. Add the flour and cook, stirring, for 30 seconds.
Remove from the heat and gradually whisk in the milk and cream
until smooth. Return to the heat and stir constantly until the
sauce is thick and reaches the boil. Lower the heat and simmer
for 2 minutes. Remove from the heat and stir in 25g/1 oz/
2 tbsp of the Parmesan, cayenne and seasoning to taste. Cover the
surface with cling film (plastic wrap) until the pumpkin is tender.

Remove the pumpkin from the oven, pour over the béchamel
sauce and stir until combined. Mix the topping ingredients
together with the remaining Parmesan and sprinkle over the
pumpkin. Return the dish to the oven for 10–15 minutes until
bubbling and golden. Serve immediately.

POMMES DE TERRE À L'HUILE D'OLIVE Ⓥ
POTATOES COOKED WITH OLIVE OIL

This simple potato dish was reputedly a favourite of Cézanne's, who loved olive oil so much that whenever he visited Paris he always took a bottle of oil with him.

SERVES 4

1kg/2 lb small new potatoes, scrubbed
6 tbsp olive oil, plus extra to serve
3 garlic cloves, chopped
4 tbsp chopped fresh parsley
salt and pepper

COOK THE POTATOES in boiling salted water for 10 minutes. Drain and when cool enough to handle, cut in half.

Heat the oil in a large frying pan (skillet). Add the garlic and fry for a few seconds to release the aroma without browning. Remove the garlic with a slotted spoon; set aside.

Add the potatoes to the pan and fry over a medium heat for 5–10 minutes until brown. Return the garlic to the pan, sprinkle over the parsley and add salt and pepper. Stir gently for a few seconds, then transfer to a warmed serving dish. Pour over a generous drizzle of olive oil and serve.

'Your father is coming to eat a duck with me next Sunday. With olives (the duck, of course). If only you could be with us!'

CÉZANNE to his friend ÉMILE SOLARI, 8 September 1897

MESCLUN DE CHÈVRE Ⓥ
SALAD LEAVES WITH GOAT'S CHEESE

Originally all the leaves and herbs in this salad would have been gathered from the hillsides and used to make a delicious wild leaf salad. Today, there is a wide variety of baby leaves readily available, but it's not quite as evocative as gathering them yourself. Many of the wild leaves would have had a bitter edge to them, so use lettuces such as chicory (Belgian endive), rocket (arugula) and escarole for an authentic flavour. Perhaps even a few edible flowers would have found their way into the salad.

SERVES 4

1 head chicory (Belgian endive), trimmed
1 head radicchio, trimmed
1 small escarole or frisée (chicory) lettuce, trimmed
50g/2 oz baby spinach leaves
50g/2 oz rocket (arugula) leaves
4 tbsp chopped fresh herbs, including basil, chervil, chives and parsley
handful of nasturtium flowers and leaves (optional)
100g/4 oz goat's cheese, crumbled

FOR THE DRESSING
1 tbsp red wine vinegar 1 tsp Dijon mustard
pinch of salt black pepper
pinch of sugar
4 tbsp extra virgin olive oil 2 tbsp walnut oil

UNLESS THE SALAD LEAVES are gritty or very dirty, do not wash them; if you do have to wash them, make sure you pat them dry on some kitchen paper (paper towels). Tear the leaves into bite-size pieces and place in a bowl – the bowl must be large enough so that there is plenty of room to toss the leaves. Add the chopped herbs and flowers, if using, and transfer to the table.

In a small bowl, whisk together the vinegar, mustard, salt, pepper and sugar, then gradually whisk in the oils until amalgamated. Drizzle as much as you like over the salad and toss until all the leaves are coated. Sprinkle over the crumbled goat's cheese and serve at once.

SALADE NIÇOISE
SALAD NIÇOISE

SERVES 4

225g/8 oz new potatoes, scrubbed
100g/4 oz French beans (thin green beans)
450g/1 lb ripe plum tomatoes, peeled and quartered
1 red onion, thinly sliced
1 × 200g/7 oz can tuna in olive oil, drained and flaked
25g/1 oz anchovy fillets in oil, drained
25g/1 oz/2 tbsp salted capers, rinsed and dried
50g/2 oz/½ cup Niçoise olives
1 small Cos (Romaine) lettuce, shredded (optional)

FOR THE DRESSING
1 tbsp lemon juice
2 tbsp chopped fresh basil
1 tbsp chopped fresh parsley
2 garlic cloves, crushed
1 tsp sugar 6 tbsp olive oil
salt and pepper

TO GARNISH
2 hard-boiled eggs, shelled and quartered
basil leaves

MAKE THE DRESSING: in a small bowl, combine the lemon juice, herbs, garlic and sugar. Gradually whisk in the oil until combined, then season to taste; set aside.

Put the potatoes in a pan of lightly salted water, bring to the boil and boil for 10–12 minutes until tender. Drain and place in a large bowl. Pour in half the dressing, toss well and leave to cool to room temperature.

Cook the beans in lightly salted boiling water for 2 minutes, then drain and refresh under cold water and pat dry. Add to the potatoes with the remaining ingredients. Stir in the remaining dressing and toss until everything is well coated. Transfer to a large platter and arrange the egg quarters and basil leaves over the top. Serve at once.

PLATEAU DE FROMAGE PROVENÇAL
PROVENÇAL CHEESE BOARD

Provençal cheese is usually made from goat's or ewe's milk, flavoured
with garlic and herbs and sometimes marinated in olive oil.
Fromage frais, a light cream cheese, can be served either topped with
crushed black pepper and drizzled with olive oil, or sweetened with
acacia honey and flavoured with lavender.
Banon, a small cheese made with sheep's milk in the summer and goat's
milk in the winter, is soaked with local *eau de vie de marc* and wrapped
in chestnut leaves to mature for several months.
Arrange a selection of these cheeses and fresh fruit on a wooden board
and pass round some warm French bread.

SORBET ORANGE ET CITRON Ⓥ
ORANGE AND LEMON SORBETS

These light, refreshing sorbets seem perfect for a summer's day in Provence, where the fierce heat can be never-ending.

EACH SORBET SERVES 6–8

FOR THE LEMON ICE
250g/9 oz/1¼ cups caster (superfine) sugar
450ml/16 fl oz/2 cups freshly squeezed lemon juice, strained

FOR THE ORANGE ICE
pared rind (peel) and juice of 2 lemons
85g/3 oz/6 tbsp caster (superfine) sugar
450ml/16 fl oz/2 cups freshly squeezed orange juice, strained

MAKE THE LEMON ICE: place the sugar in a heavy-based saucepan with 450ml/16 fl oz/2 cups water. Heat very gently, without stirring, until the sugar dissolves, then bring to the boil and simmer fast for 3 minutes. Remove from the heat, add the lemon juice and leave to cool completely. Transfer the mixture to a plastic container.

Make the orange ice: place the pared lemon rind (peel) and sugar in a heavy-based saucepan with 175ml/6 fl oz/¾ cup water. Heat gently until the sugar dissolves. Bring to the boil and simmer fast for 3 minutes. Remove from the heat and strain into a plastic container. Add the lemon and orange juices and leave to cool completely.

When both mixtures are cold, place in the freezer. After 2 hours, beat the mixtures at the sides of the containers where ice crystals will have begun to form. Continue to freeze, beating at hourly intervals until frozen. Freeze until required, but allow 20 minutes out of the freezer before serving to soften the sorbet.

TARTE AU CITRON Ⓥ
LEMON TART

SERVES 6

1 × quantity pâte sucrée (see page 119)
175g/6 oz/heaped ¾ cup caster (superfine) sugar
finely grated rind (peel) and juice of 3 large lemons
3 eggs
2 egg yolks
175g/6 oz/1½ sticks unsalted butter, softened
icing (confectioners') sugar, to dust (optional)

ROLL OUT THE PÂTE SUCRÉE and use to line a 23cm/9 in tart tin (pan). Prick the base with a fork and chill for 30 minutes.

Preheat the oven to 200°C/400°F/Gas Mark 6 and place a baking sheet on the middle shelf.

Line the pâte sucrée case with baking paper and beans and bake, on the heated baking sheet, for 10–12 minutes. Carefully remove the paper and beans and bake for a further 10–12 minutes until the pâte sucrée is crisp and golden; set aside to cool on a wire rack. Do not turn off the oven.

Put the sugar, lemon rind (peel) and juice, eggs and egg yolks into a saucepan and stir over a very low heat until the sugar dissolves. Add half the butter and continue stirring for 1 minute, or until the sauce coats the back of the spoon. Add the remaining butter and whisk until the mixture becomes thick; do not stop whisking at any point or the eggs will curdle. Set aside to cool.

Spoon the lemon mixture into the pâte sucrée case and bake for 5–10 minutes until set. Leave to cool on a wire rack to room temperature. Serve warm, dusted with icing (confectioners') sugar, if wished.

Opposite: LEMON TART

SELECT BIBLIOGRAPHY

Andrieu, Pierre, *Fine bouche: A History of the Restaurant in France*, trans. Arthur L. Hayward, Cassell, 1956

Ash, Russell, *Impressionists and Their Art*, Orbis, 1980

Baker, Jenny, *La cuisine grand-mère: from Brittany, Normandy, Picardy and Flanders*, Faber and Faber, 1994

Baldick, Robert, ed. and trans., *Pages from the Goncourt Journals*, Oxford University Press, 1978

Bayard, Jean-Émile, *The Latin Quarter Past and Present*, T. Fisher Unwin, 1926

Bellony-Rewald, Alice, *The Lost World of the Impressionists*, Weidenfeld and Nicolson, 1976

Brettell, Richard R., *Pissarro and Pontoise*, Guild Publishing, 1990

Brookner, Anita, *The Genius of the Future: Essays in French Art Criticism*, Cornell University Press, 1971

Broude, Norma, *Seurat in Perspective*, Prentice-Hall, 1978

Callow, Phillip, *Van Gogh: A life*, Allison and Busby, 1991

Carr-Gomm, Sarah, *Seurat*, Studio Editions, 1993

Cate, Phillip Dennis, *The Graphic Arts and French Society 1871–1914*, Rutgers University Press, 1988

Courthion, Pierre, *Montmartre*, Skira, 1956

David, Elizabeth, *French Provincial Cookery*, Penguin Books, 1964

Davidson, Alan and Jane, *Dumas on Food: Recipes and Anecdotes from the Grand Dictionnaire de Cuisine*, Oxford University Press, 1987

Davidson, Alan, *North Atlantic Seafood*, Penguin Books, 1980

Denvir, Bernard, *The Impressionists at First Hand*, Thames and Hudson, 1987

Elgar, Frank, *Cézanne*, Thames and Hudson, 1969

Fitzgibbon, Theodora, *A Taste of Paris in Food and Pictures*, Dent, 1974

Ford, Ford Madox, *Provence*, George Allen and Unwin, 1938

Freson, Robert, *A Taste of France*, Hamlyn Publishing Group, 1987

Gaunt, William, *The Impressionists*, Thames and Hudson, 1970

Geffroy, Gustave, *Claude Monet: sa vie, son temps, son oeuvre*, Paris, 1922

Gerds, William H., *Monet's Giverny*, Abbeville Press, 1993

Goudeau, Émile, *Paris qui consomme*, Paris, 1893

Goufflé, Jules, *Le livre de cuisine: la cuisine de ménage et la grande cuisine (The Royal Cookery Book)*, Hachette, Paris, 1867

Groom, Gloria, *Edouard Vuillard*, Yale University Press, New Haven and London, 1993

Halevy, Daniel, *My Friend Degas*, Rupert Hart Davis, 1966

Hanson, Lawrence, *Mountain of Victory: A Biography of Paul Cézanne*, Secker and Warburg, 1960

Hanson, Lawrence, *Renoir, the Man, the Painter, and his World*, Leslie Frewin, 1972

Heinrich, Christoph, *Monet*, Benedikt Taschen, Cologne, 1994

Herbert, Robert L., *Impressionism: Art, Leisure and Parisian Society*, Yale University Press, New Haven and London, 1988

Herbert, Robert L., *Monet on the Normandy Coast: Tourism and Painting 1867–1886*, Yale University Press, New Haven and London, 1994

Horwitz, Sylvia L., *Toulouse-Lautrec: His World*, Harper and Row, New York, 1973

Isaacson, Joel, *Observation and Reflection: Claude Monet*, Phaidon, 1978

Jaworska, Wlaydyslawa, *Gauguin and the Pont-Aven School*, Thames and Hudson, 1972

Joyes, Claire, *Claude Monet: Life at Giverny*, Thames and Hudson, 1895

Joyes, Claire, *Monet's Cookery Notebook*, Ebury Press, 1996

Kapos, Martha, *The Impressionists: A Retrospective*, Hugh Lauter Levin Associations, 1991

Kendall, Richard, *Cézanne by Himself*, Macdonald and Co. Ltd, 1988

Le Paul, Judy, *Gauguin and the Impressionists at Pont-Aven*, Abbeville Press, New York, 1993

Le Pichon, Yann, *The Real World of the Impressionists*, trans. Dianne Cullinane, Octopus Books, 1984

Lethève, Jacques, *Daily Life of French Artists in the Nineteenth Century*, trans. Hilary E. Paddon, Praeger Publishers, 1972

Lucie-Smith, Edward, *Impressionist Women*, Weidenfeld and Nicolson, 1989

Maupassant, Guy de, *Selected Short Stories*, Penguin, 1971

Milner, John, *The Studios of Paris: The Capital of Art in the late-Nineteenth Century*, Yale University Press, New Haven and London, 1988

Moffett, Charles S., *The New Painting: Impressionism 1874–1886*, Phaidon, 1986

Monneret, Sophie, *Renoir*, Barrie and Jenkins, 1990

Moore, George, *Confessions of a Young Man*, Heinemann, 1886

Morisot, Berthe, *The Correspondence with her Family and Friends*, ed. Denis Rouart, trans. Betty W. Hubbard, Moyer Bell Ltd, 1987

Naudin, Jean-Bernard, Gilles Plazy and Jacqueline Saulnier, *Cézanne: a taste of Provence*, trans. Henrietta Handford and Cathy Muscat, Ebury Press, 1995

Naudin, Jean-Bernard, Genevieve Diego-Dortignac and André Daguin, *Toulouse-Lautrec's Table*, trans. Alex Cambell and Deborah Roberts

O'Connor, Patrick, *Toulouse-Lautrec: The Nightlife of Paris*, Phaidon, 1991

Pach, Walter, *Renoir*, Thames and Hudson, 1984

Prather, Marla and Charles F. Stuckey, *Gauguin: A Retrospective*, Hugh Lauter Levin Associates, 1987

Rewald, John, *Camille Pissarro: Letters to his son Lucien*, Routledge and Kegan Paul, 1943

Rewald, John, *Paul Cézanne: Letters*, trans. Seymour Hacker, Hacker Art Books, 1984

Rewald, John, *Pissarro*, Thames and Hudson, 1991

Rewald, John, *Seurat*, Harry N. Abrahms, 1990

Rewald, John, *The History of Impressionism*, The Museum of Modern Art, New York, 1961

Richardson, Joanna, *The Bohemians: La Vie Bohème in Paris 1830–1914*, Macmillan, 1969

Rivière, Georges, *Renoir et ses amis*, Paris, 1921

Roskill, Mark, ed., *The Letters of Vincent van Gogh*, Collins, 1963

Rothenstein, William, *Men and Memories 1872–1938*, ed. Mary Lago, Chatto and Windus, 1979

Rouart, Denis, *Claude Monet*, Albert Skira, 1958

Rouart, Denis, *Renoir*, Albert Skira, 1959

Sagner-Duchting, Karin, *Claude Monet*, Benedikt Taschen, Cologne, 1990

Schimmel, Herbert, ed., *The Letters of Henri de Toulouse-Lautrec*, Oxford University Press, 1991

Shikes, R. E. and Paula Harper, *Pissarro: His Life and Work*, Quartet Books, 1980

Shone, Richard, *Sisley*, Phaidon, 1979

Spate, Virginia, *The Colour of Time: Claude Monet*, Thames and Hudson, 1992

Stuckey, Charles F. and William P. Scott, *Berthe Morisot: Impressionist*, Sotheby's, 1987

Stein, Susan, *Van Gogh: A Retrospective*, Hugh Lauter Levin Associates, Inc., 1986

Tabarant, A., *Pissarro*, trans. J. Lewis May, The Bodley Head, 1925

Toulouse-Lautrec, Henri and Maurice Joyant, *The Art of Cuisine*, Michael Joseph, 1966

Tucker, Paul Hayes, *Monet at Argenteuil*, Yale University Press, New Haven and London, 1982

Tucker, Paul Hayes, *Monet in the '90s*, Guild Publishing, 1989

Valery, Paul, *Degas, Manet, Morisot*, trans. David Paul, Pantheon Books, New York, 1960

Vollard, Ambroise, *Degas: An Intimate Portrait*, trans. Randolph T. Weaver, Dover Publications, New York, 1986

Vollard, Ambroise, *Renoir: An Intimate Portrait*, trans. Harold L. Van Doren and Randolph T. Weaver, Knopf, New York, 1925

Vollard, Ambroise, *Paul Cézanne: His Life and Art*, Brentano's, 1924

Wadley, Nicholas, *Renoir: A Retrospective*, Park Lane, New York, 1987

Walther, Ingo F. and Rainer Metzger, *Van Gogh*, Benedikt Taschen, Cologne, 1993

Wilson-Bareau, Juliet, *Manet by Himself*, Macdonald, 1991

Zola, Émile, *L'oeuvre*, trans. Thomas Walton, Oxford University Press, 1993

Zola, Émile, *Le ventre de Paris*, trans. Ernest Alfred Vizetelly, Alan Sutton Publishing 1993

INDEX

Page numbers in italics refer to illustrations

PICTURE ACKNOWLEDGEMENTS

Art Institute Chicago, Illinois: pp15 (Mr and Mrs Lewis Lurned Coburn Memorial Collection); 63 (Helen Birch Bartlett Memorial Collection); 93 (Mr and Mrs Potter Palmer Collection)

Barnes Foundation, Merion, PA: p98

Bibliothèque Nationale, Paris: pp54, 69

Bridgeman Art Library, London: pp3 Musée D'Orsay, Giraudon, Paris; 9 Musée D'Orsay, Lauros, Giraudon; 13 Musée des Beaux Arts, Bordeaux; 14 Private Collection, Giraudon; 16 Musée D'Orsay, Giraudon; 21 Stadelschen Kunstinstitut, Frankfurt; 25 Private Collection; 47 Courtauld Institute, London; 51 Städelschens Kunstinstitut, Frankfurt; 55 Neue Pinakothek, Munich; 59 Musée des Beaux Arts, Tournai; 60 Musée D'Orsay, Giraudon; 89 The Louvre, Paris; 90 Pushkin Museum, Moscow; 94 Phillips Collection, Washington; 97 National Gallery of Art, Washington; 100 Buhrle Foundation, Zurich; 102 Museum of Fine Arts, Boston; 125 Musée des Beaux-Art Rennes, Giraudon; 126 Phillips Collection; 129 Christie's, London; 130 Collection Josefowitz, New York; 155 Musée D'Orsay, Lauros, Giraudon; 156 Art Institute of Chicago; 159 Musée D'Orsay, Lauros, Giraudon; 160 Musée D'Orsay, Lauros, Giraudon.

British Museum, London: p11

Calouste Gulbenkian Foundation, Lisbon: p45

Galerie Schmit, Paris: p18

Harvard University Art Museums: pp7 (Gift of Friends of the Fogg Art Museum); 50 (Bequest of Meta and Paul J Sachs)

Kröller-Müller Museum, Otterlo: pp133, 163, 164

Musée D'Orsay, Paris: pp6, 123

Museum of Fine Arts, Boston: p22 (Fanny P Mason Fund in memory of Alice Thevin)

National Gallery, London: p48

National Gallery of Art, Washington: pp69 (Collection Mr and Mrs Paul Mellon); 134 (Gift of the Adele R Levy Fund)

National Art Museums, Stockholm: p2

Private Collection, Switzerland/Ingo F Walther, Alling: p153

Sterling & Francine Clark Institute, Williamston, Mass: p7

Toulouse-Lautrec Museum, Albi: p64

Roger-Viollet, Paris: p127

Wallraf-Richartz Museum, Cologne: p87